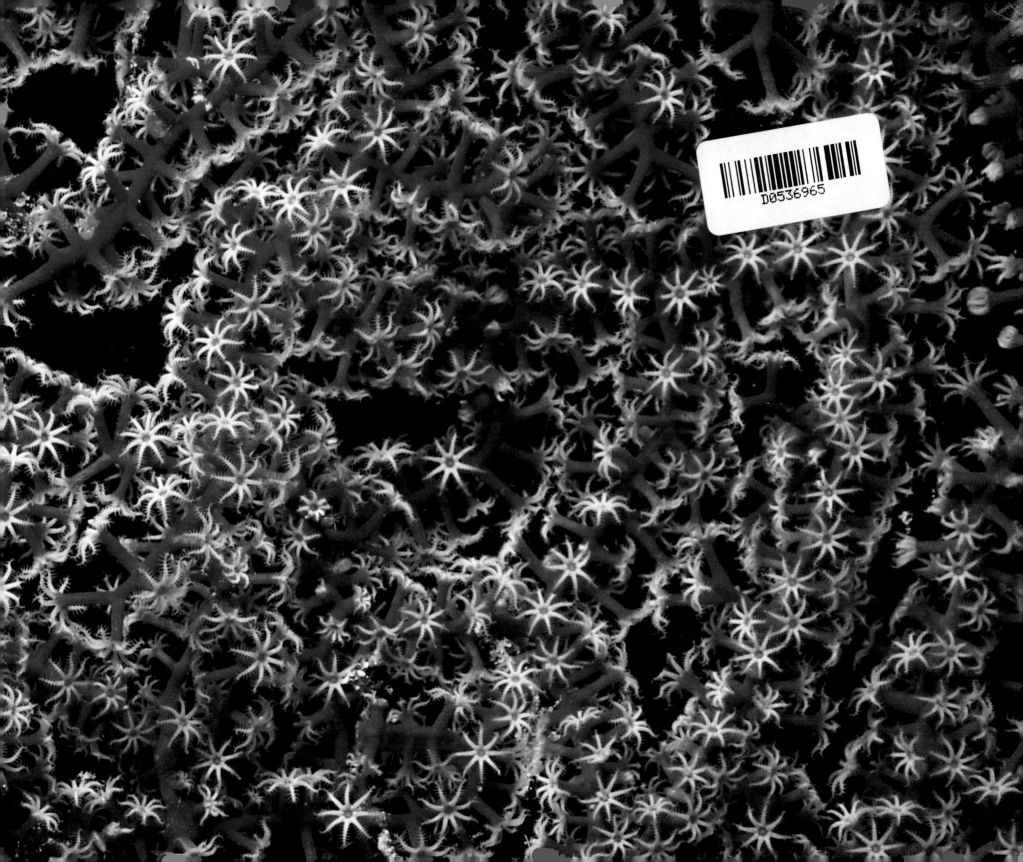

THE CORAL REEF **AT NIGHT**

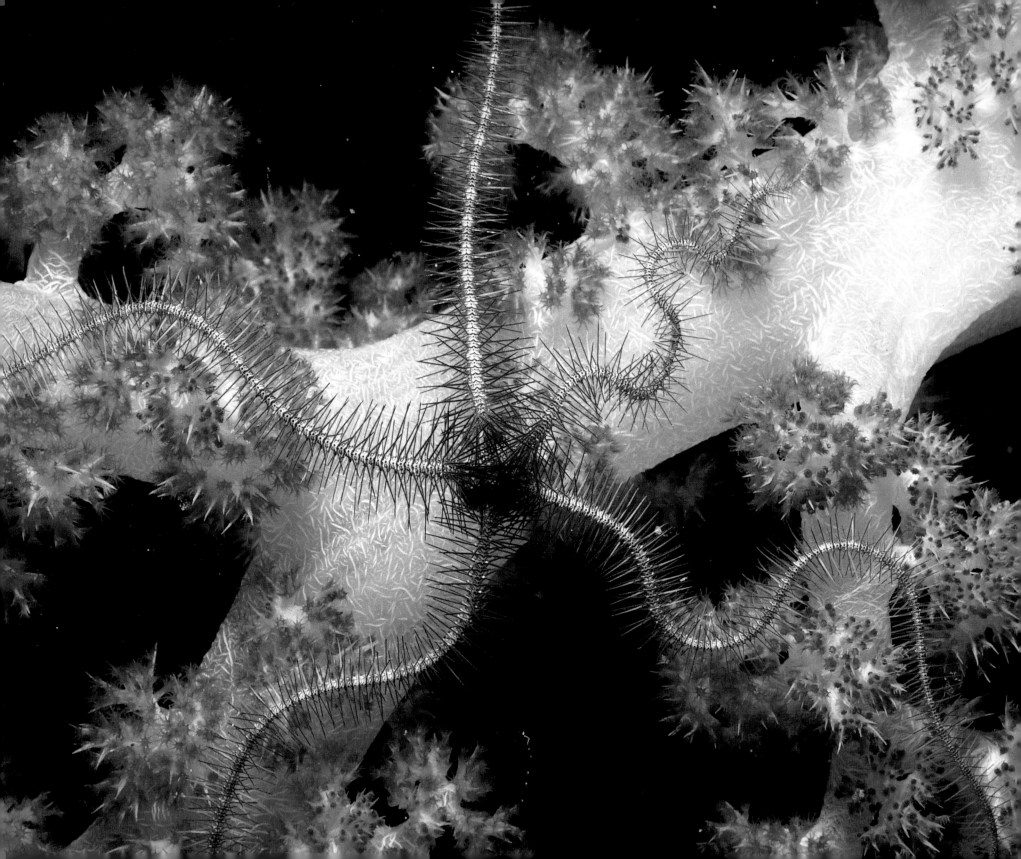

THE CORAL REEF AT NIGHT

Text by **Joseph S. Levine** Photographs by **Jeffrey L. Rotman**

Harry N. Abrams, Inc., Publishers

Project Director: Margaret L. Kaplan

Editor: Sharon AvRutick

Designer: Elissa Ichiyasu

Library of Congress Cataloging-in-Publication Data

Levine, Joseph S.

The coral reef at night/by Joseph Levine;

photographs by Jeff Rotman.

p. cm.

ISBN 0–8109–3190–7

1. Coral reef fauna—Pictorial works.

2. Coral reef biology—Pictorial works.

3. Underwater photography.

4. Night photography.

I. Rotman, Jeffrey L.

II. Title.

QL 125.L48 1993 93–12277

591.9'1—dc20 CIP

Endpapers: Gorgonian coral feeds at night.

Page 1: Bigeye on the prowl.

Page 2: Brittle star scuttles across soft coral.

Page 3: Cuttlefish eyes diver.

Page 5: Crinoid photographed from below at night.

Page 6: Octopus prepares to flee.

To Albert Gore, Jr., with hope

that his ecological vision can inspire

and guide those around him

Joseph S. Levine

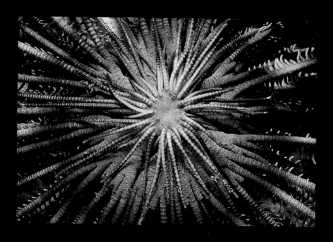

To my sister, Jane

Jeffrey L. Rotman

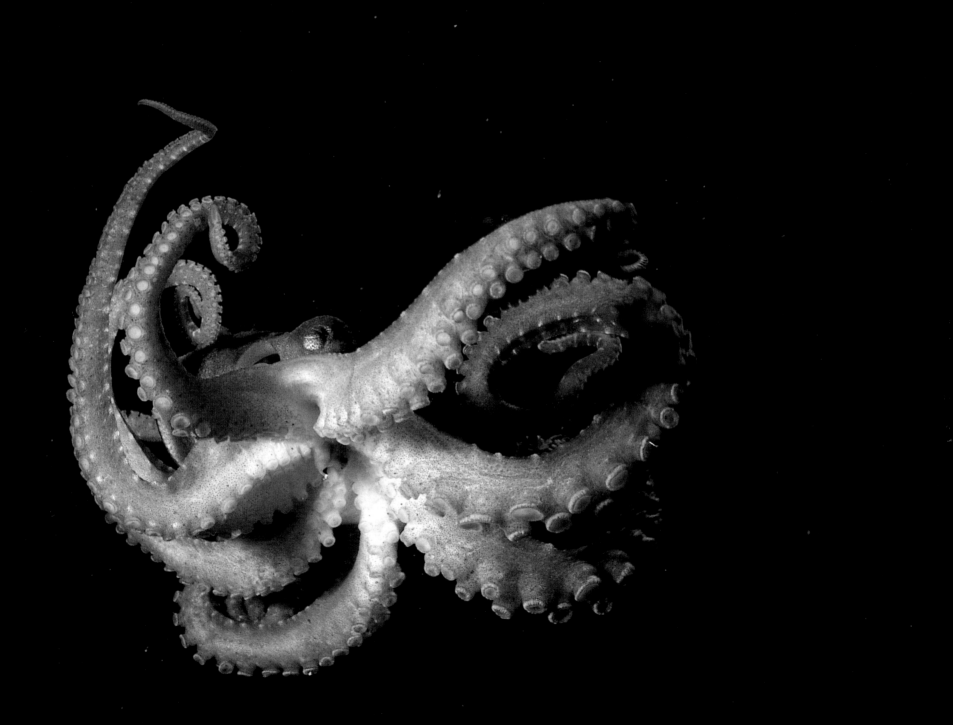

CONTENTS

INTRODUCTION THE RED SEA AT DUSK: A PRIVATE PARADISE

Rising slowly to the surface, I scanned the reef flat for stonefishes and sea urchins, planted both feet firmly on a patch of dead coral, and stood up in waist-deep water. A light breeze stirred ripples on the surface, and the tide was high and still. To the west, the setting sun blazed behind the jagged mountain peaks of the southern Sinai Peninsula. To the south, the promontory called Ras Mohammed (Mohammed's Head) formed a dark silhouette against the purple sky. To the east, the island of Tiran and the coast of Saudi Arabia faded into obscurity behind low-lying haze and dust. Overhead, stars and planets began to sparkle in the cloudless sky.

Jeff Rotman surfaced a few yards to my right, just in time to hear me heave a sigh of relief and pleasure. "So, Yossi," he said, chuckling, "it's good to be back home, isn't it?"

I smiled, nodded, looked around, and sighed again. Jeff, the photographer, is lucky enough to dive the Sinai coast on a regular basis, but I hadn't been there in years. It *was* good to be home, back—after too long an absence—in the waters of the Red Sea.

Jacks, separated momentarily from their school, hunt during the predawn darkness on Jackson Reef in the Gulf of Aqaba.

8

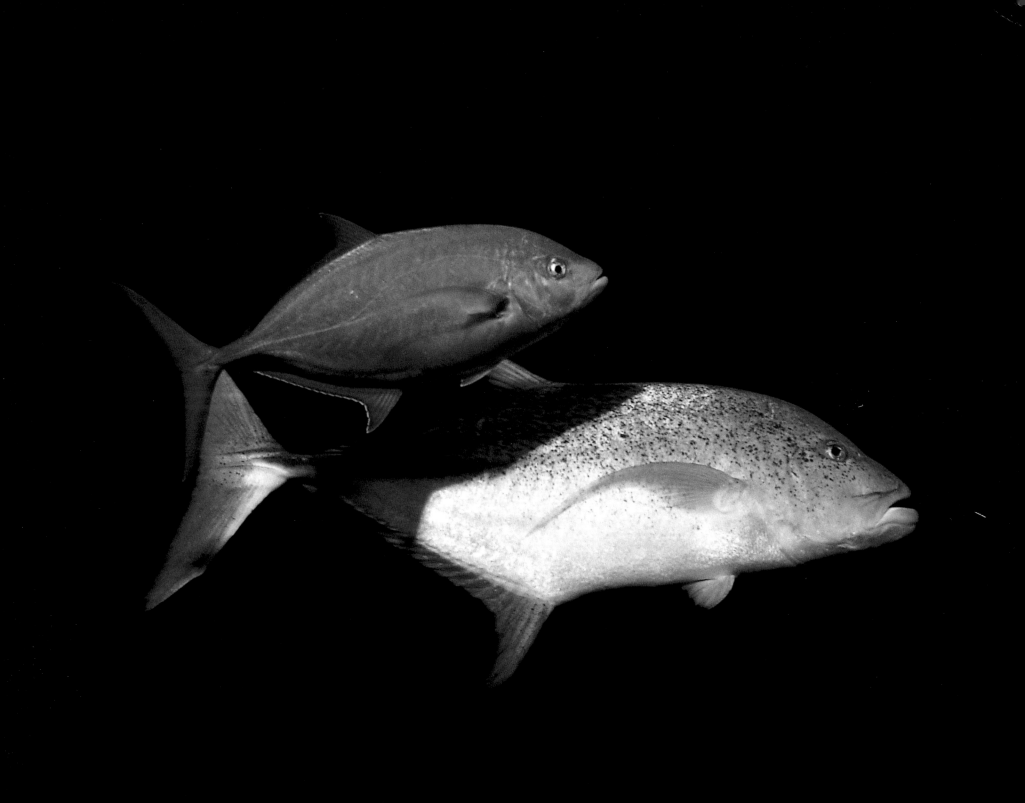

We had literally run to the reef after the dusty drive to Sharm-al-Sheikh, eager to hit the water as soon as possible. Dumping our luggage at the hotel, we grabbed masks, snorkels, and wet-suit boots, and headed straight for the shore as afternoon shadows grew and merged into the gathering darkness of evening. Without wet suits, flashlights, or even flippers, this first sortie had to be short; even the shallow and protected portion of the reef could be dangerous in total darkness without the proper gear.

But as brief as that first dip was, it reassured us that the weeks of preparation and the long trip had been worthwhile. The water was warm and inviting. The fringing reef at Ras um Sid, along which Jeff and I had dived many times in the past, was just as I'd remembered it. And the reef animals themselves seemed to be saying "Welcome!" through displays of undulating bodies and fluttering fins as elaborate and as ritualized as the Arabic greetings of our Bedouin hosts.

After clambering up the rocky bluff to the car, we shed wet bathing suits and toweled off as the sun winked out behind the mountains. We donned dry clothes in the dark, climbed into our seats, and headed for home base—the Hotel Senafir, a postmodern Moorish concoction of arches, domes, and courtyards named after one of the reef-fringed islands guarding the entrance to the Gulf of Aqaba. On the way, we discussed our excitement about working together on the reef at night, the length and depth of our professional relationship, and our emotional ties to the Sinai and the Red Sea, both of which had changed a great deal during the twenty years we had known them.

Our introduction to the Gulf of Aqaba in the early 1970s coincided with a brief period of peace in the Middle East following the Six-Day War. At that time, the only real inhabitants of the Sinai Peninsula's eastern coast were Bedouins who sometimes fished for food but otherwise paid little attention to the reefs that fringed the shore. The two main coastal oases, Nuweiba and Dahab, and the dusty port of Sharm-al-Sheikh housed only a few dozen Bedouin families, their camels, and their goats.

For a while, the most regular divers in the gulf were scientists: Hebrew University's Adam Ben-Tuvia, Tel Aviv University's Lev Fishelson, the University of Hawaii's Jack Randall, the University of Maryland's Eugenie Clark, and the Max Planck Institute's Hans Fricke. Their trailblazing diving expeditions carried both water and food to remote sites and depended for scuba tank refills on a cantankerous compressor at Willy's Aqua Sport in Eilat—the great-grandfather of local diving clubs.

Jeff and I did not know each other in those days, and we each learned about the Red Sea in our own ways. Independently, both of us became fascinated by the complex and interwoven cycles of activity that govern life in tropical seas over the course of each twenty-four-hour period.

As a student at Hebrew University in Jerusalem, I was lucky enough to meet many prominent researchers and to work briefly under several of them during expeditions that were memorable for events both above water and below. One of our trips, for example, aimed for dive sites inaccessible to all but the most rugged four-wheel-drive vehicles, which our budget did not provide for. Instead, for local transportation we relied on camels—who suffered the unaccustomed weight of scuba tanks remarkably well. Diving was new to the Sinai and its people then, and the best explanation I could offer in fragmentary Arabic to our perplexed Bedouin guides was that our tanks contained "wind from Eilat" that we could breathe underwater.

My studies gave me my first taste of diving at twilight, while I was recording the daily rhythms of peculiar animals nicknamed "garden eels." Those sinuous, three-foot-long fishes spend most daylight hours concealed in deep burrows they dig in sandy areas below and around shallow reefs. At dawn and dusk, however, they stretch out to nearly their full body length, rippling and swaying like underwater question marks as they select tasty morsels from clouds of passing plankton. In later years, while studying the role of vision in fish behavior, I examined the structures and functions of fish eyes and worked with investigators who chronicled changes in the behavior of aquatic animals at different times of day.

Jeff, for his part, had become an insatiable diver with an adventuresome bent that quickly led him to stretch sport divers' ordinary hours. His photographer's eye soon noticed a practical application for marine animals' cycles of activity and torpor. Acquainting himself with the bizarre creatures that emerge to prowl the reef only after dark, he soon discovered that working under cover of darkness enabled him to photograph many animals far more intimately than he could during daylight. Renting a flat in the Israeli frontier settlement of Ophira, near Sharm-al-Sheikh, he was soon combing the reefs of the southern Sinai at all hours.

When Jeff and I finally met in 1976—by chance, rather than by design, and in Boston, rather than in the water—we began a friendship and working partnership that still continues. Given our similar passions, it was only a matter of time before we began working on a book about the reef at night. Many hours of diving later, we were ready to go back to the Red Sea, for the series of dives would serve as the capstone for the project.

Later that night in Sharm-al-Sheikh, we discussed our hopes for this book over a dinner of humus, baba ganoosh, and kebabs. Jeff's photographs, I knew, would open people's eyes to the nighttime beauty of the underwater world. My writing, Jeff was confident, would inform readers about undersea goings-on that they had never imagined. But the ride back to our hotel had taken us past new sights and sounds—some of them amusing, some of them disturbing—in what had once been the southern edge of the Sinai's "great and terrible wilderness." Those changes in the face of Sharm-al-Sheikh convinced us to give this book a larger purpose: to persuade recreational divers to take a new look at reefs they think have no more excitement to offer.

Spreading their delicate tentacles wide, these colonial anemones shine against the darkness when illuminated by a photographer's strobe.

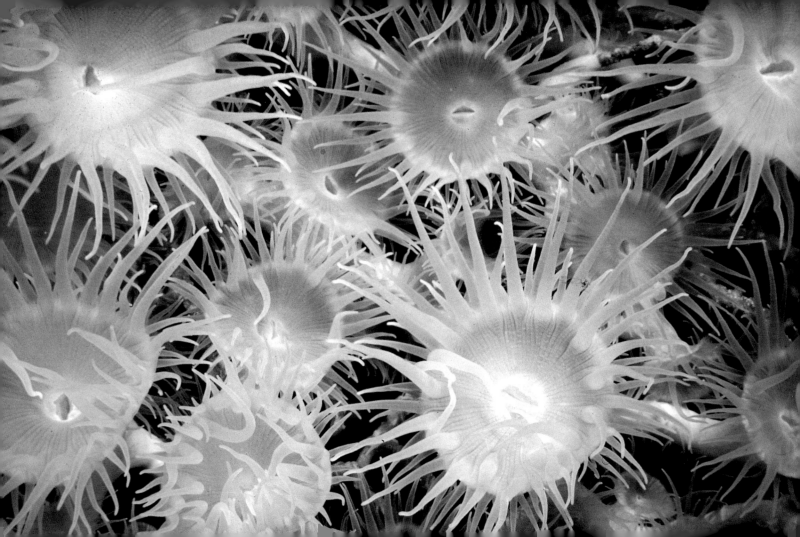

The transformation of once-sleepy Sharm-al-Sheikh reflects the increasingly crowded (and upscale) world of recreational diving. Word of the area's world-class reefs spread rapidly during the Israeli occupation of the region. By the late 1970s, European sport divers began arriving in growing numbers, and it wasn't long before the first professional dive club opened in southern Sinai. "Red Sea Divers," its T-shirts proudly proclaimed, "Best way into the sea since Moses!" By the early '90s, many clubs were operating scores of boats and offering accommodations ranging from Spartan to sybaritic. The once-placid arc of nearby Na'ama Bay grew crowded with hotels serving gourmet cuisine, boutiques offering the latest fashions, open-air cafés equipped with communal water pipes, and nightclubs spewing pop music into the desert air.

We know that many who frequent those facilities are caught up in a constant search for new thrills—traveling ever farther afield for that deeper wreck; that steeper, more spectacular drop-off; that mysterious blue hole with treacherous tidal currents. We understand (and share) their quest for adventure and the craving for the rush of adrenaline that fuels those searches. We know that clear water and exuberant coral growth encourage divers to careen along the reef at full tilt, always searching for the next grand vista. And we can forgive enthusiasts who say, "Yes, it's beautiful, but I've already seen that a dozen times." After all, divers who always hit the water at mid-morning or mid-afternoon sooner or later start seeing more or less the same animals doing more or less the same things. And as spectacular as those animals and their antics may be, they lose their novelty after a time.

Diving at different times of day and night, on the other hand, reveals entirely new worlds of life, not only on the grand reefs of the Indo-Pacific, but even on modest patch reefs scattered around resort islands in the Caribbean. The reef and its inhabitants dramatically change in both appearance and activity as light levels rise, peak, and fall. Mobile animals change places, vanish from sight, or appear out of nowhere. Fishes display curious mating rituals or indulge in orgiastic bouts of group sex involving males, females, and hermaphrodites in every imaginable variation of aquatic sexual acrobatics. For that reason alone, daytime, twilight, and nighttime dives are guaranteed to introduce a diverse cast of new characters and to reveal radically new aspects of old favorites.

In addition, twilight and darkness constrain human vision; in the enveloping gloom underwater, nothing is visible outside the narrow beam of a flashlight. Restricted by caution and nearsightedness, night divers swim more slowly, stop more often, and peer, poke, and probe at smaller, nearer objects. The result is a more intimate relationship with the reef, fueled by glimpses into the lives of creatures that are too small, too shy, or too quick to be seen easily. That familiar dive site will never look quite the same again. And that is one main message of this book.

There are other benefits to off-hours diving, too—benefits that Jeff and I relished on our recent stay when we set out from a pier jammed end to end with divers and dive boats. In late afternoon, we boarded a boat whose Arabic name, *Acharaya*, means "freedom." The *Acharaya* is owned by Jeff's Bedouin friend Embarak—a successful entrepreneur who, gifted with a keen business sense, parlayed his intimate knowledge of the reefs into a thriving dive operation that specializes in trips to the best sites and supplies only the most reliable crew and equipment.

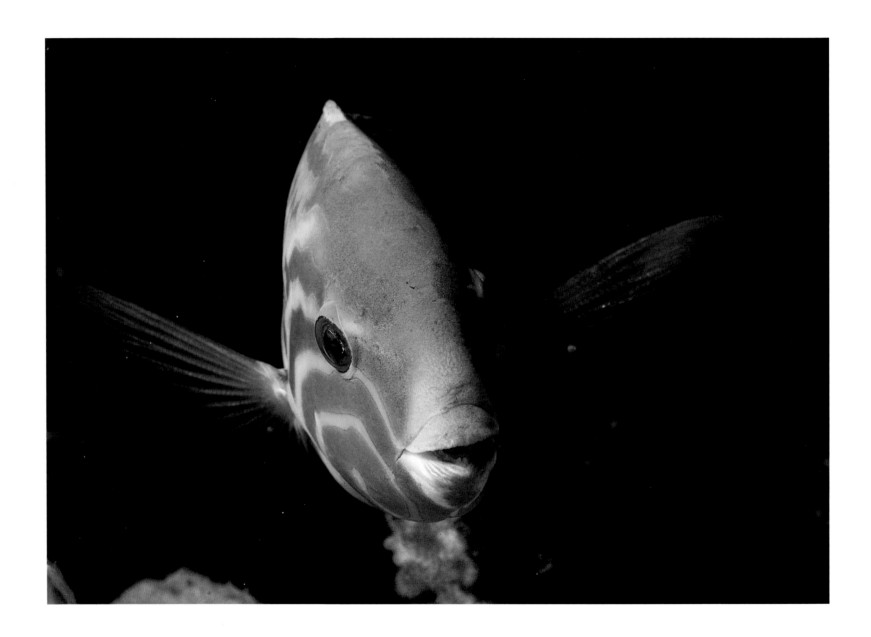

This wrasse, poised in surprise after having been roused from sleep in a cave at night, displays the flamboyant coloration, small, specialized mouth, small eyes, and highly maneuverable fins that typify its strictly daytime family.

We set out for the spectacular coral wall known on maritime charts as Jackson Reef and renowned among divers as the premier dive site in the Straits of Tiran. When we arrived, there were nine other dive boats perched on moorings there—a sobering sight, as neither Jeff nor I enjoy sharing a reef with dozens of other divers. But no need to worry. Our captain, Ibraheem, steered deftly over the reef and anchored in the lagoon, where a brief, shallow dive gave us a chance to check our equipment, adjust our weight belts, and relax. By the time we had dried off and sat down to dinner, the first of the other boats was headed for home. Before we finished our coffee, we were alone.

For the next three hours we relaxed on deck, reveling in the magnificent solitude of this spot where the desert meets the sea. The western sky blazed with russet light that transformed the surface of the sea into a firestorm before fading to purple and black. The Milky Way appeared and broadened to cover nearly half the sky. Luminescent plankton sparkled as waves washed the hull and currents swept past the anchor line. Listening to the wind in the rigging, I found it easy to imagine the ghosts of Pharaoh's ships and Solomon's trading fleets slipping quietly past us in the dark—to Ophir, to Sheba, and beyond.

As we roused ourselves to don our diving gear again, I wondered what new sights our first night back on the reef would offer us. By the time I had suited up, Jeff and our safety diver were double-checking the cameras. We smiled, settled our masks in place, gave the "thumbs up," and plunged over the side.

Yes, it was certainly good to be home.

CHAPTER ONE LIVING TOGETHER

In the otherwise monochrome, camouflaged, streamlined world of the sea, the coral reef glimmers like a living Oriental carpet. Its brilliant colors and improbable shapes have provoked hyperbole in writers ever since eighteenth-century explorers described coral fishes as covered with "polished scales of gold, encrusting lapis lazuli, rubies, sapphires, emeralds, and amethysts." The vivacity and extravagance of thriving reefs captivate even jaded tourists who glimpse them, even for just a few moments, and even from the remove of a glass-bottomed boat.

From a biological perspective, that's not too surprising. In the natural world, reefs' bewildering diversity is rivaled only by that of tropical rainforests. And the diversity of reef life covers more than sheer numbers and variety of plants and animals; reef organisms dwell in closer proximity to one another and engage in more intricately interwoven behavioral and ecological connections than the inhabitants of any other ecosystem on earth.

Corals, fishes, and scores of lesser-known invertebrates (animals without backbones) all contribute to the staggering diversity of color and form on the reef. Hard corals' limestone skeletons form the reef's structure, while coral animals' partnership with single-celled plants helps them provide sustenance to many other reef dwellers. Soft corals in shades ranging from green to bright yellow, orange, and reddish-brown lack limestone foundations, so they sway gracefully in the current. During midday, schools of scarlet *Anthias* swarm around the edge of the reef, seldom venturing much farther from shelter than those shown here.

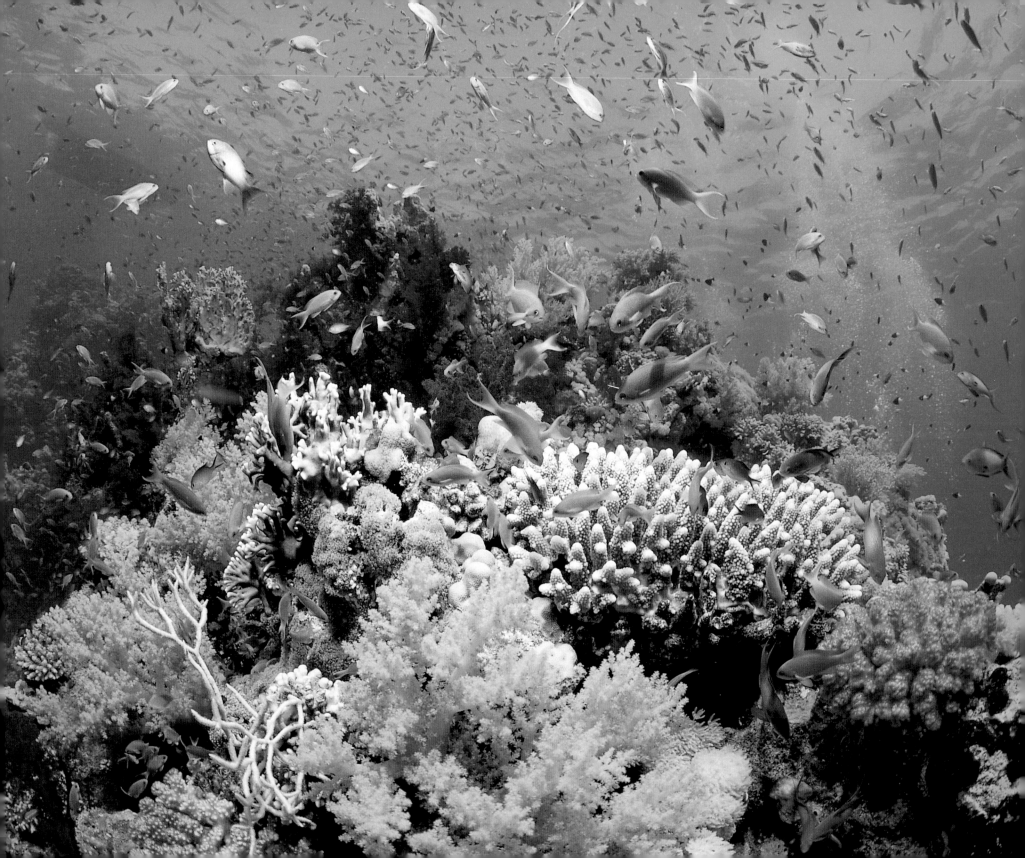

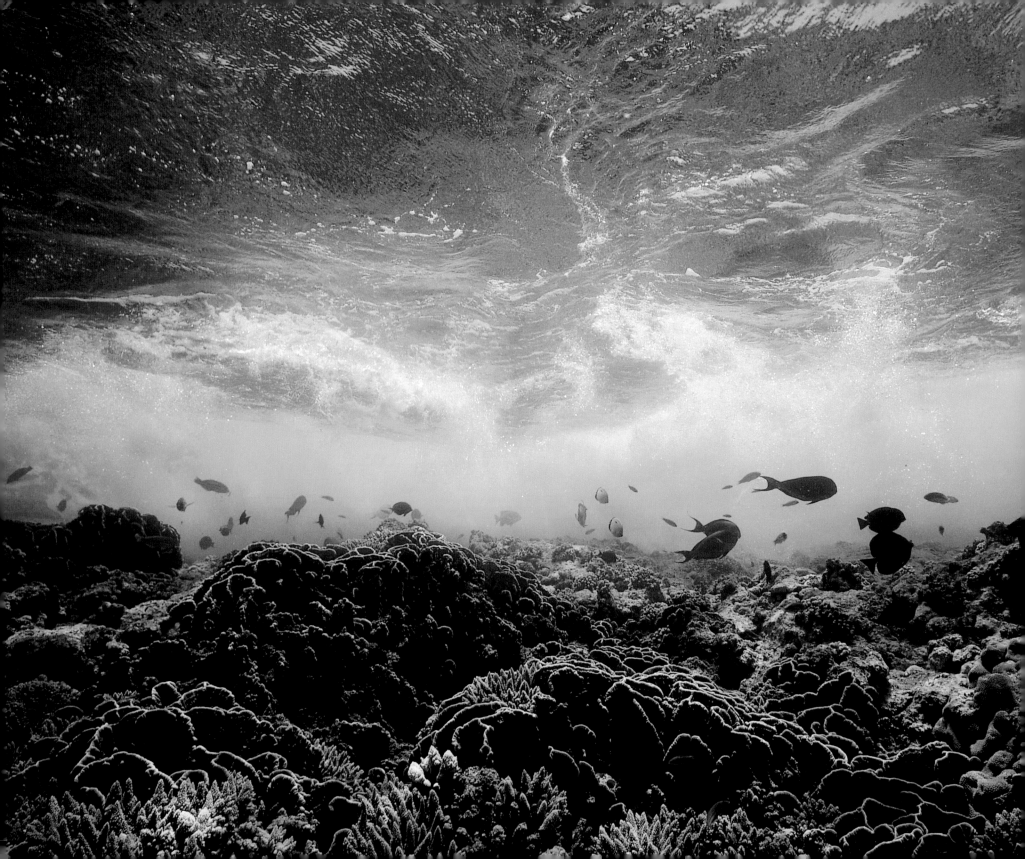

The reef as most snorkelers see it seems flat and solid, with its top — known as the reef flat or reef table — close enough to the surface that bits and pieces of it may be exposed at low tide. Its complexity begins to show at its seaward edge (following pages), where it drops off — sometimes precipitously, sometimes more gradually — into deeper water.

The complexity of coral communities makes them easy to fall in love with, but hard to understand. Divers visiting reefs see too many things moving too quickly in too many directions to fathom what is going on. How is it that all these creatures actually live together? What sorts of relationships do they have with one another? What rules govern where they live and how they make a living?

Reefs owe part of their allure — and much of their mystery — to their remote locations. A few types of corals hold their own along the rocky shores of New England and California, and one or two species even thrive in the frigid waters off Alaska, but none of them amount to much, ecologically speaking. More substantial reefs cling to life near the edge of their range in places such as the subtropical Florida Keys; there they survive at the whim of winds and currents that (usually) bathe them in warm water from nearby equatorial seas. But fully mature, exuberant coral reefs thrive only in the tropics proper. And the biggest, most impressive, and most biologically diverse reefs aren't found even in properly tropical parts of the Atlantic and the southern Caribbean. The real gems are scattered across the marine province biologists call the Indo-Pacific, in places like Palau, Micronesia, Australia, Indonesia, India, and the Sinai Peninsula.

Yet reefs' geographical seclusion and biological eccentricity have been mixed blessings. Until recently, their locations (like those of tropical rainforests) have insulated reefs from the worst depredations of temperate-zone civilization, while their bizarre cast of characters drew nature lovers and bewildered scientists in droves. With a few notable exceptions, corals and humans coexisted rather well.

But today, wild places need public relations consultants, and endangered species depend on ecopolitical spin doctors. As the experience of such organizations as the Sierra Club and the World Wildlife Fund has shown, public support of conservation hinges on the right combination of exoticism and familiarity. And in that popularity contest, rainforests hold higher cards than their aquatic counterparts.

Rainforests are forests, after all, and people know (or think they know) what forests are. Cute and cuddly creatures live there: parrots and hummingbirds, monkeys and sloths, diminutive deer and big cats. Even forest animals that aren't quite so "huggable" are still familiar: Tropical butterflies are prettier versions of local insects, fluorescent tree frogs are impish cousins of spring peepers, and anacondas are overgrown garden snakes. And, of course, rainforests' central elements are trees — plants with local counterparts that grow just about anywhere (including Brooklyn) that is fit for human habitation.

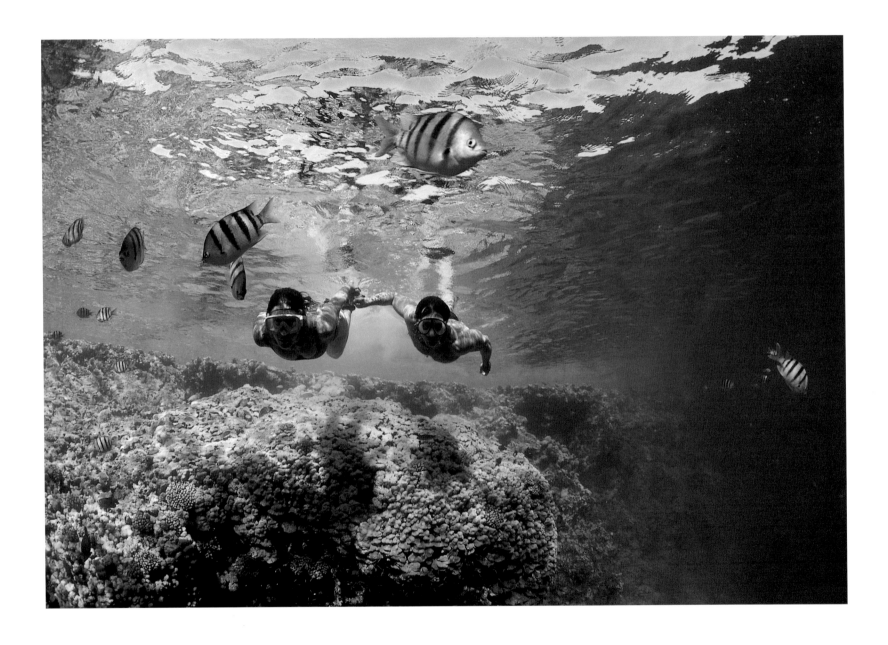

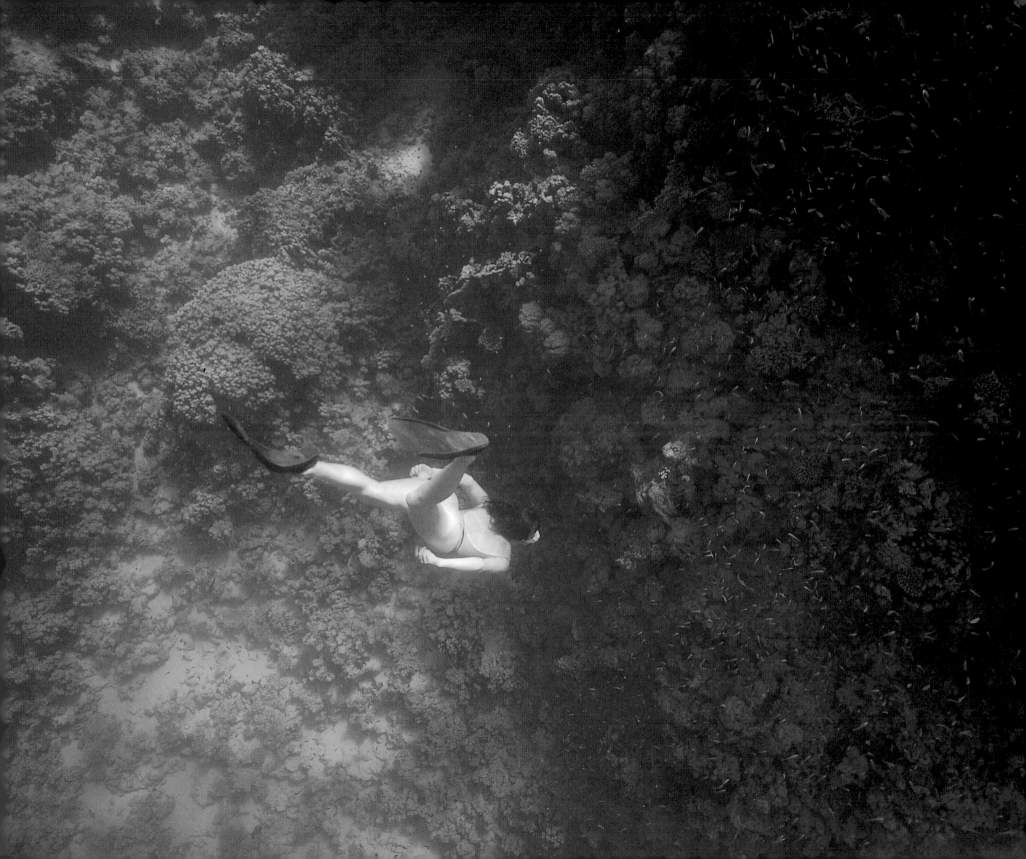

Of course, in reality tropical rainforests differ dramatically from their temperate-zone counterparts in many important ways. (That's a good part of the reason why efforts to exploit them in temperate-zone fashion have caused such devastation.) But these forests' familiar plants, adorable animals, and accessibility to ecotourists make it easy for neophytes to love them, visit them, and rally to their defense.

Reefs, on the other hand, are not only tropical but aquatic. As a consequence, their structure and inhabitants are almost totally foreign, and the associations they do carry aren't always positive. To mariners, for example, the word *reef* conjures images of wave-pounded shallows that rip bottoms off boats. Fishes, the reef's most visible stars, are usually discussed in terms of palatability, not personality. The supporting cast of reef animals includes a bewildering array of invertebrates—animals without backbones, such as sea anemones, urchins, shrimp, and worms—which not only aren't "warm and fuzzy," but stir memories of lists of Latin names that terrorize students in introductory biology courses. And then there are the corals themselves. Are they animals? Are they plants? Do they bite? Do they flower?

To biologists, the general public's lack of enthusiasm for reefs and reef animals is puzzling. If a living, breathing *Tyrannosaurus* ever came to light, *The New York Times* would splash it across the front page, *People* would profile its discoverers, *The New Yorker* would serialize an account of the expedition, and Hollywood would crank out a film in an instant. Yet plenty of animals prowling reefs today have done so since before the first *T. rex* ever crawled from its nest; somehow they survived the mass extinctions that wiped out their Mesozoic fellow travelers, both on land and in the sea. Reef animals' penchant for forming bizarre (and often little-known) partnerships with one another bewilders ecologists struggling to understand how such a madcap coalition of biological miscellany manages to survive. And their beauty takes the breath away from divers meeting them for the first time.

But sea slugs and their neighbors, as beautiful as they are, lack the charisma that serves pandas, gorillas, and elephants so well in garnering attention and protection. Even nature and science magazines usually relegate fishes and marine invertebrates to "News in Brief"

Beneath its deceptively intact face, the reef is anything but solid. Riddled with caves, crevices, tunnels, and serpentine pathways, it offers homes of all sizes to a wide range of animals. Some, such as these sweepers, use its recesses as daytime or nighttime sleeping quarters. Others attach themselves to its interior surfaces.

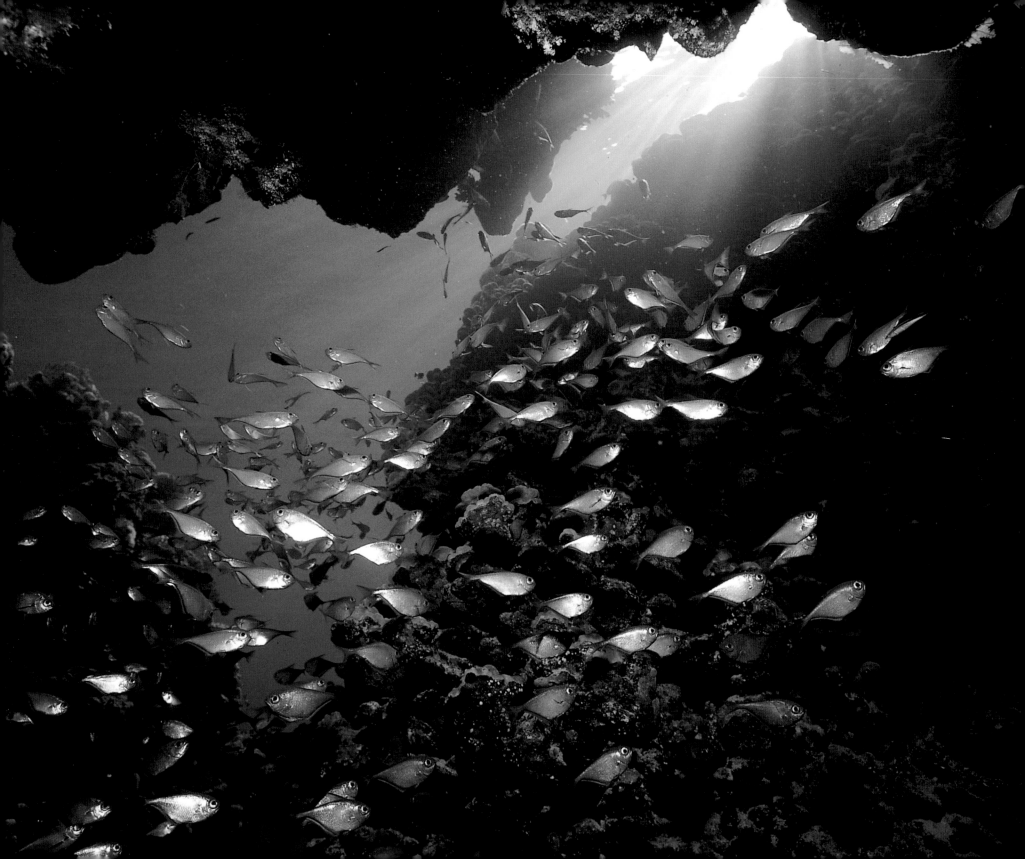

segments, reserving most cover stories and feature articles for animals with fur, feathers, big, round eyes, or, at the very least, blubber. For better and for worse, dolphins and whales, favorites with kids and the save-the-planet crowd, are known to visit reefs but don't live on them. So those of us enamored of coral reefs start off with a handicap when we try to cultivate interest in, understanding of, and concern for these extraordinary ecosystems.

Perhaps a metaphor linking human and piscine experience will help to bridge the gap between temperate-zone, terrestrial mind-set and tropical, aquatic habitat.

Bear with me, then, and envision the reef as an alien version of a human metropolis. A real metropolis. Not a picturesque town with a few hundred residents, well-kept houses, and a respectably low crime rate. Not even a good-size city like Houston, Denver, or Boston, with reasonable cultural diversity and turbulent history, but a huge urban center like New York, where skyscrapers and subway tunnels, high culture and violent crime, vibrant neighborhoods and burned-out slums confront and complement one another, and where all these discordant components create an urban tapestry greater than the sum of its parts.

Now close your eyes and imagine that you are an invisible observer from another world, floating down past the Empire State Building to the streets of midtown Manhattan. As soon as you arrive, you are enveloped in the energy and intensity of city life. People of every conceivable age, size, shape, and skin color swarm around buildings of unfamiliar shapes and proportions. There are flashing sirens, honking horns, shouts, and peals of laughter. Your first impression is of dazzling diversity and absolute chaos.

But watch the throng closely for several days—particularly during rush hour, as people scurry between home and work along sidewalks and through subway tunnels—and you'll begin to notice two phenomena: even greater diversity within the crowd and patterns in the way individuals behave. The people wear different clothes, escort different pets, travel in different kinds of groups, and communicate in different languages. Some are city people who work in town, others live downtown but travel to jobs in the outer boroughs, and still others are suburbanites who either work or shop in the city. Most have favorite routes which they abandon only when construction or traffic jams block their path or when unusual errands demand their attention. When not actively working, they eat, sleep, make love, and otherwise amuse themselves in specific rooms of particular buildings or in selected spots around them.

During daylight hours, hard corals such as these—with their living tissues withdrawn as far as possible into intricately patterned limestone skeletons—scarcely seem to be alive. Although they look more like rocks than living organisms while the sun shines, these corals are, in fact, performing a vital role in the ecosystem of the reef. Single-celled algae living in partnership with the nearly invisible coral animals trap solar energy and perform photosynthesis. In so doing, they help create a dynamic plant-animal partnership that efficiently accumulates and recycles scarce nutrients in the clear waters of shallow tropical seas. This intimate collaboration—a prime example of what biologists call mutualistic symbiosis—is both physically and energetically the foundation of reef life.

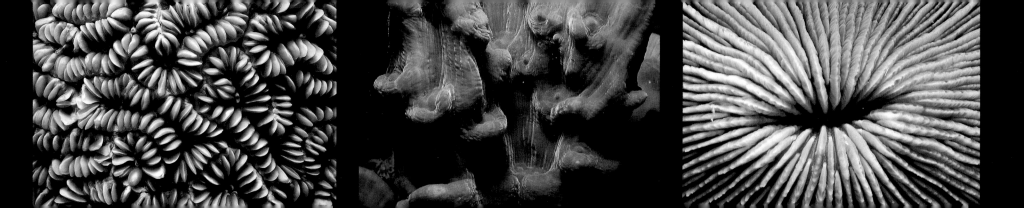

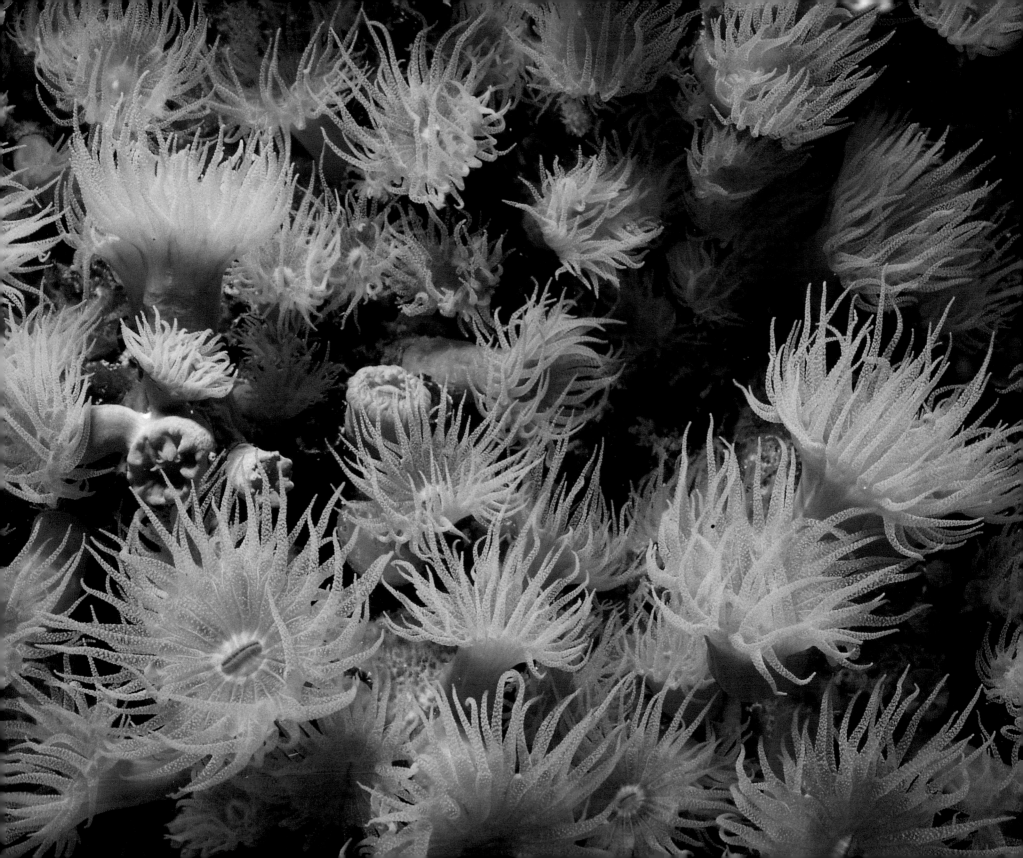

At night, corals undergo an almost magical transformation. The plant half of the partnership takes a back seat while the animal component stretches out its stinging tentacles to capture small animals that float past as part of the drifting clouds of life called plankton. Although it would seem as though hard-coral animals should be able to survive perfectly well by feeding in this way, they cannot. Without the help of their plant partners, hard-coral colonies cannot produce their limestone skeletons, and seem to be weakened in other, less-understood ways.

They also labor at a bewildering array of jobs. Stand on a street corner for any length of time, and you'll notice construction workers and street vendors, doctors and con artists, waiters and garbage collectors. Ask directions to a bakery and you'll have to specify precisely what you are looking for—doughnuts, bagels, croissants, bran muffins, pita bread, or white chocolate cheesecake—because, instead of a single all-purpose bakery, scores of specialty shops ply their trade.

Inhabitants of the coral metropolis display the same sorts of frenetic activity, habitual behavior patterns, and professional specializations. The reef's coral formations—domes, towers, tables, and jumbled clusters of odd shapes—serve many of the same functions as buildings in human cities. These structures (along with the spaces between and beneath them) serve reef dwellers as homes, playgrounds, feeding grounds, hangouts, lovers' lanes, sex clubs, and even doctors' offices. What's more, they are connected by a network of subterranean passages whose intricacy and uses rival those of New York's subway, Paris's Metro, and the sewers of both cities.

Yet too literal a comparison between reef and city underestimates the complexity of the reef community, for the buildings, streets, and

transportation networks of human cities are inanimate objects built by the people who live in and around them. These sorts of structures do exist in nature; a few that come to mind are beehives, termite mounds, and the arboreal apartment houses of Africa's colonial weaverbirds. But the "buildings" of the reef aren't inanimate structures, and they aren't built by fishes or other mobile animals. Rather, the physical structures of the reef are themselves alive. Or at least, their surfaces are—covered with a thin film of living tissue that defies simple description as animal, vegetable, or mineral, because it combines elements of all three.

The fact that coral colonies are breathing, feeding entities, of course, complicates our urban analogy a bit. Like all living things, coral colonies grow at varying rates, depending on their location and environmental conditions. They also reproduce, doing their part to perpetuate their genes. And despite the fact that they are committed at an early age to a sedentary existence, they compete fiercely with one another for space; coral colonies poison, overgrow, and even digest one another in their struggle to claim their place in the currents and the sunlight they need to survive.

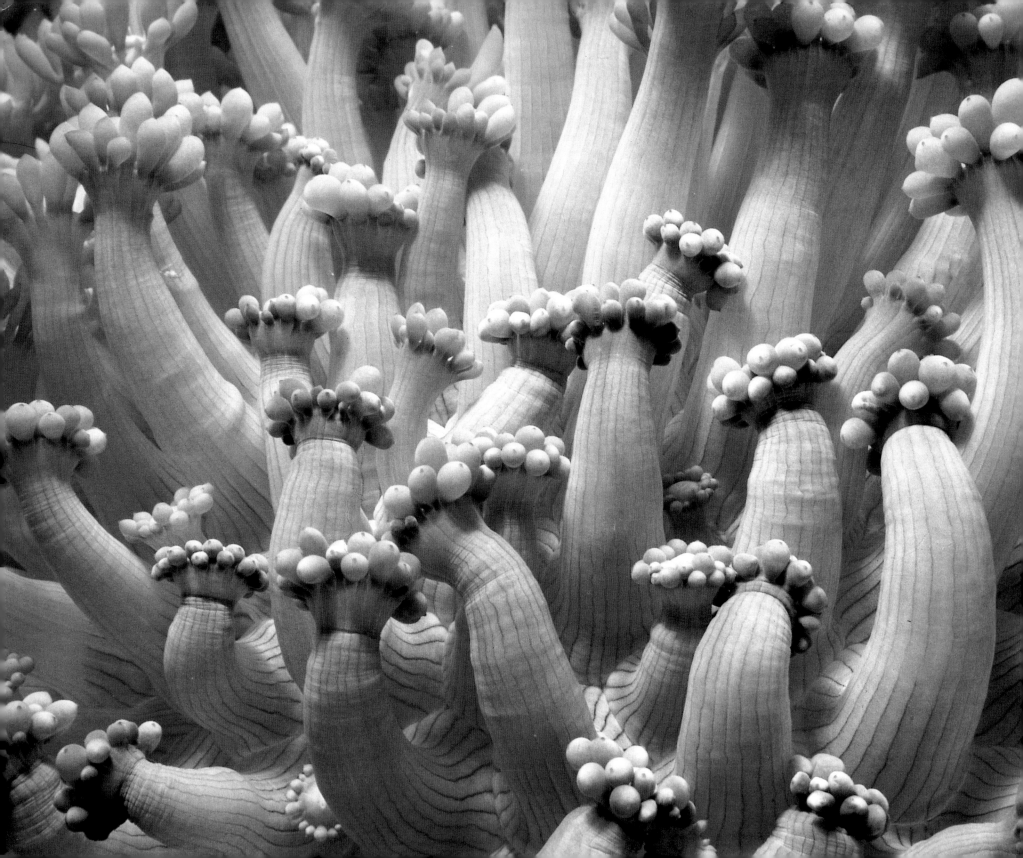

Soft coral polyps—shown here expanded, in their feeding mode—are usually shrunken by day into swellings that look like goosebumps on the leathery surface of the colony.

So if we tried to force the analogy in reverse (city as terrestrial reef), we'd have to imagine a phantasmagorical Gotham whose skyscrapers, factories, and apartment buildings carry state-of-the-art solar energy collectors and stretch out sticky, poisoned appendages to catch cockroaches and pigeons for food. These buildings would also grow, reproduce, and struggle with their neighbors for space and open air. Envision, if you can, pint-size Empire State Buildings sprouting unexpectedly on the Bowery and in Central Park, a strapping young Eiffel Tower strangling a wing of the Louvre, or a Greek Revival train station battling with a postmodern apartment building for sidewalk frontage. Images from the fictional settings of *Blade Runner* and *Mad Max* seem tame by comparison.

If, on the other hand, we compare reefs to more familiar biological systems, lowland tropical rainforests once again come to mind. Like reefs, rainforests depend on both their physical environment and on intricate, three-dimensional living structures that are themselves alive. There are other similarities, too: Both reefs and rainforests are home to odd and bizarre organisms, and both support an abundance of plants and animals in places where the raw materials of life are scarce.

Importantly, both systems, while resilient to such natural environmental insults as tropical storms, are painfully susceptible to abuse at the hands of *Homo sapiens*. The public is finally becoming aware of rainforests' vulnerability in this respect. If we remove the canopy of trees (or create conditions under which trees can't survive), other forest-dwelling plants and animals will be forced to relocate or die, and a onetime Eden turns into biological purgatory. The same is true of the reef: Collect coral colonies for curios, shatter them with anchors, nets, or dynamite, cover them with silt from dredging, or pollute their water, and even the oldest, grandest reefs become inanimate shadows of their former selves.

But this parallel can go only so far. One major difference between reefs and rainforests is that visitors in search of tropical nature are likely to find reefs much more "user-friendly." Humans in a rainforest are earthbound in a vertical ecosystem which, at ground level, can seem monotonously green and devoid of animals larger than insects. Most rainforest action goes on where the monkeys, butterflies, birds, and orchids live—in branches 100 feet or more above the ground. On the reef, by contrast, human visitors start at the top—where the action is. And scuba gear allows divers to float through the water almost effortlessly, descending as deep as physical condition and diving experience allow.

In addition, reef fishes are far less fearful of humans than are the birds, butterflies, and mammals of rainforests. Observant divers quickly learn how easy it is to follow and observe fishes from a discreet distance, and soon figure out what that distance is for each species. And even strictly wild reef fishes often become tame fairly rapidly, learning to tolerate or ignore well-behaved divers after only a few encounters.

Once this mutual acclimatization period is over, hawkfishes, gobies, blennies, and many other species that enjoy perching on coral outcroppings allow divers to come within a foot or so of their favorite lookouts before scurrying off to reevaluate the situation from a safe distance. Spunky clownfishes, between dives into the tentacles of their sea-anemone homes, will even be so bold as to nip (harmlessly) at overly curious divers' outstretched fingers. Even schools of reef fishes flee only when they feel directly and closely threatened; swim into their midst, and they will effortlessly create a comfortable empty volume around you. And many invertebrates—as vibrantly colored and intriguing to watch as any organisms on earth—are nearly oblivious to humans as long as they aren't physically disturbed.

Another reef-as-city parallel can be drawn when you think about the hours after dark. If you were planning to visit New York or Paris, would you be content to see only what goes on at noon? Of course not. No tour of a great city would be complete without a chance to watch (or join) several parts of the daily parade: lunch break in Central Park, art students at the Louvre, young lovers on an evening promenade, bons vivants at the theater, and perhaps even ladies and gentlemen of the evening plying their trade at the fringes of society.

To really understand why so many different kinds of people live where they do (not to mention how they make a living) you've got to witness the full, twenty-four-hour spectrum of life—some parts of it predictable, others bizarre and unexpected. Visit greengrocers only at noontime, and you'd never even imagine the hustle and bustle of their dawn produce deliveries or their evening trash pickup. Restrict yourself to watching working men and women on streets and in offices by day, and you'd miss the sight of these stuffed shirts stripping off their shackles, donning radically different costumes, and packing nightclubs after dark.

The same is true on the reef—with the added enticement that the players comprise a cast of characters that makes the dating bar from *Star Wars* look like a Sunday school class. Anyone who's studied or visited the reef during daytime only has seen but a fraction of the activities that enable that diverse community to thrive.

But you can't fully appreciate the importance of after-hours life without knowing a bit more about what makes the reef tick. Not surprisingly, the best example of a reef's distinctive character can be found in the organisms most central to its system—the hard corals themselves.

BEST OF ENEMIES, BEST OF FRIENDS

The spectacular reefs of the Red Sea are both paragon and paradox; paragon because they are as complex and spectacular as any coral habitats in the world, and paradox because they—like most other coral communities—teem with life in the midst of virtual aquatic deserts. For the water that bathes these reefs carries precious few of the nutrients essential to plant and animal life. In particular, the water of tropical seas is often deficient in two of the three main nutrients

needed by plants and found in every balanced fertilizer: nitrogen and phosphorus. The third major element, potassium, is not usually in short supply.

Other marine environments known for abundant life—the rich fishing grounds of Georges Bank in the North Atlantic off Massachusetts, for example—are amply supplied with these nutrients, either by freshwater runoff through rivers and streams or from currents that bring water from the ocean bottom to the surface. Water thus enriched, no matter how spectacularly blue it looks from a boat on a sunny day, invariably looks green (or even brown) beneath the waves. The greenish tint comes largely from decomposed plant material, while the cloudiness is caused either by river-borne silt or by swarms of minute floating plants and animals called plankton. And where plankton thrive, enormous schools of fishes flourish too.

The clarity and sparkling blue color of the water that bathes coral reefs, by contrast, are clear signs that both nutrients and plankton are in short supply. And therein lies the paradox: How can one of the world's most densely populated communities thrive in water nearly devoid of life's basic requirements? It would be just as surprising to find a full-fledged rainforest in the middle of the Sahara.

Following pages: Gorgonians fall in between hard and soft corals in terms of their body structure. Though they lack the limestone skeleton of hard corals, they do produce inner cores of tough, flexible protein akin to human hair or fingernails. Most species, including the two shown here, lack symbiotic algae, so, like soft corals, they thrive where dependable currents keep their polyps well fed. During the day (left), gorgonians remain closed; like most corals, their polyps expand maximally only under cover of darkness (right).

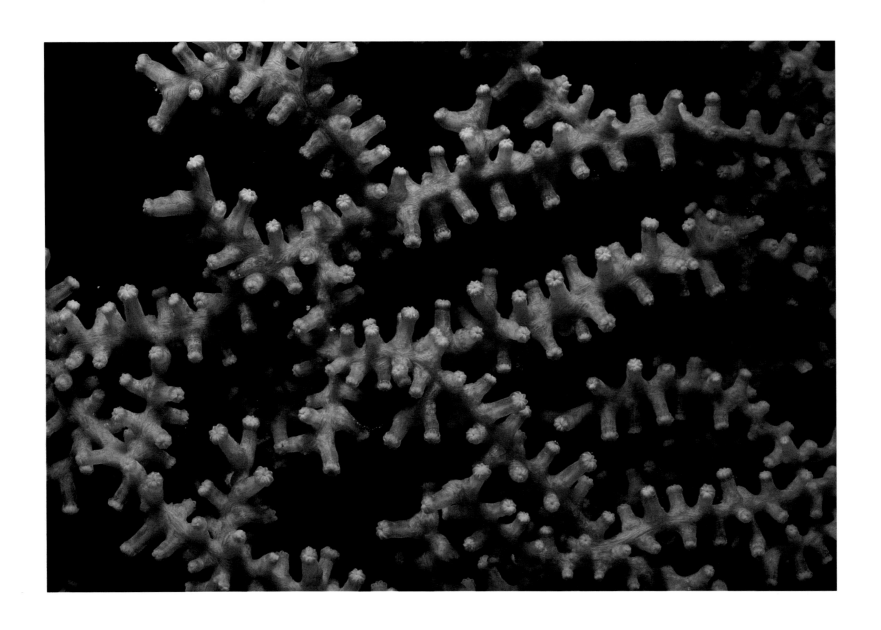

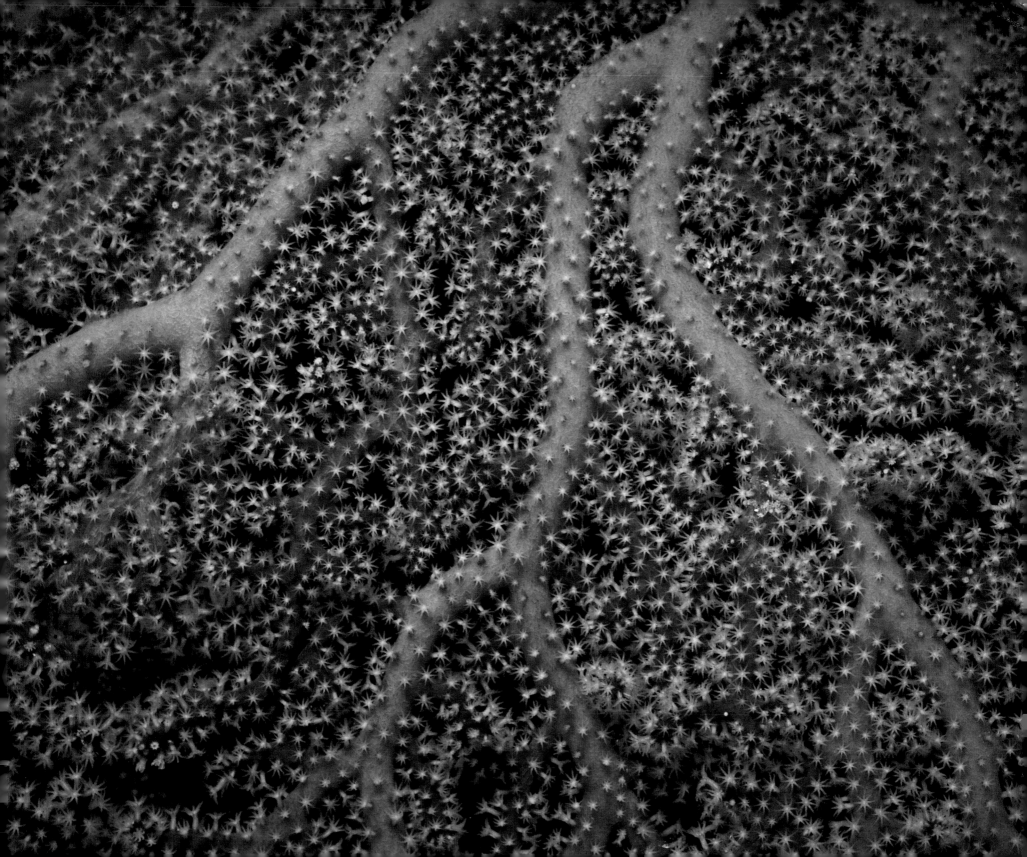

To understand how hard coral colonies and their collaborators make such good use of such scarce resources requires knowing why the rest of us living things can't match that feat. Humans, like most animals, eat other organisms to procure two fundamental requirements of life—energy to power our body processes and nutrients to serve as the building blocks for our tissues. We get certain nutrients from animal foods, others from plant foods, and energy from both. Our digestive systems break food apart and absorb useful bits of carbohydrates and proteins. Our body tissues, while using oxygen to extract energy and molecular building blocks from these compounds, generate carbon dioxide and wastes containing nitrogen. Ultimately, these wastes are eliminated in urine, and carbon dioxide is discarded in the air we exhale.

In the normal scheme of recycling in nature, bacteria decompose animal wastes (and dead animals) into smaller chemical compounds (such as ammonia and nitrates). Plants treat these animal discards as fertilizer. (Any organic gardener knows the magic of well-rotted manure.) Harnessing solar energy through the magic of photosynthesis, plants assemble these nutrients, together with carbon dioxide, into carbohydrates and proteins. In the process, they get rid of their main waste product, oxygen.

This system is expensive in several ways. Animals have to work, first to catch food, and then to digest it. The digestive process (ingestion, the breakdown of food, and the absorption and distribution of nutrients to body tissues) is inefficient; lots of potential energy and nutrients are wasted or thrown away. And once nutrient molecules are released into the environment, they become widely scattered. In order to put these nutrients to use, plants must expend significant amounts of energy to absorb and concentrate them again.

That standard method of nutrient cycling—feeding, digestion, and excretion by animals; decomposition, re-absorption, and photosynthesis by plants—works well in many situations. It must, obviously, because most plants and animals work that way. But its cost can limit the concentration of plants and animals where nutrients are scarce. Just as efficient use of water is vital to survival in terrestrial deserts, frugal resource management is a plus in nutrient-poor situations. And that's where the remarkable organisms called corals play a central role.

Biologists classify corals as animals, because they're obliged to call them *something*. But living coral tissue is actually composed of an extraordinarily tight partnership between animals related to sea anemones and certain single-celled marine plants. That relationship, called symbiosis (literally "living together"), makes possible a quantum leap in ecological efficiency—a way for both plant and animal partners to have their cake and eat it, too.

The animal component strains passing plankton from the water by using crowns of flexible tentacles as living fishnets. The plant component harnesses solar energy through photosynthesis. Then, after exchanging various compounds, to the benefit of both plant and animal, this partnership produces the porous limestone rock that serves as its skeleton. The addition of this new limestone, a process essential to the colony's growth, cannot be done by either member of the partnership alone.

Functionally, the coral-algae partnership is remarkably efficient in recycling nutrients. Coral animals, rather than having to find and eat plants, cultivate the algae within their own bodies. Coral tissues pamper their green guests with a steady supply of carbon dioxide and animal wastes, both of which the plants use without having to scavenge them from the environment. The transparent coral tissues even go so far as to arrange their single-celled guests in layers oriented to make maximum use of available sunlight. The algae, offered nutrients free of charge, trap solar energy, go about their photosynthetic business, and—in a biochemical quid pro quo whose rules we still don't completely understand—release complex organic molecules that coral animals need but cannot make for themselves.

And there's more. Exciting evidence from recent experiments suggests that the limestone skeletons of some coral colonies house another kind of microscopic guest: one or more forms of photosynthetic bacteria—ancient, simple-looking, yet biochemically sophisticated entities. These bacteria, once called blue-green algae, are among the only organisms able to make use of nitrogen gas from the atmosphere. As they do so, these nitrogen fixers, as they are called, convert that nitrogen into a form that other organisms can use. These ancillary symbiotic partners thus enable corals to take up dissolved atmospheric nitrogen from seawater—a feat that corals and algae could never accomplish on their own. (A more familiar partnership of this general type is the relationship between nitrogen-fixing bacteria and plants of the pea family.)

The result of all this living together is a nearly self-contained ecosystem: an "animal" equipped with a built-in solar converter, sewage-treatment plant, nutrient recycler, and hydroponic garden rolled into one. Vital nutrients, which can be recycled, travel largely (though not completely) in internal circles. Energy, which cannot be recycled, is constantly imported from the sun. Nitrogen, in short supply in useful organic form, is spirited out of the atmosphere. As a result of these combined tricks, to a great degree, a healthy coral reef can be as much as fifty times more biologically productive than nutrient-starved waters of the adjacent open sea.

Physically, the results are striking. Over time, individual coral colonies grow and fuse to each other, often glued together by various other types of algae that produce the equivalent of limestone cement. Over many centuries, collections of living coral colonies and old coral rock form reefs, which vary enormously in size and shape. Among the smallest are "patch reefs," which range from the dimensions of a compact car to those of a good-size house. Patch reefs are common in shallow, sandy-bottom areas of the Bahamas and the lagoons of many other tropical seas. At the other end of the size spectrum stands the Great Barrier Reef, which runs parallel to Australia's coastline for about 1250 miles, and has been called the largest unified biologically built structure on earth. In between those extremes are typical fringing reefs (like those of the Red Sea and the Caribbean), which hug the shoreline in places where the land drops off steeply into deep water.

Of course, there is no such thing in nature as a totally free lunch; to perform this ecological sleight of hand, hard corals require just the right sort of environmental conditions. Coral colonies' algal and bacterial companions need sunlight for energy, so the association can survive only where underwater light is strong enough to power photosynthesis. That's why hard corals can't live in caves or at depths where light fades into gloom. And none of the symbiotic partners—as effective as they are in recycling important compounds—can conjure organic molecules out of nothing. Efficient recycling enables them to maintain themselves on minimal food, but in order to grow (and reproduce) they must somehow take in additional nutrients. The coral animals do so, first by trapping plankton with their tentacles, and then by sharing the bounty with their guests. This need for food, combined with the fact that corals are rooted firmly in place at an early age, means that the colonies must live in places where local currents supply at least occasional supplies of plankton.

The symbiosis that takes place inside coral colonies, however, is just the beginning. Equally fascinating (and equally important) symbiotic partnerships involve scores of other reef animals that occur around corals. Some of these biological alliances, which shape the life of the reef overall, involve styles of give-and-take so subtle and so unexpected that their true natures are only now coming to light, even if the relationships between the animals involved have been known for decades.

The strikingly patterned mantle of this giant clam is more than just an ornament; it is also home to symbiotic algae not unlike those that inhabit coral colonies. Clams such as this one are active filter feeders that pump water through their bodies and over a set of gills that trap plankton and small particles of organic matter. Yet giant clams, like hard corals, benefit from their partnership with algae.

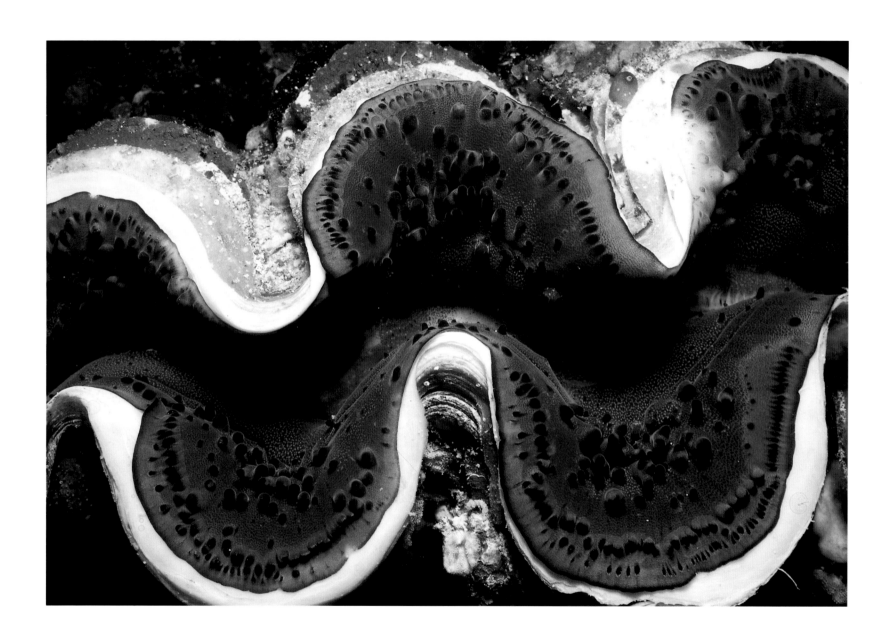

Take, for example, the fact that fishes and reef invertebrates alike depend upon corals for shelter in one way or another. The black-bordered damselfish, a case in point, is found in the Red Sea only in close association with branching finger corals; the fish spend most of their time among the branches. For years, researchers assumed that this relationship, like similar associations involving everything from fishes to barnacles, was a strictly one-way affair: It offered protection to the damselfish—whose predators couldn't catch them amid the sheltering coral branches—but it neither helped nor harmed the host corals.

But recent studies have shown that coral colonies grow faster when they are inhabited by damselfish schools than when they are not. What link could there be between resident fishes and coral growth? This damselfish, like many of its relatives, is an active plankton feeder that forages for food in the water close to the reef. When it returns to its coral home after feeding, it releases body wastes in the form of ammonia into the water. The corals absorb that ammonia and channel it to their resident algae for use as supplemental fertilizer. Thus, hard coral associations that host damsels and other fishes have more nutrients at their disposal than those that don't.

(If you find yourself groping for a familiar terrestrial counterpart to this phenomenon, consider the lush growth of trees used as roosts by crows or other birds. The important difference between the two situations is that damselfish are much more closely tied to their home corals—in both the short and long term—than crows are to their roosting trees.)

Stepping back to take a larger view of the reef ecosystem as a whole, some scientists—members of an international research project named REEFLUX—have come to view the entire coral reef as one enormous, symbiotic system. How? Marine biologists have known for decades that different plankton-feeding animals hunt in different places; corals scour the water at the reef surface, schools of damselfishes hunt immediately above, swarms of scarlet *Anthias* comb the yard or two beyond that, and still other fishes mass farther out into open water above and beside the reef. Recent data show that, together, all these hungry mouths work like a giant, many-level plankton net that scoops up as much as eighty percent of the plankton carried over the reef by wind and tidal currents.

The ongoing REEFLUX study has discovered that while many plankton-feeding fishes find food in the water around the reef, they get rid of waste products back on the reef itself. That behavior effectively removes nutrients from open water (where plankton pick them up) and channels these nutrients to corals, algae, and other reef dwellers who can use them. This larger pattern of de facto ecological cooperation among species further contributes to the reef's remarkable fertility.

The most famous case of living together on the reef is the easily visible and endearing partnership between the spunky clownfish and the sedentary sea anemone. Though not as biochemically intimate as the relationship between corals and their algal partners, this alliance, too, has benefits for both partners. Clownfishes somehow "know" instinctively from birth to rub against the body of the anemone in a way that mixes that animal's mucus coating with its own. As a result, the clownfish is treated as "self," rather than "other" by the anemone's tentacles, which sting any other animal foolish enough to touch them. It was once believed that only the clownfish benefited from this association, by gaining protection—at least for its eggs and young—from enemies repelled by the anemone's noxious sting. But we now know that the anemone gains as well. Pugnacious clownfishes attack animals many times their size (including divers) who threaten their anemone home. To divers, the fishes' nips are merely amusing. But to certain butterflyfishes who would otherwise relish a meal of anemone tentacles, the attacks are powerful deterrents.

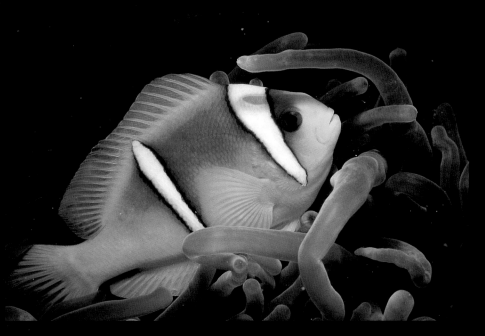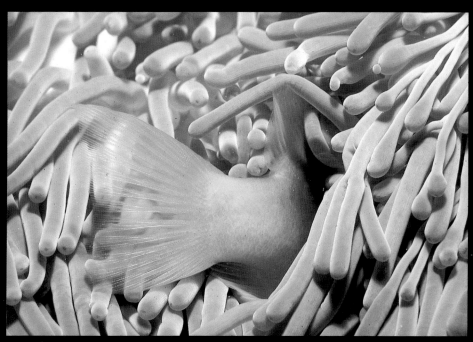

It also raises theoretical questions of the sort sparked by British scientist James Lovelock on a larger scale. Lovelock was the first proponent of the Gaia hypothesis—the notion that our entire planet has evolved as a sort of "superorganism" involving both animate and inanimate components. To Lovelock's way of thinking, winds and ocean currents function as global circulatory systems for that planetary entity. Various ecosystems, meanwhile, serve as the equivalent of planetary organs, regulating global temperature and fine-tuning the cycling of nutrients in ways that help keep earth hospitable to life.

The core of the Gaia hypothesis—its basic observation that earth's living systems are interconnected in ways that we still don't completely understand—is widely accepted (at least in private) by many biologists. After all, those nutrient cycles we do understand can link unlikely chains of organisms and ecosystems through peripatetic routes that literally span the globe. With a little imagination, an ecologist in a whimsical mood could easily conceive of a path by which atoms from a batch of "nutrients" deposited by a goat in the foothills of the Himalayas could end up on a dinner plate in London—having passed through a Red Sea coral reef on the way.

Still, the concept that our planet has evolved as a superorganism, or even the corollary notion that ecosystems have evolved to serve specific functions, remains controversial. Why? It is hard enough to understand how the diverse types of cells that make up our bodies have changed over time and have "learned" to work together in gathering and distributing food to other body tissues. But because the cells in a single body are united by a common set of genes, the tissues and organs they comprise are a single, cohesive biological entity—the individual, which just happens to be the basic unit of classical evolutionary theory.

Evolutionary biologists are therefore reasonably comfortable with efforts to explain how groups of similar individuals—both populations and species—evolve over time in response to changes in their environment. Researchers also have fairly solid notions about how pairs or small groups of species may have evolved in response to one another's presence. But when it comes to describing how relationships evolved among dozens (or even hundreds) of separate species in ways that enable ecosystems to function (which is what the Gaia hypothesis tries to do, in some sense), consensus rapidly disappears.

Many symbioses involve such expert camouflage that partners are nearly impossible to spot—especially by day when the grand vistas of the reef beckon. But at night, when divers' attention is necessarily focused on nearer, smaller, more intimate details, otherwise hidden associations reveal themselves to experienced eyes. Here, a mated pair of tiny coral blennies perches on the main trunk of an alcyonarian—a soft coral whose fluorescent hues they match with uncanny precision. The fishes' diet probably includes coral mucus and an assortment of organic particles that stick to it. (The mucus, though hardly appealing to humans, has significant nutritional value.) What, if anything, this particular coral gains from the fish is not yet known.

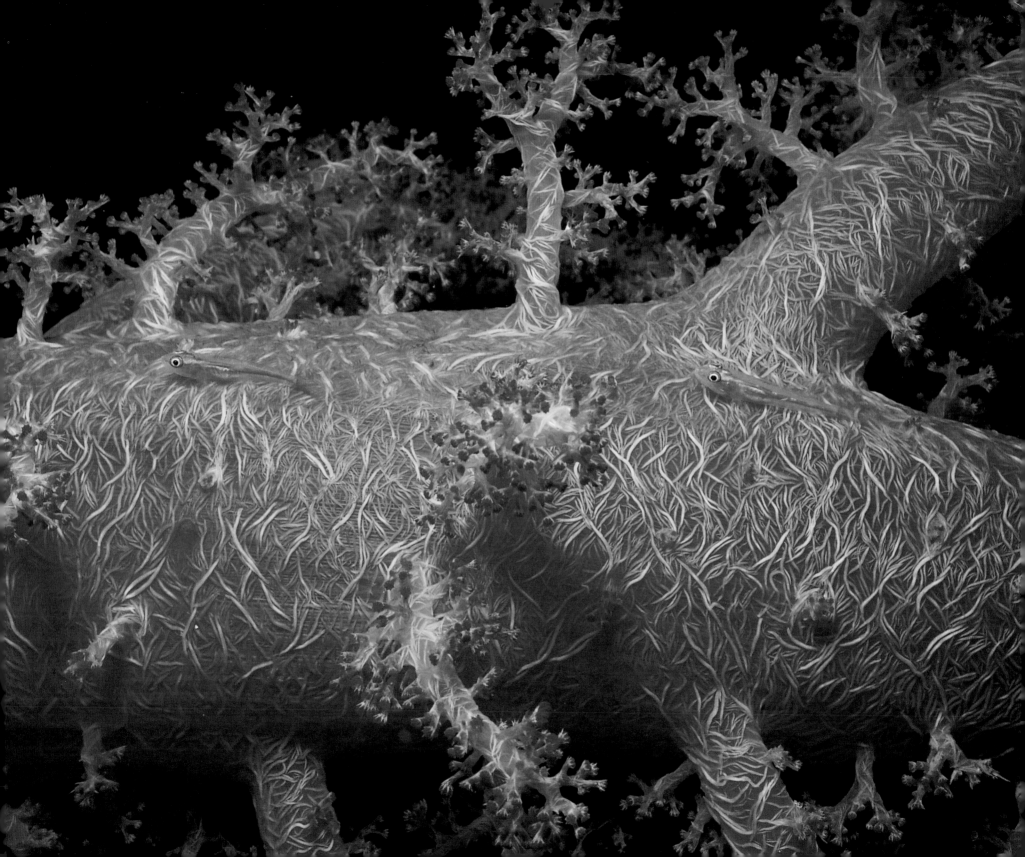

It isn't always clear to nonbiologists why scientists find so many sticking points in such ideas. After all, it's not hard to imagine how simple links among humans in one-horse towns become more involved as those towns grow into cities. It seems obvious, for example, that as urban housing displaces in-town farms, grocers are likely to have trouble obtaining produce. The solution is simple: Either some clever grocer buys a truck or an equally clever trucker starts hauling in food from rural districts. As years pass and the city grows, general stores multiply and grow into supermarkets. At some point, smaller shops appear, specializing in meat, farm produce, baked goods, or hardware. Time and time again, some resourceful entrepreneur perceives a demand and provides the supply by creating a new business. A new way of making a living—and a new economic "species," if you will—is born. Ultimately, just about every imaginable profession is represented.

As helpful as this analogy may seem in understanding nature's metropolis, it is misleading. Why? Because humans, whether or not we choose to work in each other's best interests, can communicate with one another and change professions when it suits our purposes. A grocery store owner can say to a friend, "You know, I can't tend the shop and run out to the farms, too." The friend can then decide to bring the food downtown to market. If this new "species" of business is run well, it survives.

But the natural world doesn't work that way. Evolutionary change is a random process that operates blindly, without either the insight or intent that drives human actions. Damselfishes may "know" that predators can't reach them in a thicket of coral branches. But fishes can't possibly know that their homes grow faster thanks to their metabolic wastes, and they certainly didn't take up shelter among corals in order to help the corals grow. (For that matter, corals didn't take in their algal boarders in order to benefit from fish excreta.) The same is true of the hordes of plankton feeders and the reef's other symbiotic relationships. Organisms may operate in ways that have the effect of boosting their ecosystem's productivity. But neighboring species can't talk to one another as humans can, can't mentally evaluate their options, and can't direct their evolution in order to accomplish a specific goal.

So how did the mouths of plankton-feeding reef animals come to serve, not only as mouths for the animals themselves, but as nutrient collectors for the reef as a whole? How did all the organisms that depend on nutrients collected by fishes and recycled by corals come to inhabit the reef? Did these relationships develop entirely by accident, or was the evolution of the reef community shaped by a form of natural selection that we don't yet understand?

The answer is that we simply don't know. From all appearances, theoretical ecologists, evolutionary biologists, field researchers, and Gaia advocates will be battling things out over these issues for some time to come. In the meantime, the rest of us must content ourselves with looking at the smaller parts of the puzzle, which we think we understand.

OF BAKERS AND BUTTERFLYFISHES

Ecological wonders notwithstanding, the reef's kaleidoscopic face is invariably what hooks most people who fall in love with it. That's not surprising; nowhere else (other than in dreams and chemically altered states of consciousness) do so many hues and shapes collide in a single scene. And vision is our favorite way of exploring the world. Though we relish sensations of taste, smell, hearing, and touch, seeing truly is believing.

What we see on the reef leads us directly to two of its most striking features. The visual variety highlights the ecological diversity of reef life, and the contrast between brightly hued reef animals and somber marine life elsewhere suggests both that something about the coral world either demands or allows bright coloration and that a keen sense of sight plays a vital role in this system.

But what exactly do we mean when we say that reefs are ecologically diverse? Simply put, we mean that reef animals have evolved remarkably specialized ways of making a living—in other words, they are exceptionally picky eaters. Several butterflyfishes restrict their diet to living polyps plucked from a handful of hard coral species. Other members of that family spare the polyps themselves, preferring to harvest corals' mucus by sucking it off the surface of the colonies with their thick, fleshy lips. Still other butterflyfishes snack on corals only now and then and choose to hunt for tiny shrimplike animals that inhabit the cracks and crevices in the reef surface.

And that's just a few species from a single fish family. Certain angelfishes are just as fastidious as their butterfly cousins but choose different foods. Some species eat only a few specific types of sponges, while others use comblike teeth and protruding jaws to scrape algae gingerly from the surface of rocks. Some parrotfishes, by contrast, use their powerful, beaklike jaws to munch away at solid coral rock impregnated with algae, grinding the limestone to sand in their guts and digesting the plant material as it passes through.

Even plankton feeders—which might all seem, at first glance, to be feeding on the same things—turn out to select different kinds of plankton from the mixed crowd drifting past them. Some take larger plankton, others opt for only smaller species. Some select only certain types of planktonic animals—the immature stages of shrimp and crabs, for example, or eggs and larvae of their fellow fishes. As a group, plankton feeders demonstrate remarkable efficiency at harvesting their food; this is aided, in no small part, by the fact that different species are experts at spotting and snagging specific prey. Keep in mind, too, that these examples involve just a few of the most familiar fishes; reef invertebrates have even more widely ranging strategies.

Biologists, seeing all these idiosyncrasies, immediately try to explain how they evolved and to understand how so many species manage to coexist with one another. The answer (in at least some cases) seems to be that natural selection minimizes ecological competition between two similar species by pressuring them to evolve in ways that maximize their differences. Ecologists call this phenomenon "character displacement." In a human city, it would be called "good business sense."

Imagine, for example, a growing city that happens to attract lots of bakers. That attraction could happen by chance, it could be based on the fact that surrounding farms grow lots of wheat, or it could be a result of local folks' fondness for baked goods. In any case, the first bakeries to open, facing lots of customers and little competition, could offer any sensible range of respectable products and survive.

As more and more bakeries open, competition begins. Soon, quality becomes an issue among consumers, and production efficiency determines which bakers stay in business.

At the same time, as the city's population grows larger and more diverse, the business climate makes specialization possible. Sooner or later, one baker notices a growing French population in the neighborhood and begins to experiment with a line of French products. Another proprietor, near a European Jewish neighborhood, starts producing bagels, ruggelach, and honey cake. Still another concentrates on cannolis and other Italian desserts.

What's happened? Faced with competition, bakeries that started off fairly similar to one another have specialized. By deciding to produce only a relatively narrow range of goods, bakers can produce them more efficiently and either sell them more cheaply, enjoy a higher profit margin, or both. All other things being equal, those bakers whose products are most different from those of their competitors (while not being too bizarre for their customers) will face the least competition and have the best chance for success.

Perched on a living ledge conveniently provided by its host anemone, an anemone shrimp eyes the camera. Warily? Defensively? Nervously? It's hard to tell with shrimp. These animals apparently gain the same sort of benefits from their hosts that clownfishes do, and in addition may feed on anemone mucus and bits and pieces of food regurgitated when the anemone swallows larger items than it can digest. Unlike clownfishes, however, these shrimp hardly seem able to repay their benefactors. Relationships such as these—where one member benefits while the other is neither helped nor harmed—are often called commensal, rather than mutualistic.

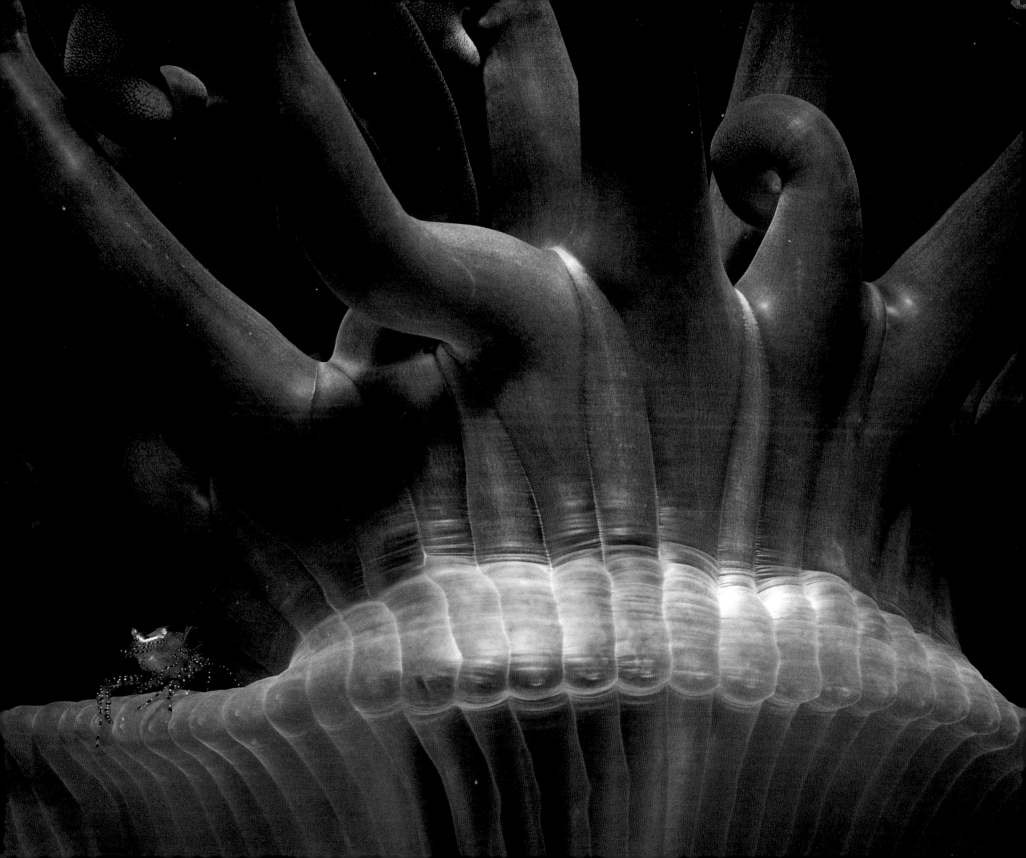

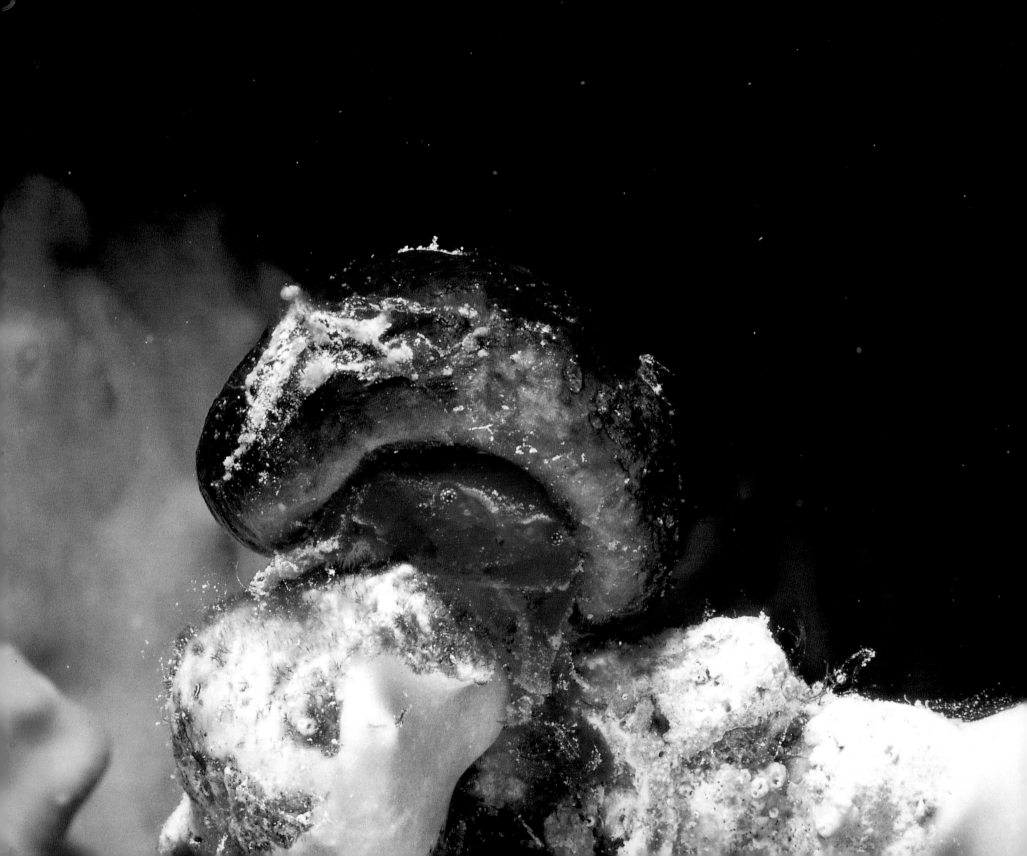

When does a crab not look like a crab? When its back is covered by a sponge. This diminutive crustacean—barely visible here as a crescent of red beneath its blue-gray cap—is admirably camouflaged by a sponge that encrusts its hard external skeleton. That camouflage may protect against more than detection by sight; many sponges have distinctive odors, and quite a few apparently leave a foul taste in the mouths of would-be predators. The relationship seems more passive than many others, but the sponge probably benefits as well. This barely multicellular organism—which would otherwise have to spend its life rooted to a single spot—is carried hither and yon by the crab. Thus able to experience regular changes of food-bearing currents, the filter-feeding sponge may also benefit from "sloppy seconds" scattered into the water by the crab, a notoriously messy eater.

Note that dozens of ethnic specialty bakers can't coexist in a frontier town; the customer population wouldn't be large or diverse enough to guarantee a steady clientele. And in cities undergoing major fluctuations in size, unpredictable changes in economic fortune, or large turnovers in population, highly specialized shops are high-risk operations. But in stable, prosperous cities with large, diverse populations, specialty shops do well, surviving handily alongside supermarkets selling white bread.

The same situation holds on coral reefs, where the sun shines and the water stays warm year-round, and where corals and their associates provide a steady food supply. There, many animals have been able to evolve specialized lifestyles, because their potential food supply (like the customer base in a metropolitan area) is diverse, yet predictable. With that sort of habitat insurance, each species (like the bakers in our human analogy) can concentrate on one particular resource—a few kinds of coral, perhaps, or a limited number of shrimp varieties. Once that evolutionary choice has been made, a species is free to evolve specific adaptations in body shape, physiology, and behavior that enable it to utilize that food source more efficiently. Its teeth and mouth adapt to gathering and preparing particular foods. Its gut concentrates on producing those particular digestive enzymes that break down that chosen food efficiently.

In reality, there is almost always some overlap between species that live together. (Lots of bakers in New Orleans make corn bread, for example, and a surprising number of shops in New York City carry bagels.) Nonetheless, the more different ways species divide up available resources—and the less each species competes for food with its neighbors—the more species can coexist in the same environment.

Where, then, do all the colors and patterns found in reef animals fit into the story? For a start, the diversity of species allows visual variety to exist. After all, individuals belonging to fifty different species are freer to look different than fifty members of the same species. That simple reasoning, however, is necessary but not sufficient to explain the situation.

Another piece of the puzzle has to do with the ways that animals use bright colors—strategies that also have surprising parallels among humans. Traditional costumes of ethnic groups around the world, for example, make clear statements about the group to which people who wear them belong. Bold colors and designs exaggerate the masculinity or femininity of people who wear them. And urban gangs use patterns on baseball caps, jackets, and sneakers to proclaim their identities.

Parallel uses of colors among animals are legion. Mature males of many species, such as peacocks, rely on colorful plumage and strutting displays to convince females not only that they are members of the correct species but that they are the studliest fellows around. Experiments on and observations of many species confirm that the more flamboyant the display, the more successful the courtship ploy, and the more chances the male gets to sow his oats. Were this the only factor guiding the evolution of body colors, the sky would be the limit.

But a bold and unique wardrobe carries its message to all who see it—including those whose attention one might prefer not to attract. Gang members showing off to their rivals also attract the attention of the police. Devotees of high fashion, for their part, may find that sartorial extravagance can make them targets of both con artists and thieves.

Animals face a similar conundrum: striking the right balance between the benefits of communication and the risk of being preyed upon. The most conspicuous members of a population—though they are likely to attract the most members of the opposite sex—are also most visible to potential predators. Individuals with colors that camouflage them, though somewhat less "sexy," tend to survive longer.

For fishes in most marine habitats predation is a serious threat. In the open sea, salt marsh creeks, and meadows of undulating tropical sea grass, prey discovered by their enemies have nowhere to run and nowhere to hide. The best defense is to avoid being seen in the first place. Small wonder, then, that in many habitats, camouflage is king.

But then there are the living rainbows of the reef. What's different here? Several researchers point to the reef's three-dimensional maze of coral heads, holes, and tunnels, and argue that all those spaces offer safe haven to small fishes being threatened by larger predators. In this situation, agile species can run for cover when threatened and don't have to worry so much about being seen by their enemies. Thus freed from the need to blend in with their backgrounds, fishes with bright colors wouldn't necessarily lower their chances of survival.

Still, bright, complex color patterns seem extravagant, and penurious nature rarely wastes its currency. Is there any reason why reef fishes would need conspicuous color patterns? Nobel prizewinning animal behavior researcher Konrad Lorenz thought so. He described those patterns as *plakatfarben* (German for "poster colors") because he believed they served like advertising billboards, broadcasting a distinctive message for all to see. According to Lorenz, these species-specific patterns enable the reef's highly specialized animals to identify themselves to others, to recognize members of their species, and to discriminate among the scores of other species in their neighborhood.

Close up, the poster coloration of daytime reef fishes involves intricacies of hue and pattern that still puzzle biologists. The dorsal fins of parrotfishes (left) and surgeonfishes (right) are a case in point. Among parrotfishes, male coloration often differs from that of females, and juveniles of both sexes may carry patterns different from adults. So dramatic are the distinctions that in some cases fishes of different sexes and ages were classified as different species for decades. Apparently, fishes are more astute at interpreting their color patterns than are human observers. Among surgeonfishes, bands of contrasting color often outline body parts. Such patterns might heighten general visibility or emphasize shape or size.

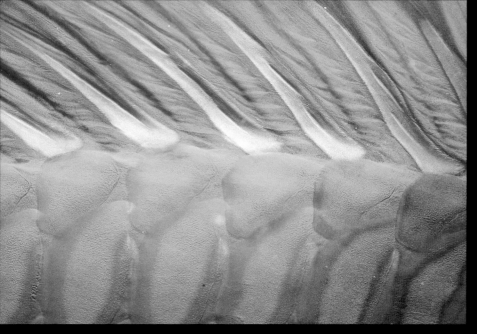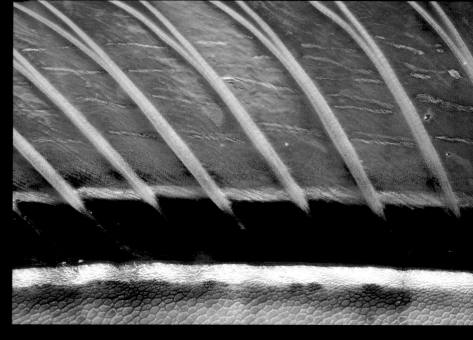

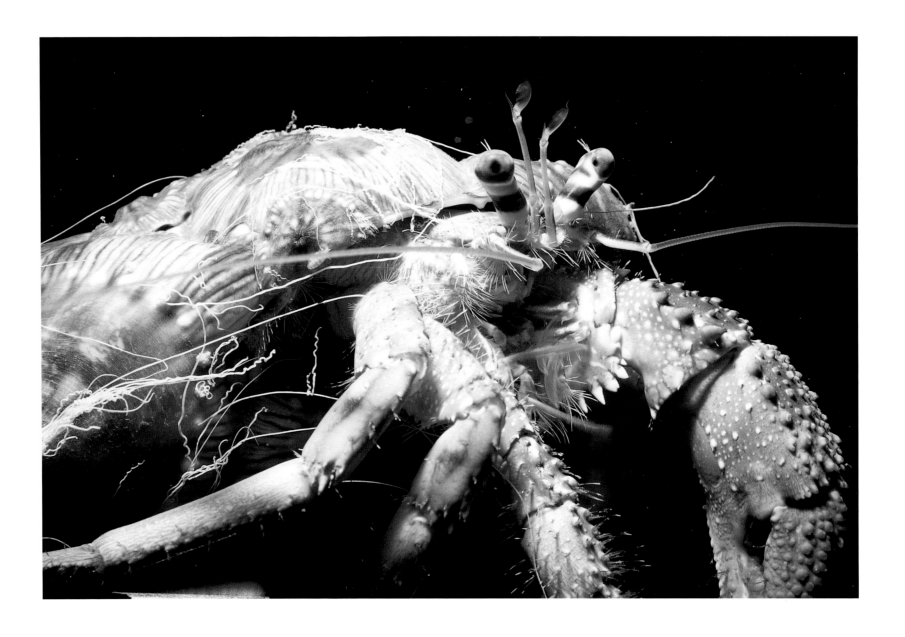

Certain canny hermit crabs evince more instinctive sense than many divers credit them with. This individual, spotted during its nocturnal ramblings around the reef, has cleverly covered its shell with several anemones—here sufficiently disturbed by the photographer to withdraw into rounded lumps. The dangling white strings are fragile threads covered with powerful stinging cells that the anemones extrude when physically threatened. Had the mouth of a potential predator (rather than a gloved diver's hand) disturbed the scene, it would have become tangled in those threads; the resulting discomfort would probably have discouraged it from paying further attention to what it thought would be an easy meal. Intriguingly, the anemones don't just "happen" to attach themselves to the shell. Hermit crabs periodically switch to larger shells as they grow. When the crab changes domiciles it gently holds the anemones while tickling them around the base of the disk attaching them to their home. After the anemones let go, the crab positions them on the new shell, to which they are usually quite willing to attach.

Lorenz's argument goes as follows: The highly specialized species described earlier have invested all their evolutionary eggs in one single basket, so to speak. As a result, they need to guard that basket fiercely. To do so, Lorenz predicted that poster-colored fishes would stake out territories and defend them against members of their own species. But because actual physical battles consume precious time and energy and can even be fatal to victor or vanquished, natural selection should favor any strategy that enables animals to maintain their territory without getting hurt. Thus, it would help if each territory holder carried color patterns that proclaimed, for example, "I am a masked butterflyfish, and this is my turf. Keep out!" If this message is received, properly interpreted, and obeyed by potential rivals, it could help to space out individuals across the reef while minimizing wasteful battles.

Nearly three decades of research have proved that this hypothesis may explain the coloration of some reef fishes, including coral-feeding butterflyfishes. These animals graze on various corals species much as cattle feed on grasses and other vegetation. Like grazing mammals, coral-feeding butterflyfishes spend between thirty and ninety percent of their time feeding. Their food supply is spread out in a stable pattern, recovers well from moderate grazing, and can suffer from overharvesting.

Unlike cattle, however, coral-feeding butterflyfishes don't hang around in groups. What's more, they do tend to act in ways that wouldn't have surprised Lorenz but might astonish folks who don't know fishes very well. Several species that choose not to live by themselves form stable, monogamous pairs when they are less than two years old. These pairs stay together for life—as long as a decade. Each of these pairs establishes and defends a particular piece of coral turf with boundaries marked by specific landmarks. Together, the two fishes patrol their territory tirelessly, almost always sticking together, feeding, and facing down intruders of their own kind as they travel.

Intriguingly, there seem to be few real fights between the fishes guarding their turf and potential intruders. There's lots of patrolling and a good deal of posturing, but very little in the way of piscine fisticuffs. Yet something is clearly keeping outsiders outside. For if resident fishes are removed, their former neighbors immediately enter the vacated territory and begin to feed. If one member of a pair is removed, the remaining member's turf may shrink by as much as seventy-five percent, suggesting that two territory guards are much better than one. Conversely, when animals do leave their territory for any reason, they are often chased by the animals upon whose turf they intrude. Apparently, Lorenz was right; real physical clashes are replaced by simple visual displays.

There's little doubt that animals who establish territories really know their turf well. As they make their rounds—which they do almost constantly from dawn to dusk, they follow specific routes and seem to recognize individual coral colonies along the way. Furthermore, as anyone who has ever tried to catch these animals knows, it is difficult, if not impossible, to catch them off guard or chase them out of their home ranges, for the animals' mental map of their home turf includes not only tasty coral heads, but hiding places as well. When threatened, they disappear into hidden refuges, wait till obvious danger has passed, and then emerge to go about their business.

For better and for worse, Lorenz's hypothesis is too simplistic to account for all cases of poster coloration on the reef. Some fiercely territorial fishes (such as certain damselfishes) are not poster colored. And numerous fishes that are not territorial (such as parrotfishes) could pass for living rainbows. In these cases and others, coloration serves other purposes, as a number of the photographs and captions scattered through this book demonstrate.

THE EYES HAVE IT

These behavioral observations give us an idea of how important vision—and, by implication, the light that vision requires—must be on the reef. The visually based tasks we've just described are complex and require acute vision. Specialized feeders need to do much more than just detect potential food items; they must inspect them, distinguish them from other items of similar size, locate them precisely, and decide whether or not to pounce. This task is often difficult or impossible for human observers without the aid of a microscope or hand lens.

Reef animals have managed, however, to evolve all the biological equipment needed to support that kind of visual skill. The eyes of butterflyfishes (and of most other diurnal fishes) are of reasonable size and have relatively small pupils. Contrary to popular misconception, they do not provide a distorted "fish eye" view of the world, and are highly mobile, enabling the animals to focus at a wide range of distances and

To fish watchers, fish faces speak volumes about the animals' styles of life. This parrotfish (left) is a prime example of the specializations evolved by contemporary diurnal reef fishes. Its small eyes are packed with light-receptive cells adept at discriminating among colors. Highly modified jaws form the "beak" that gives the family its common name. Those jaws are powered by strong muscles that can give a nasty bite but are normally used only to scrape algae from dead coral and limestone rock on the reef. Large eyes and reddish coloration testify to this bigeye's nocturnal nature (right). Because its sensitive eyes are blinded by strong light, it spends daylight hours hiding within coral caves or deep in the shadows provided by overhanging reef ledges. It is most comfortable during twilight and after dark, when it emerges to feed. The design of its simple, open-and-shut mouth dates back to the earliest predators among the bony fishes. This type of mouth can open wide to swallow prey, and it is often filled with tiny, sharp teeth. But its simple design lacks the refinements found in more "modern" predatory fishes such as groupers and sea basses. According to many reef biologists, bigeyes and their kin were pushed into their nocturnal habits when they faced competition from more recently evolved fishes.

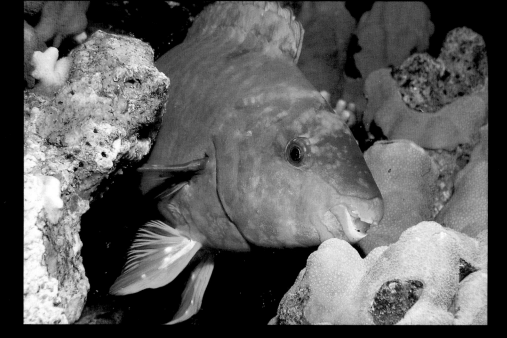

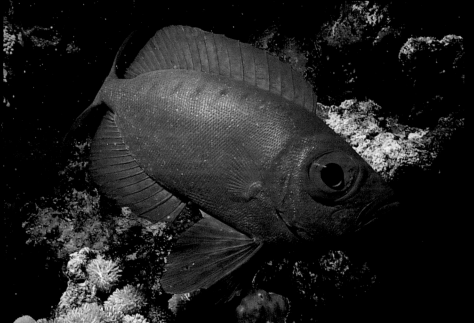

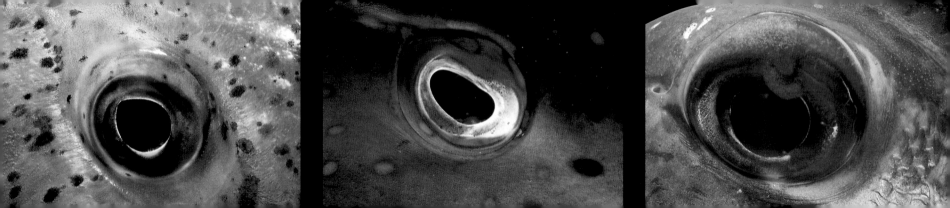

throughout a large field of view. In fact, many old-fashioned ideas about fish vision come from old, poorly conceived studies that were long ago supplanted in the scientific literature. The lenses in fish eyes give remarkably distortion-free vision in water, and many reef fishes also have excellent binocular vision and depth perception— a necessity for operating in the complex, three-dimensional world of the reef. Studies suggesting that a fish could see sideways only and could literally not see the nose in front of its face were conducted on fast-swimming, open-water species whose anatomy and physiology are both markedly different from those of reef dwellers.

The rest of reef fishes' visual equipment is equally sophisticated. Most of the light-detecting cells in reef fishes' eyes are cones, the class of light-sensitive cell responsible for color vision in all animals with backbones. What's more, the cones of daytime fishes are extremely small and are crammed tightly into repeating patterns that cover the back of the eye. These repeating patterns include three or sometimes four different cone types, each of which is maximally sensitive to a different part of the visible spectrum. That combination equips the eyes for color vision of a sort not too terribly different from—and in some ways more highly developed than—our own.

Anyone familiar with photography can easily appreciate how the design of these eyes equips fishes to see colors with maximum acuity. The relatively small opening provided by the pupil—like smaller apertures in camera lenses—helps maximize the range of distance over which things are in focus at one time. (That's what photographers call depth of field.) The small size and dense packing of visual cells—like the very fine grain of the best photographic films—provides an image of high resolution. That exceptional sharpness enables fine discriminations between very small, closely spaced objects.

Eyes, however, are only part of the story. Many fishes combine sharp eyes with mental abilities necessary to perform complex, visually related tasks: recognizing and discriminating among various coral species, identifying and remembering predators in and around their territories, and being able to recall the locations of hiding places.

At least some species even seem to have something resembling the general concept of a predator. Presented with a model of a typical, relatively harmless species—with eyes of normal size and a small, downturned mouth—they pay little attention. But show them a model that includes features of a typical predatory face—large eyes and an oversize, upturned mouth—and they know that trouble is afoot. They act "nervous," moving more slowly and staying closer to the reef surface than they would normally. If the threat comes closer, they hang closer to favored hiding places, ready to make themselves scarce at a moment's notice.

Yet these visual abilities are achieved only at significant cost. As is usually the case in biological systems, functional trade-offs invariably assure that any given living thing can't do everything. The eyes we've been discussing are superbly specialized for acute color vision, but that specialization means that butterflyfishes and other diurnal species must have the bright light of day to see well. As light levels fall, their visual systems begin to fail. Their small pupils restrict the amount of light that enters their eyes, and dim light doesn't stimulate their cones sufficiently to produce a solid, well-defined image. Thus, these strongly diurnal animals are at a significant visual disadvantage in twilight, and are practically blind in the dark. Again, photographers will understand the problem: Standard color film and box cameras work perfectly well in strong light but have problems indoors and in twilight.

That handicap under low-light situations is our first clue to the dramatic changes on the reef between night and day. While the eyes of daytime fishes put them at a disadvantage in the dark, the eyes of predatory reef fishes are a different story. These large-mouthed fishes sport huge, staring eyes with outsize pupils that allow as much light as possible to enter. What these large openings sacrifice in terms of depth of field they gain in sensitivity. These fishes' light-sensitive cells are primarily giant rods—a class of visual cells that are much larger than cones. These rods are so sensitive to dim light that some can detect the presence of a single photon, but they don't, as a rule, participate in color vision. As a final touch, many predatory species have reflective layers in the backs of their eyes that work like similar mirrors in cats' eyes: They reflect light back onto the visual cells, effectively doubling the brightness of dim images.

All these adaptations create eyes that work like high-speed, large-grained, black-and-white film to produce useful images in dim light.

During much of the day, these fishes act as though blinded by sunlight; they shun open water for shadows of coral overhangs or the darkness of tunnels and caves deep within the reef. Come twilight, however, they emerge, staring eyes well suited to the gathering gloom. They probably can't see color very well, and their view of the world is nowhere near as sharp as those of daytime fishes. But they can locate the outlines of potential prey in light so dim that, in it, we humans can't see our hands in front of our faces.

The basic elements necessary to understand the driving forces of reef life are now all in place: the diverse assortment of species, the highly specialized strategies those species use to make their living in a nutrient-poor environment, and the strikingly different sorts of visual equipment they carry. With that information we are ready to enter the water just as most observers are leaving it—an hour or two before the sun slips behind the horizon.

CHAPTER TWO TWILIGHT PROCESSIONS

Sunset brings both beauty and change to the natural world. When shadows lengthen over North America's Great Plains, the harsh light of noon mellows, shifting first to gold, then to russet, then to violets and purples. In the deserts of northern Africa, evening brings a respite from midday heat, allowing both people and camels to go about their business more comfortably. And beneath the surface of tropical seas, sunlight that once penetrated far into the depths recedes, cloaking reefs in shadows that first muddy and then obscure the colors of their inhabitants.

As twilight approaches, animals everywhere —on plains and deserts and in forests and oceans—respond in similar ways: Light lovers prepare to sleep while those that revel in darkness begin to stir. Frogs court in marshes, songbirds roost on tree limbs, rodents scuttle through underbrush, and owls stir in the trunks of dead trees. Over evolutionary time, they seem to have "learned" that what daylight exposes, darkness conceals, and what sunshine almost always forbids, shadows usually allow.

These blue fusiliers, which swarm close to coral heads by day, form huge schools at dusk. Here, they prepare to run the gauntlet of jacks and other predators on their way out into open water to forage for the night.

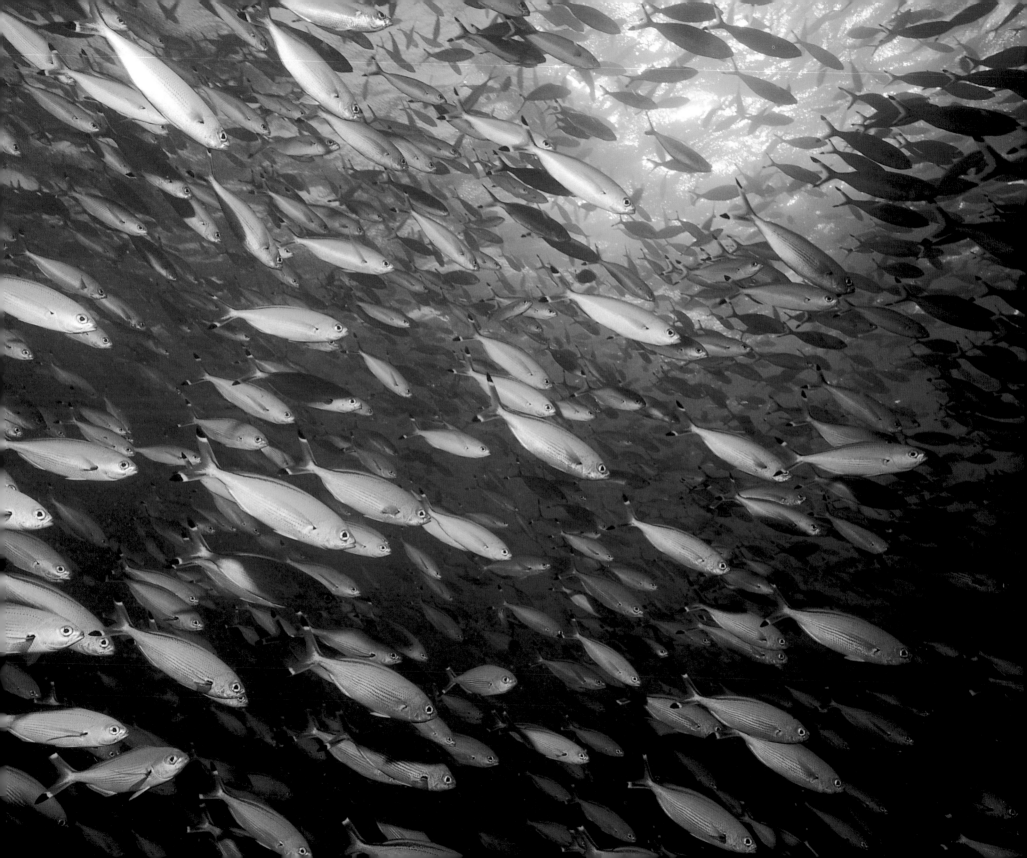

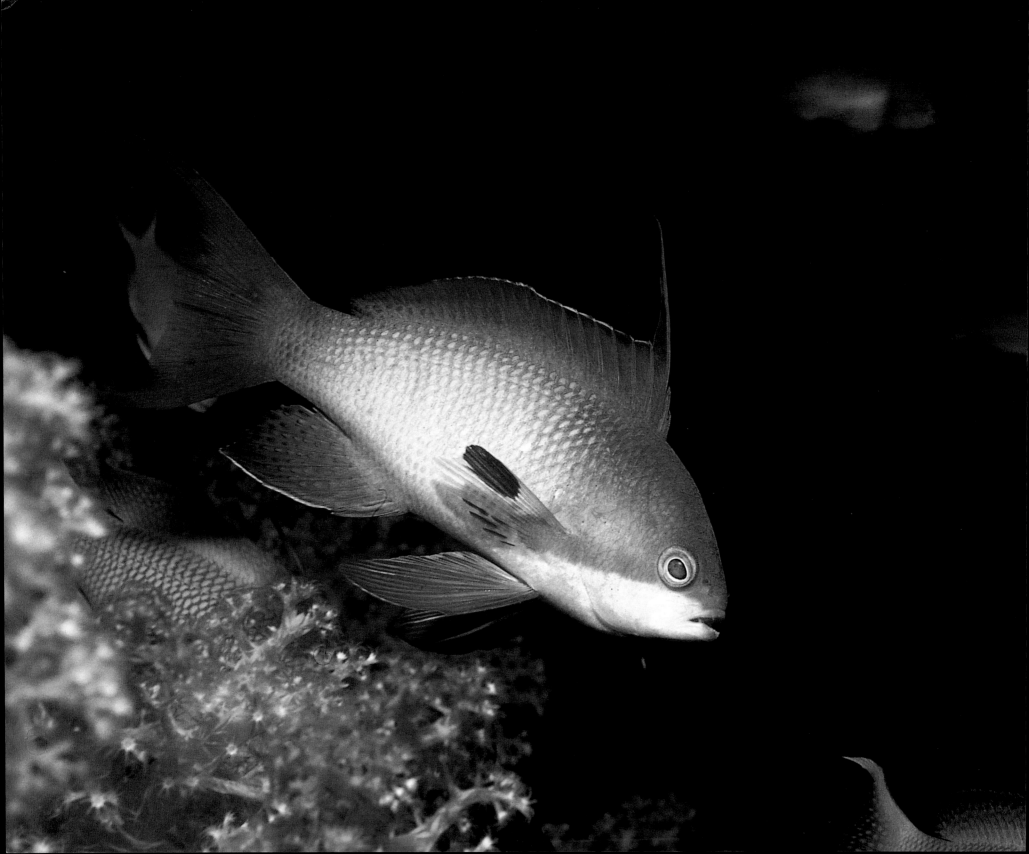

For humans, night is (mostly) a time to sleep. Like songbirds, honeybees, and our great ape cousins, we are diurnal creatures who rely on strong light to hunt for food and to engage in most (though not all) social games. Moths, owls, and bats, by contrast, rise at dusk, hunt through the night, and return home to sleep at dawn. But leopards, several other big cats, and such freshwater game fishes as bass and pike don't fit neatly into either diurnal or nocturnal camps. As both anglers and amateur naturalists know, these twilight predators prowl the shadows of dusk and dawn, though they do hunt and nap alternately during both day and night.

Coral reef animals, too, hunt, sleep, court, and breed at different times. Somewhere between half and two-thirds of fish species work the day shift. Roughly half that many reverse their schedules, sleeping (or resting) by day and working by night. And a few species—barely ten percent by most researchers' reckoning—roam as leopards and bass do, during the shadowy hours of dusk and dawn.

Now, ten percent doesn't sound like many fishes. What's more, nights fall suddenly and days break swiftly in the tropics; as anyone who's vacationed there knows, twilight rarely lasts more than an hour. With only a small fraction of fishes out and about during those brief slices of the day, one wouldn't expect twilight to be as interesting or as ecologically important as midday or midnight, when far more animals are active.

One would be wrong. The fleeting periods of dawn and dusk wield disproportionate power to shape the lives of reef animals—and even the evolutionary history of species.

Why? For a start, precisely because most reef species are either diurnal or nocturnal, morning and evening are shift-change times, during which most animals drastically alter their behavior. The result, at first glance, is the hustle, bustle, and confusion common to rush hour in big cities. Reef commuters, though, face a traffic jam in a city that has no police force, no lights on streets and sidewalks or in buildings, and no social code governing behavior. Predators prowl its precincts, taking advantage of the confusion to bring life-and-death confrontations to their daily peaks. The resulting struggle between those who need to eat and those who prefer not to be eaten has shaped the most prolonged and elaborate changing of the guard in the natural world.

Genreal themes of daytime, nighttime, and twilight behavior are common to all habitats, but the reef houses so many different kinds of animals and those animals have such diverse habits that shift changes that are simple and tedious elsewhere become complex and fascinating. Each group of reef organisms—from butterflyfishes to corals to sea urchins—performs its own variation on the basic themes of feeding, reproduction, and defense. And like orchestral variations composed for piano, violin, or clarinet, these behavioral variations are shaped by the character of the "instrument" that performs them. Because sea urchins are so different from corals and fishes (far more different than, say, an oboe is from a saxophone, or for that matter, a gorilla is from an owl) the range of behaviors on the reef is much broader than that of all the world's temperate forests combined.

This statement isn't offered glibly. In temperate forests, the vast majority of visible animals belongs to one of two major groups—the insects (phylum Arthropoda, class Insecta) or the vertebrates (phylum Chordata, subphylum Vertebrata). In the grand biological scheme of things, squirrels are indeed quite similar to chickadees in basic body plan, and butterflies really are rather like crickets in the way their organs are arranged and put together. Butterflyfishes, urchins, and corals, on the other hand, belong to completely different branches of the animal kingdom (the phyla Chordata, Echinodermata, and Cnidaria, respectively); they differ radically from each other in their basic body plans and ways of making a living. Yet these animals are only three of the better-known inhabitants of the reef; scores of other reef dwellers—belonging to just about every phylum of animal life—differ from each other just as widely.

In addition, within each major category of reef animals, different species of fishes, corals, and urchins improvise further on their groups' characteristic variation, in ways that reflect their biological diversity. Extending our musical metaphor further, we could say that all wind instruments are closely related—yet each has unique characteristics and plays a different role in the orchestra. We could go further and liken the category *saxophone* to the biological category *genus*. While there are major differences between a saxophone and a clarinet, there are also smaller differences between a tenor and an alto sax. In the same way, the clown butterflyfish and the masked butterflyfish are both butterflies—they are both in the genus *Chaetodon*—and thus share certain characteristics with each other while differing from angelfishes and parrotfishes. Yet they differ predictably from one another as well, and so are considered different species: The first is *Chaetodon paucifasciatus*; the second, *Chaetodon semilarvatus*.

This grouper displays the adaptations that make it such a fearsome predator during the twilight hours of dawn and dusk. Its eyes, with both total sizes and pupil openings proportionately larger than those of daytime fishes, admit more light, which their lenses focus on an array of light receptor cells that are sensitive to dim light. Its mouth is large and equipped with teeth that enable it to grasp prey firmly and swallow them whole.

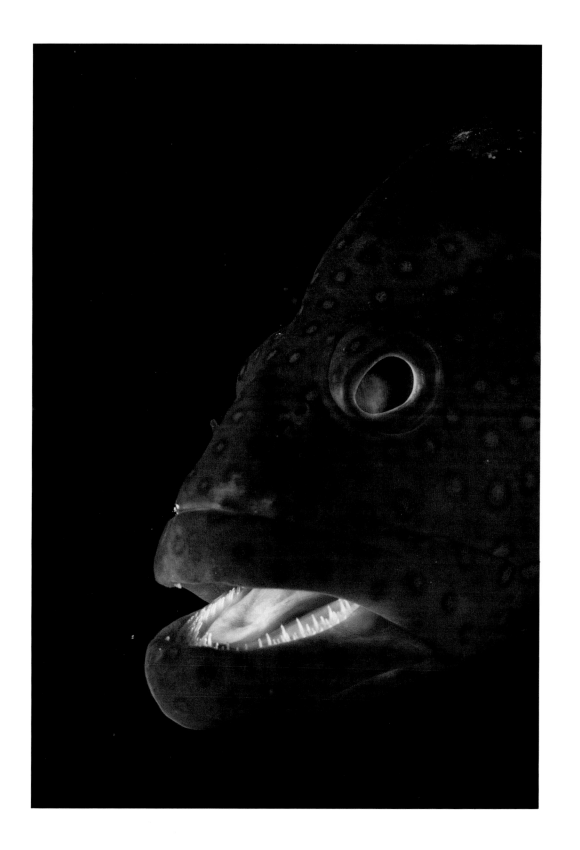

Well-known land animals offer a familiar example of how species' unique features shape their habits. Lions are big and strong, and hunt in prides, so although they prefer to stalk their quarry at dusk or by night, they can also bring them down by day. The smaller and more solitary leopard doesn't have as much of a choice; it succeeds dependably only by ambushing prey at dusk near watering holes. Cheetahs, also small as big cats go, rely on high-speed chases (up to seventy-five miles per hour) to overtake fleet gazelles—the only prey small enough for them to subdue. Because of that strategy, cheetahs are nearly alone among big cats in hunting mostly by day and in open areas where their speed and maneuverability work to good advantage.

That same sort of species-by-species variation is true of reef animals, in spades. And there are lots of different kinds of fishes on the reef. One authoritative book that attempts to list only "the most common reef fishes that a snorkeler or diver might encounter in the Red Sea" (John Randall's *Red Sea Reef Fishes*, Immel Publishing, London) includes fifty-seven families. The listing for butterflyfishes, just one of those families, includes twelve species. And that is far from the largest group; the same source lists thirty-two species of damselfishes and twenty-one species of predatory groupers. (This discussion, of course, says nothing about the hundreds of reef invertebrates.) East Africa's Serengeti Plain, by contrast, supports only a few dozen species of grazing animals and just five major predators.

There's still another level of complexity on the reef. For though the twilight behaviors of single species are fascinating when viewed in isolation, they can't be fully appreciated that way—any more than you could appreciate a Tchaikovsky piano concerto by studying the solo piano part alone. Just as instruments in an orchestra work in harmony, pass melodies to one another, and provide counterpoint, each species' behavior accommodates the actions of its predators, its prey, and its symbiotic partners.

Scarlet *Anthias*, among the most conspicuous fishes of the Red Sea by day, prepare to retire for the night in this remarkable photograph taken during the second stage of twilight on the reef. As light levels drop, so do the fishes, hovering closer and closer to their coral homes until they begin to nestle in, one by one, between the coral branches. Fifteen minutes after this photograph was taken, not a single individual of this school could be seen in open water; instead they filled virtually every available space in this particular coral formation.

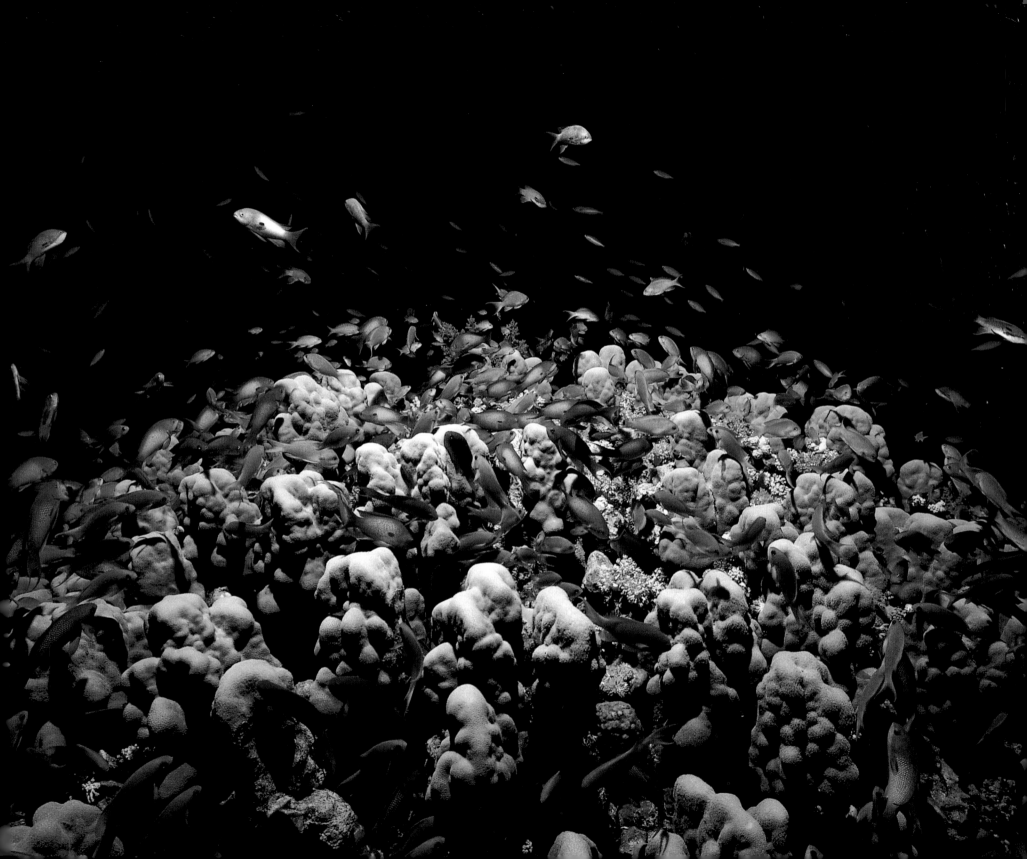

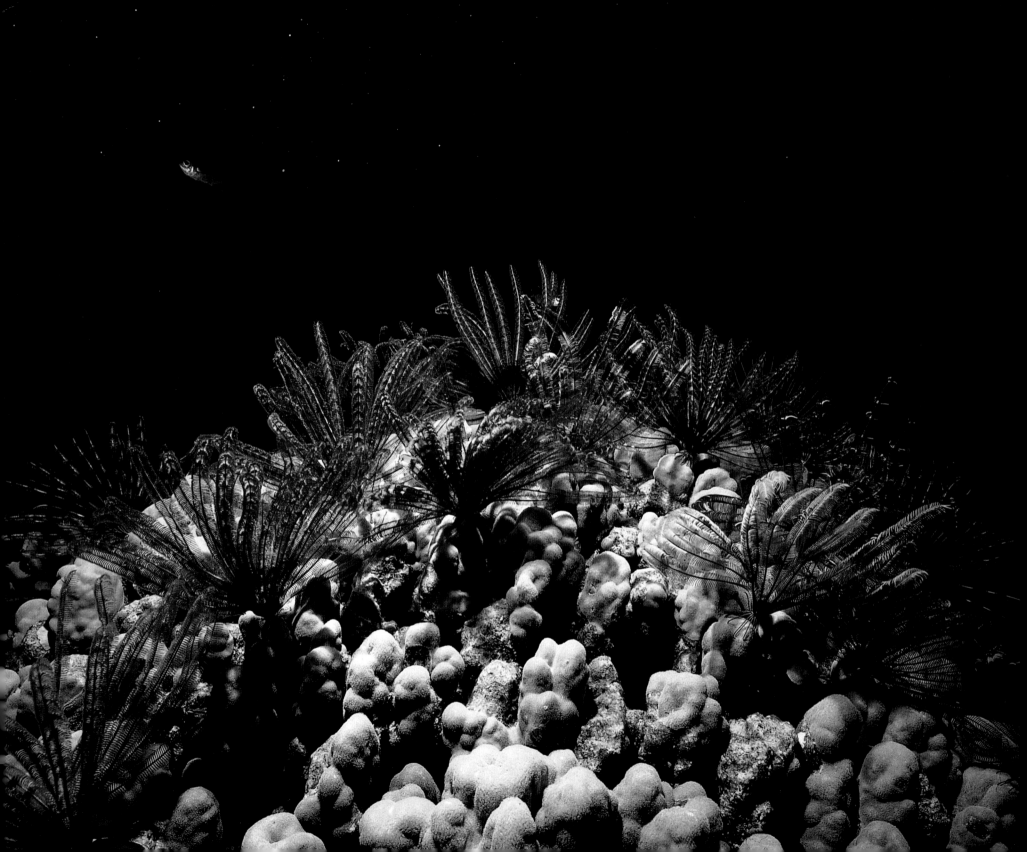

After daytime fishes disappear, nocturnal animals emerge, often from the same sorts of hiding places used by their diurnal counterparts. This photograph, taken after total darkness has fallen, shows a cluster of feather stars taking their nighttime positions on the tips of coral branches. There they will set their plankton traps, often positioning their arms in the shape of a fan held perpendicular to the current.

These life-and-death relationships shape behavior, both over the lifetimes of single animals and over the evolutionary lifetimes of species. Individuals who behave inappropriately either starve or are eaten, and species whose members make too many fatal errors slip toward extinction. Returning briefly to the economic metaphor of a human city, businesses with different specializations either adjust their working hours to the demands of their clientele or risk bankruptcy. A bakery specializing in bagels or Danish pastries expects to be busiest through the morning, for example, while one that features cannolis, eclairs, or chocolate cheesecakes should be jammed from afternoon through evening. If the first baker stayed closed till noon, or if the latter opened only for the hours around dawn, they would each risk going out of business.

The first major players in the twilight drama are the hundreds of species of daytime reef fishes. Compared with many other reef dwellers whose roots stretch back far beyond the time of the dinosaurs, diurnal reef fishes are evolutionary newcomers, fully equipped with all sorts of high-powered, late-model ecological adaptations. Their eyes, finely tuned for acute color vision, function as well or better than our own in the bright-blue light that bathes the reef by day. Their physical,

physiological, and behavioral specializations to reef life enable them to make their living by preying on different organisms, in different places, and in different ways. Their bright colors, evolved under conditions in which being noticed by predators isn't a problem, help them advertise their presence, their sex, their readiness to mate, and their willingness to fight.

Naturally, the arrival of these advanced fishes affected the lives of the older reef inhabitants, on whom they prey. To understand just how profoundly diurnal fishes have shaped the daily rhythms of reef life, we must briefly sidestep the discussion of twilight to explain the ways in which these animals make their living.

First, we can group diurnal fishes into four or five major ecological categories. For the sake of simplicity, we'll refer to them by using names for classes of ecological "professions" that biologists often call guilds. It is important to keep in mind that—as is the case for human guilds of bakers, butchers, dentists, or musicians—no two such groups are exactly alike.

Some diurnal species, like butterflyfishes and angelfishes, feed primarily on either corals or sponges. Certain species in these groups may depend exclusively on one species of prey, may select several related prey species, or may vary their diets with the many kinds of small, shrimplike animals that live on the surface of the reef.

Another group, including surgeonfishes, tangs, and parrotfishes, are plant eaters. These animals graze on algae that grow between coral colonies, on dead coral rock and rubble, and on the blades of sea grasses in lagoons near the reef. Some herbivorous fishes are solitary and defend private territories. Among these, surgeonfishes are particularly well equipped for turf wars; when squabbling with each other they brandish the razor-sharp spines they carry at the bases of their tails. Other plant-eating fishes form groups that roam over large areas of the reef, calling certain areas home, perhaps, but not defending them from intruders. Sometimes these groups use a strength-in-numbers tactic to overwhelm territorial individuals; if they do so, they feast briefly in the disgruntled fish's dining area and then move on.

The largest daytime-active guild belongs to the plankton eaters, a highly visible and entertaining group that includes many damselfishes, small groupers, some (though not all) snappers, and a host of rainbow-colored wrasses. These animals, though small in size, are conspicuous to divers because they form large groups that are active all day, usually hovering near edges or corners of the reef where wind and tidal currents carry them a steady supply of food. Because damselfishes and their colleagues have exceptionally acute eyes, they can hunt for food that is very small by human standards. They tend to prefer free-swimming shrimp, young invertebrates, and floating eggs, which are often less than one twenty-fifth of an inch across.

Naturally, some diurnal fishes don't fit neatly into these categories. Many pufferfishes and triggerfishes, for instance, gobble up enough plankton that they are often called plankton eaters, or planktivores. But several species in both families also prey heavily upon crabs, worms, snails, and sea urchins that live on the surface of the reef or in burrows within coral rock. These fishes use sharp, beaklike teeth and powerful jaws to crush or pick apart the defensive armor that shields their victims from nearly all of their other enemies.

Like its cousins the feather stars, this so-called basket star emerges from recesses in the reef and spreads its arms to feed. The animal's scientific name — *Gorgonocephalus* or "gorgon-headed" — aptly describes its appearance. Those many-branched arms writhe through the water like snakes, curling and uncurling in a silent ballet meant to help catch planktonic food.

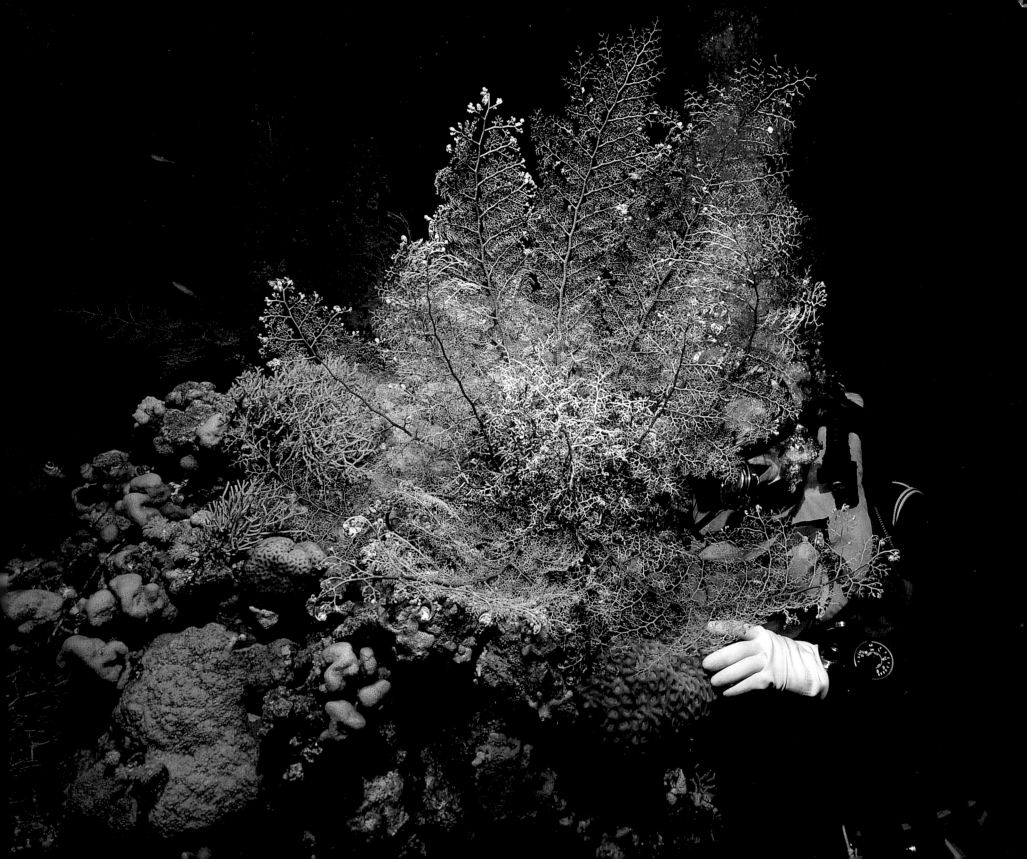

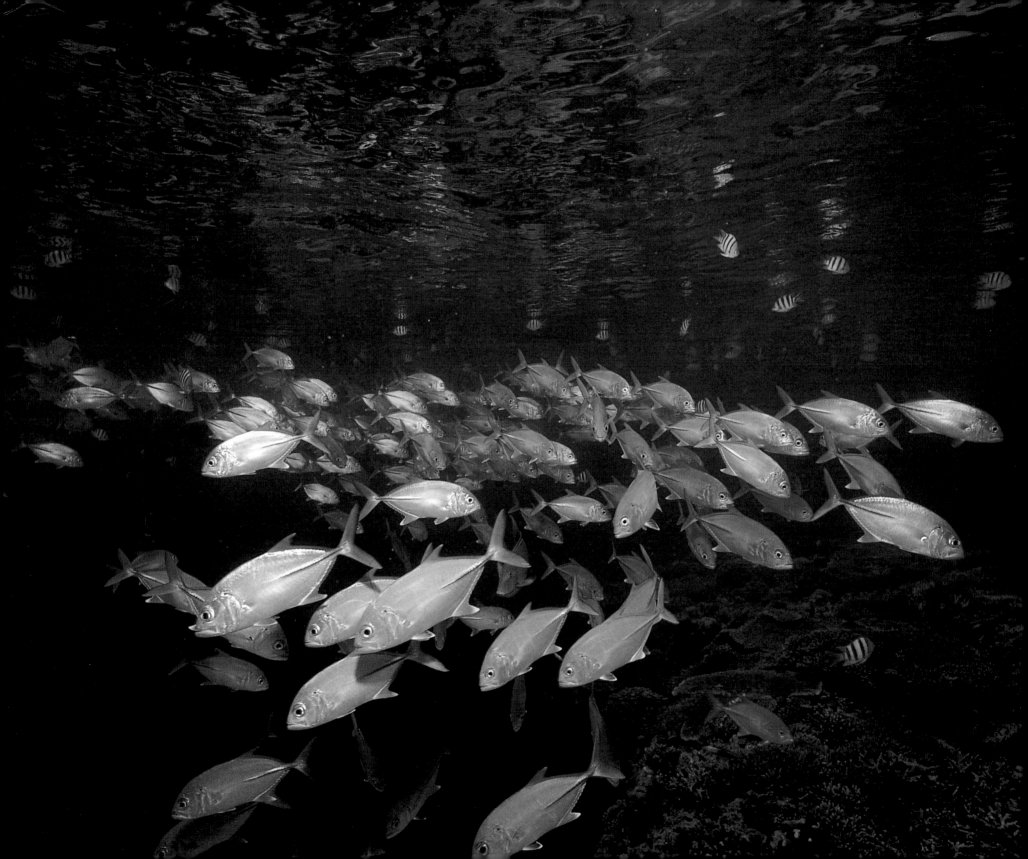

Jacks are among the most numerous and fearsome midsize predators on reefs in the Indo-Pacific region. Swift and agile in open water, they are at a disadvantage on the reef itself, for they lack coral fishes' ability to stop on a dime, hover, and turn on a moment's notice. For that reason, they hunt in schools at dawn and dusk, surprising, herding, and overwhelming prey foolish enough to be caught away from the cover of coral formations.

Triggerfishes in particular can be astoundingly clever at making mincemeat out of animals that most other fishes (and divers) avoid as though they were walking land mines. Hans Fricke, a German marine biologist who has been observing fish behavior in the Red Sea for more than two decades, succeeded in catching some of this behavior on film. Fricke removed a spiny sea urchin from its daytime hiding spot in a pile of coral rock and placed it out in open sand near the reef. In no time, a large triggerfish spotted the prickly morsel. Deterred by its long spines from attacking it directly, the trigger backed off, turned on its side, and hovered close to the sand. It then began blowing water out of its mouth in strong puffs that first knocked the urchin off balance and then turned it upside down. No sooner had the fish's huffing and puffing exposed the urchin's unprotected underside than the fish swooped in with its powerful jaws and made short work of the prey's edible insides.

This triggerfish's success in dispatching even such heavily armored prey is just a single example of how a recently evolved fish, whose maneuverability, specialized jaws, and behavioral flexibility give it a powerful advantage, makes a living on the reef by day. Scores of other species shown in photographs throughout this book have similarly successful—if less obvious or dramatic—strategies that have made them kings and queens of the daylight hours.

Diurnal fishes' success in perfecting daytime survival skills stands in sharp contrast to the poor showing made by the "old-fashioned" fishes. These old-timers, most of whom feed on fairly large prey and many of whom are fish eaters, rarely manage to feed by day—and not because they aren't hungry. Predators may try to snag a meal between dawn and dusk but rarely succeed because the sharp eyes and quick responses of daytime fishes help them stay out of harm's way. Solitary daytime fishes often hug the surface of the reef, staying close to refuges that are too small for predators to enter or maneuver in effectively. The few diurnal fishes that do venture far from shelter—some plankton feeders, for example—usually do so in large schools. They thus enlist the many watchful eyes of the whole group in the defense of each member.

If fish eaters ever do manage to grab a meal during daylight, it's because they capitalize on what one researcher calls "infrequent errors in judgment" by their quarry. Unwary prey who

stray too far from coral refuges or wander off from their schools may be snapped up by barracuda or trumpetfish. These patient hunters can hover motionless until prey ignore them; given the opportunity, they strike faster than a human eye can see. Other fatal mistakes are tough to avoid; even the most astute fish could easily stray too close to such superbly camouflaged ambush hunters as scorpionfishes. (Divers must take extra care not to tread on these masters of disguise. Their teeth pose no threat to humans, but their venomous spines can inflict painful injury or even cause death.)

More "ordinary" fish predators—jacks and mackerels, for instance—seem to make occasional halfhearted passes at prey during the daytime, almost as if testing their vigilance and reaction speeds. While the occasional dimwit or sluggard in a school may fall victim to these attacks, predators can rarely count on a midday meal (or even a light snack).

But diurnal fishes' main defenses, those sharp and ever-watchful eyes, are badly compromised by dim light. It's true that fish visual systems can adapt to moderate changes in light intensity given enough time, just as ours can. But even our highly developed mammalian eyes have trouble while they are switching from high light to low light. There's a brief period in between full-fledged day vision and full-fledged night vision where neither system is fully operational. That's why driving a car at dusk is more challenging than performing a similar visual task during either day or night. During twilight, squint and stare as we might, we just can't see clearly.

The problem encountered by daytime reef fishes at twilight is more serious. Apparently, it's closer to the virtual (though temporary) blindness we contend with after walking from a sunlit street into a darkened movie theater. Faced with that severe a visual handicap and surrounded by potential enemies alert for the first wrong move, diurnal fishes must change their survival tactics radically as darkness falls. And as the hordes of daytime fishes react to twilight, virtually all the animals on the reef— prey as well as their predators—respond in ways appropriate to their positions in the food web. The result is an intricate dance with recognizable movements, each of which begins as light levels fall another notch.

MOVEMENT ONE:
TWILIGHT ENDS THE DAY SHIFT

The first events on the reef as the day comes to a close can be totally inscrutable to those who've never seen them before. Take parrotfishes, for example. For most of the afternoon, as the sun sinks slowly toward the horizon, these thick-beaked, rainbow-hued animals browse in the shallows, nibbling off pieces of algae-impregnated coral rock as they have done since dawn. But as underwater light falls below a certain threshold, scores of them gradually stop feeding, as though responding to an order. Together, they perform a curious ritual dance, standing on their tails and twitching and rubbing their heads with their fins. Then, one after another, they fall into a formation that looks from a distance like a trail of oversize ants marching home from a fallen ice cream cone. That mysterious, silent convoy snakes across the reef and descends into deeper water where the fish vanish from sight.

Meanwhile, certain species of surgeonfishes are also acting oddly. During the day, these animals gather in small groups and browse for algae on rubble and beach rock in shallow water around the reef. But at some point during late afternoon, they too stop eating, one at a time. Also acting as if reacting to an invisible cue, each fish heads toward the ocean side of the reef. There, as individuals gather, they fall, one by one, into single file, spacing themselves a foot or two apart. The resulting train heads off purposefully along the reef. On the way, other trains merge into the procession, until as many as a thousand individuals are moving together as though of a single mind.

The group then converges on one of several landmarks, often a prominent coral knoll or outcropping that juts out toward deeper water. There the animals break formation and mill about briefly, filling the water with randomly moving bodies. Within a few minutes, however, hundreds of them at a time fall into line again and head off, unerringly directed into deeper water, toward a more distant goal.

As underwater shadows lengthen, surgeonfishes gather and begin a striking migration along paths that are obviously well marked to them although invisible to humans. Lining up in long trains, they commute in the eerie half-light between daytime foraging areas, twilight spawning locations, and nighttime resting spots.

What are these animals doing? The parrotfishes are among the first members of the day shift to respond to decreasing light levels. Perhaps their eyesight is easily compromised by early twilight. As yet, we cannot say for sure. But we do know that several species seek nighttime shelter in deeper parts of the reef some distance away from the shallower areas where their favorite algae grow. Somehow responding to the fact that reaching those nether regions takes time, they stop "work" earlier than other fishes, and seek safety in numbers while migrating. Once the caravan reaches a suitable depth, it's every fish for itself; the migrating group disperses, and each individual seeks a nook or cranny in which to spend the night.

Surgeonfishes, too, must seek shelter for the night. But on many evenings throughout summer and fall, they have other important business to attend to. After traveling some distance from their first reconnoitering point, their single-file lines once again break up. This time, as many as 2000 fish gather into large groups that mill about, forming tightly packed aggregations in the shape of a low, dome-shaped mass about eight yards in diameter.

Slowly, the dome rises, its center stretching up farther than its edges, rather like a mass of dough rising in a time-lapse film. Just as the fish in that central area reach a height of about three yards from the bottom, they dash down, again forming a low, dense school. This pattern repeats for about a half hour, the mass of fishes pulsating up and down in cycles lasting about two minutes each. At the peak of each pulse, the top of the dome stretches a little further toward the water's surface.

Then, as ambient light dims noticeably, groups of roughly a dozen individuals begin to form within the pulsing mass, and each cluster soon separates slightly from the throng as the dome reaches its highest point. Finally, as though released from a tautly strung bow, first one group, then two groups, then five or more fling themselves up toward the water's surface simultaneously, pivot sharply, and dash back down into the milling mass. At the apex of each group's ascent, its members leave something behind—small, white clouds of eggs and sperm that float slowly away in the water.

This spectacular group spawning behavior is not restricted to surgeonfishes. In the Bahamas and St. Thomas, groupers act in much the same way, although their "domes" can be much larger—stretching vertically in the water as far as thirty yards. Quite a few other fishes, including goatfishes, parrotfishes, and wrasses, also spawn in large numbers at dusk.

Many of these fishes (particularly wrasses and groupers) begin life as males and mature into females, start off as females and grow into males, or even function as males and females at

the same time. Consequently, these episodes of group sex involve permutations that put Baudelaire, Rabelais, and even de Sade to shame. Watch a school of *Anthias* just before dusk, and you'll be able to spot a few large males who alternately court and trounce the largest females in the group—quivering, diving, swooping, and chasing them nonstop. Observe that school for long enough and you'll find that if one of those males disappears, the largest female quickly takes his place—changing color, fin shape, and behavior within days, and switching over from making eggs to producing sperm almost as quickly.

Fish sex at dusk isn't always so unorthodox, though. Young butterflyfishes settle into sedentary lives with partners for life. These animals also prefer to spawn at dusk, but they do so one on one, rather than en masse. Their courtship, which begins within their territory in late afternoon, involves only the pair itself—and an occasional wayward male or two that may try to horn in on the action.

Why do so many kinds of fishes spawn at dusk? And why do several species wander so far from home to satisfy their libidinal urges? Humans may consider twilight the most romantic time of day, but dusk is a dangerous period for diurnal fishes. All evening spawners mentioned (with the exception of some large groupers) place themselves at considerable risk by indulging in this conspicuous behavior. Even more puzzling is the fact that some of them seem to enter what researchers call a spawning stupor— a state in which they show surprising (and uncharacteristic) disregard for personal safety.

When biologists see several unrelated animals engaging in such puzzling behavior, they immediately suspect that such actions have a hidden advantage. Otherwise, chance and natural selection would very likely have led the species involved down a more sensible path. But what common advantage could impel such different fishes—some of them herbivores, some of them carnivores, some of them planktivores—to behave in such curious ways?

The spawning styles of all these animals have two elements in common: Parents simply squirt eggs and sperm into the water, and then abandon defenseless offspring to a drifting, planktonic life. As a consequence of this apparently apathetic approach to reproduction— which, by the way, is not shared by all reef-dwelling fishes—those tiny, floating eggs and the diminutive larvae that hatch out of them would be easy prey for any of the plankton-eating animals that swarm over the reef. These hordes of planktivores are incredibly efficient—often managing to devour more than three-quarters of the plankton that drift over the reef.

But plankton-eating animals that specialize in small prey rarely wander far from the safety of the reef. (Some nocturnal planktivores feed at some distance from the reef but probably don't pose anywhere near as much of a threat to tiny eggs.) In this context, the escapades of surgeonfishes and other evening spawners begin to make good evolutionary sense. The spawning fishes don't place themselves at risk frivolously but in a manner that helps to ensure the survival of their offspring.

Group-spawning fishes release lots of eggs, a rich potential food resource that doesn't go unnoticed in the reef's competitive game of evolutionary one-upmanship. Many Pacific reefs, for example, support a few species of dusk-active, open-water planktivores. At least one of these, the streamlined lunar fusilier, forms large schools that locate surgeonfish spawning aggregations, sit downstream from them in the current, and pick off as many eggs as they can.

Such solitary spawners as butterflyfishes exhibit their own equally remarkable (though less conspicuous) tricks to maximize the survival of their offspring. Research conducted by oceanographer Phil Lobel, currently of the Woods Hole Oceanographic Instutition, and his colleagues in Hawaii shows that several species not only spawn at dusk but concentrate their efforts at specific times of the lunar month. Even more astonishingly, detailed maps of tidal currents have shown that some fishes unerringly spawn at those periods when tidal currents are positioned to carry their eggs away from all those voracious mouths on the reef. What's more, those currents form giant open-ocean eddies that revolve slowly and later carry the developing baby fishes back home. The return of the young fishes back to the reef is amazingly well-timed— they arrive just about the time they are ready to abandon planktonic life for adult-style residence on the reef.

MOVEMENT TWO: GIMME SHELTER

As the spawning fishes are winding up, most of the reef's other daytime animals begin to get nervous. Underwater shadows deepen, and each species, in each location on the reef, sooner or later finds its surroundings getting dark enough to compromise its particular visual system. At that point, individuals, pairs, small groups, and schools all stop their routine feeding behavior. As the animals begin to dart about nervously, their bold daytime markings begin to fade; the "pajama patterns" that replace them are simpler and darker. While their colors change, the fishes actively seek shelter.

Alcyonarians are among the most spectacularly colored of all marine invertebrates. Lacking the symbiotic algae of their hard-coral cousins, alcyonarians are not restricted to sunlit spots on the reef and can grow wherever currents bring them a dependable supply of plankton and dissolved nutrients. Deceptively fragile looking, they are actually leathery in texture, but their polyps are still vulnerable to the sharp jaws of diurnal coral-eating fishes. That's why they extend to their full, glorious spread only after dark.

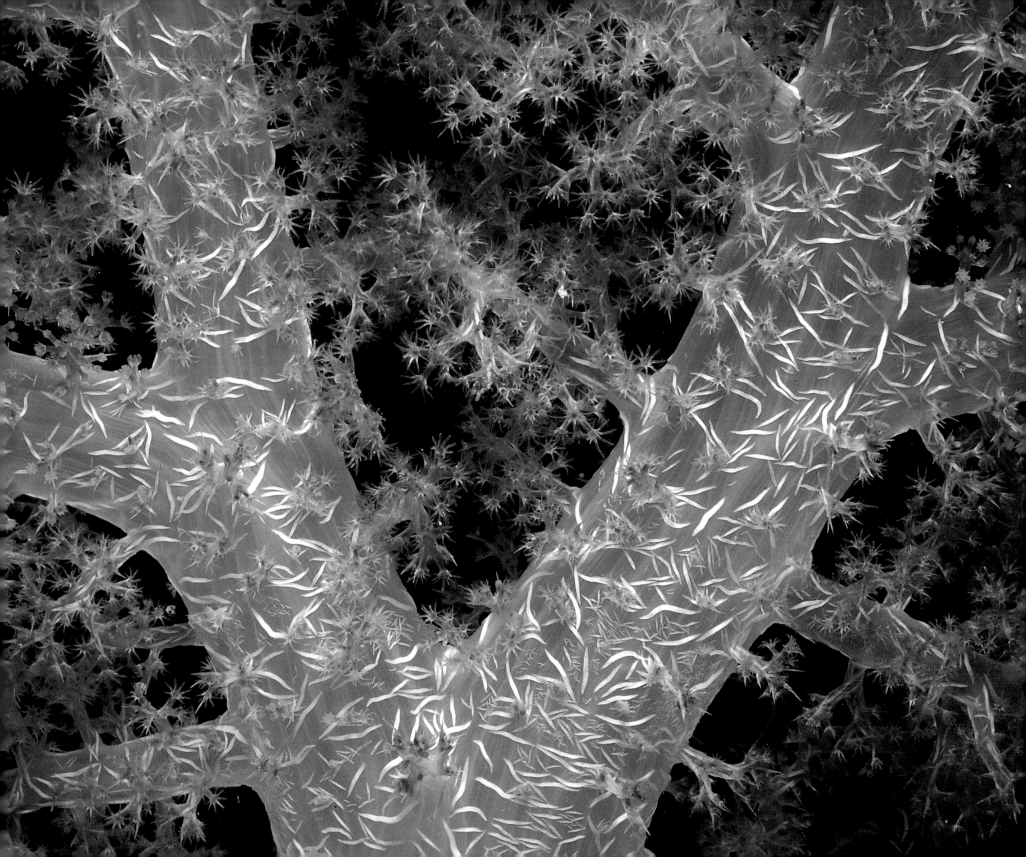

Each species goes about hiding in its own way and in the places it finds most comfortable. The parrotfishes described earlier leave their caravans to search individually for protected holes and caves large enough to hold them comfortably. Just finding the right spot isn't enough for parrotfishes, however, because these animals—unlike many other fishes—actually enter a state that resembles human sleep.

Surgeonfishes, too, need to find shelter before total darkness, and, because their sexual activity takes them so far from home, returning to the reef one at a time in the gathering gloom would be risky. After individuals in the spawning group release their eggs and sperm, they somehow identify similarly exhausted neighbors, form new single-file processions, and head back to shallow water. Perhaps so that the fishes can get their bearings, each train passes close by its original reconnoitering point before splitting into smaller trains that head off in different directions. As these smaller groups proceed along the reef, individuals leave the procession one at a time and dive quickly into nearby shelters whose locations they seem to know in advance.

By this time, virtually all the other familiar daytime reef denizens—angelfishes, butterflyfishes, wrasses, and triggerfishes—are also vanishing into their personal shelters.

Butterflyfishes, even those that live in pairs, shelter in strictly private fashion, one by one, retiring in favored resting spots that many of them use for years. Triggerfishes, fearless and combative by day, turn tail and dive headfirst for cover. Once inside a cozy crevice, each animal uses a large, stiff spine on its dorsal fin to wedge itself firmly into place. In front of that large spine, a smaller spine, the "trigger" for which the animals are named, locks the larger spine into place, helping ensure that these fishes can't be dragged backward from their private sanctuaries.

Damselfishes and *Anthias*, whose tightly knit schools are almost impervious to predation during the day, run into trouble at dusk. These fishes, too, find their vision failing and may become disoriented as a result. During this critical time, even the slightest confusion can prove fatal, because schooling jacks, semisolitary snappers, and reclusive groupers—all of whom have eyes better suited to dim light—can pick off isolated, distracted, or straggling members of the school with relative ease. Small wonder that these small fishes hover ever closer to the reef and finally seek refuge. Ultimately, they pack themselves so tightly into spaces between hard coral branches that the entire school seems to disappear.

Carrying venomous spines concealed beneath all that frilly finnage, this lionfish stalks its prey slowly and imperturbably during dawn and dusk twilight periods. On spotting a potential meal, lionfishes use fanlike pectoral fins to corral their quarry in a tight corner. A lightning-fast gulp of a large, vacuum-cleaner–like mouth then often spells the end of the hunt. If their target escapes, lionfishes don't seem to get upset; adjusting their fins like birds smoothing their feathers, they simply shift their focus to the next opportunity. The much-touted dangerous spines are used only in defense; threaten one of these animals and it will calmly aim its dorsal fin at the nearest offending body part. Their venom, unlike that of their relatives the scorpionfishes, is not lethal, but it does cause painful stings.

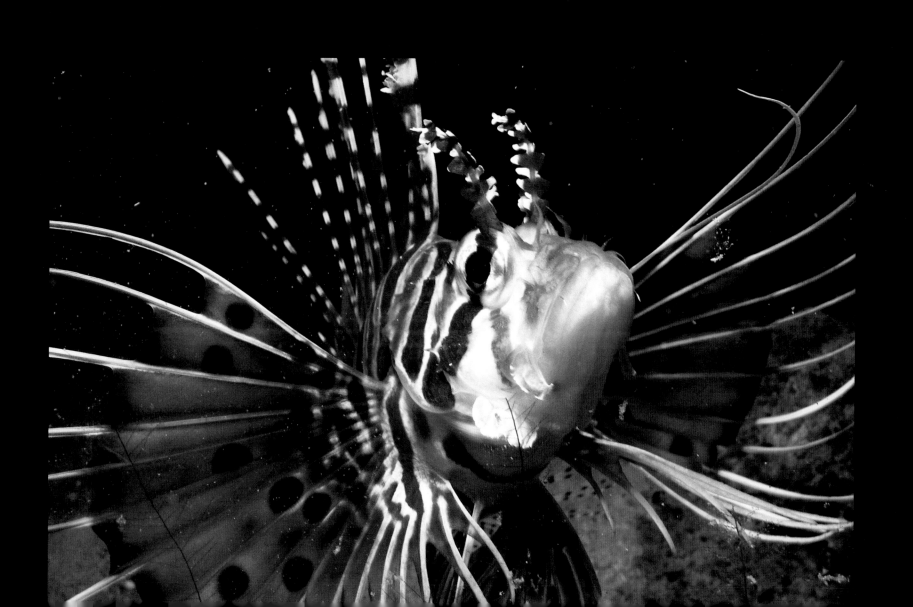

Sufficiently well camouflaged to fool even experienced divers, this rabbitfish prepares to turn in at the end of the day. Like many other daytime-active fishes, its eyes don't function well after dark, so it makes itself as inconspicuous as possible and waits out the hours of darkness.

MOVEMENT THREE:
SILENCE OF THE LAMBS

If the period leading up to sunset is exciting for its unusual goings-on and frenzied activity, the twenty-minute stretch that begins about ten minutes after sunset is striking for its almost total stillness. Gone are the multicolored clouds of plankton eaters that swarm across the reef by day. Not a single butterflyfish, angelfish, wrasse, or triggerfish can be seen.

This aptly named "quiet period" is eerie, even frightening to divers who've come to know the reef only by day, and not just because of the almost total lack of familiar animals out and about. In addition to the visual vacuum, the water is preternaturally silent. Gone are the popping sounds made by the claws of pistol shrimp, the crunching sounds of parrotfishes feeding, the grunts of damselfishes, and the snapping of triggerfish jaws.

All the small and medium-size fishes make themselves scarce at this time, for obvious reasons. Jacks, groupers, snappers, reef sharks, and other dusk-active predators are now at the peak of their powers. The solitary hunters in this fearsome crowd lurk just above the reef, where their dark and generally nondescript coloration makes them difficult to see. As they hover, they are constantly on the lookout for the occasional wayward daytime fish that has failed to seek shelter in time. Waiting for just the right moment, twilight hunters position themselves beneath their prey, silhouetting them against the waning light radiated by the evening sky. Then, striking from the shadows, they lunge upward with such speed and force that they often break the water's surface. The nearly blind prey, unable either to see or react in time, rarely escapes.

Schooling predators also fare well during the quiet period, stalking their quarry in much the same way that wolves and wild dogs hunt grazing animals that travel in herds. Jacks, which often aim for schooling fishes separated from their fellows, also make forays against those lunar fusiliers that are brave (or foolish) enough to wander too far too fast. Working both as individuals and as a team, the jacks try to split their victims into smaller groups and herd a few of them up against the surface of the water. Individual jacks take turns making brief, wild dashes into the center, not so much to grab individuals as to scare a few out of the school where they become easy targets. The hunt continues until thwarted by total darkness.

Even as daytime fishes are driven into hiding to escape this carnage, their prey breathe a sigh of relief (figuratively, at any rate). For just as butterflyfishes hide from sharks and their kin at dusk, corals and other invertebrates that are at the butterflies' mercy in bright light do their best to make themselves scarce by day. Now that all those constantly probing mouths and prying eyes are gone, however, the very surface of the reef undergoes an astonishing transformation.

Among the first to react are the corals, whose double life as both plant and animal slowly becomes apparent. Coral polyps spend their days hidden deep within the recesses of their coral skeletons, where they are as safe as their sedentary lifestyle allows from the small, agile jaws and sharp teeth of diurnal coral-eating fishes. As they withdraw, the polyps graciously arrange their single-celled plant guests into layers oriented to make the most of the available sunlight. Thus, from dawn to dusk, hard corals act simply as plants.

But when coral-feeding fishes retire for the night, corals undergo a visually dramatic and ecologically significant metamorphosis. As the last daytime fishes disappear during the quiet period, corals inflate their flexible bodies with water, stretch out fingerlike tentacles armed with stinging cells, and set their living nets to snag passing plankton. In the space of a few minutes, hard coral colonies are transformed from inanimate-looking lumps of limestone into collections of hungry mouths surrounded by waving tentacles. And as hard corals emerge, their soft coral cousins—colonial animals with flexible, rather than rigid, skeletons—come to life in their own way. Expanding their leathery bodies and extending their countless polyps, they grow to many times their daytime size as they sway gently with the current.

One by one, other invertebrates begin to emerge, as though somehow aware that triggerfishes and their other dangerous enemies are asleep. Nudibranchs, shell-less sea snails whose brilliant colors have earned them the nickname "butterflies of the sea," also wander out to graze, their naked bodies temporarily safe from piscine jaws. Crabs, some of which are no larger than a thumbnail, and others that would make a hearty meal for a hungry human, appear out of nowhere and begin foraging on the face of the reef. Brightly colored tropical lobsters emerge cautiously from their burrows to browse for food and search for mates.

A pufferfish, partially inflated for protection, settles into a hiding spot in which it is camouflaged. There it will rest fitfully through the night, neither as comatose as parrotfishes nor as active as nocturnal species.

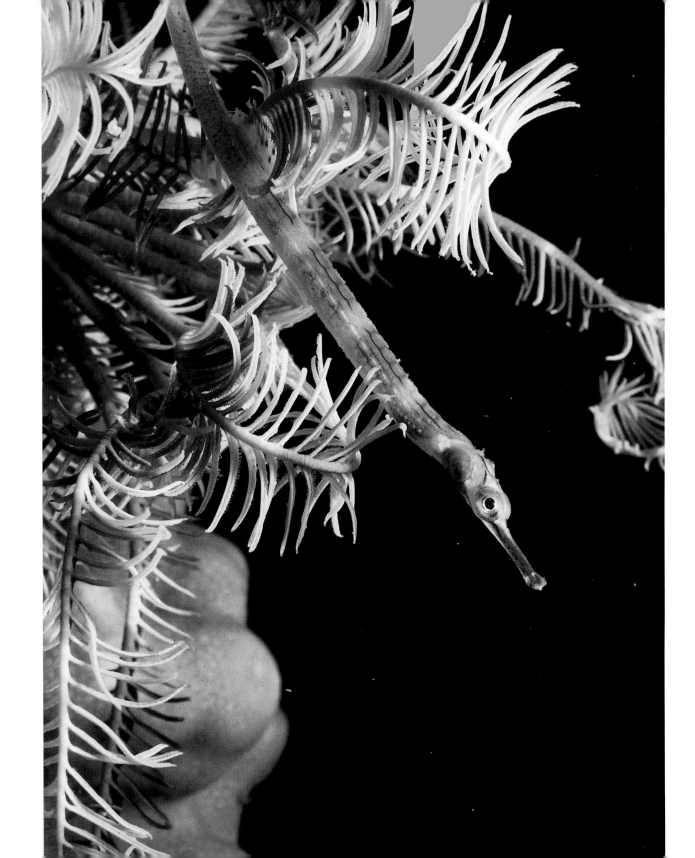

Pipefish, small, reclusive relatives of the better-known seahorses, are most easily seen during twilight and at night, when they wander fairly widely over the reef.

Among the most unusual creatures to appear during this period are the spiny-skinned echinoderms, an entire group of animals found only in salt water. The best known of these, the sea urchins, crawl slowly and steadily from their hiding places to take the place of daytime plant eaters. Meandering ponderously across coral rocks, urchins use their five-part jaws to scrape algae from the surface. Meanwhile, brittle stars, reclusive and anorexic-looking relatives of more common starfish, extend slender, spidery arms slowly and tentatively from tiny crevices among and between coral colonies. When they finally emerge, they can scuttle across the reef with surprising speed, allowing scarcely a glimpse of their flattened, pentagonal bodies.

Exotic and graceful sea lilies (also called crinoids), which still bear a remarkable resemblance to fossil forebears 250 million years old, also appear out of nowhere. At first these peculiar animals, which can have as many as fifty-five feathery arms painted in striking colors, keep all their appendages curled tightly, so they resemble balls of coiled wire. It takes them as long as half an hour to crawl slowly and ponderously on their curved, feathery arms the few yards from hidden cavities within the reef toward perches on the tips of coral branches exposed to the current. Finally grabbing hold with a second set of smaller, wiry arms, they settle into place, expanding their arms into semicircular fans positioned at right angles to the current. There they remain throughout the night, waving their arms in search of plankton.

MOVEMENT FOUR: DARKNESS FALLING

Roughly half an hour after sunset, the last vestiges of light disappear, and human vision underwater reaches its limit. Shadows that have been lengthening slowly seem to leap up and embrace one another, merging into a cloak of darkness that envelops the reef and obliterates even the most prominent underwater landmarks.

By this time, most divers sit down to dinner, ready to swap fish tales and turn in for a good night's sleep. But only now do most of the reef's truly nocturnal creatures begin to creep, crawl, slither, and swim into the open. Some have spent the day squirreled away in tunnels deep within the coral labyrinth. Others have cowered in the shadowy mouths of open caves or lurked beneath overhanging coral ledges. Now, like shadows from the underworld released to revel in the gloom, they emerge. The real night moves have begun.

CHAPTER THREE GARDENS OF THE NIGHT

Darkness transforms the brightly colored, whimsical daytime reef into a murky, alien world filled with ambiguous shapes and brooding shadows. Water that beckons invitingly by day swallows light greedily, as if to remind visiting mortals that they hover at the edge of an abyss. The beam of even the strongest underwater searchlight vanishes within a few yards, limiting vision to an uncomfortably small sphere. Anything beyond the reach of that light is both unseen and unseeable.

While some tension and unease are unavoidable on night dives, their real attraction isn't fear, but novelty. Not only does the nocturnal reef present a myriad of different faces that are invisible by day, but night divers see those faces in a radically different and invariably much more personal way.

Like mist in a coastal forest on an autumn day, darkness on the reef at night forces human observers to concentrate on small objects near at hand. Animals that attract attention tend to be tiny, delicate, and elusive. Fleeting encounters seem to end almost before they've begun. It isn't unusual for half a dozen night divers to surface with completely different, intensely private stories to tell.

Crinoids are striking and unusual relatives of more familiar starfish and sea urchins. The most common types of crinoids, which are often (though not always) nocturnal, carry two dramatically different types of "arms" in multiples of five. The long, feathery appendages sweep through the water to gather plankton. The smaller, more ropelike arms beneath are used for "walking" over or grasping onto coral formations.

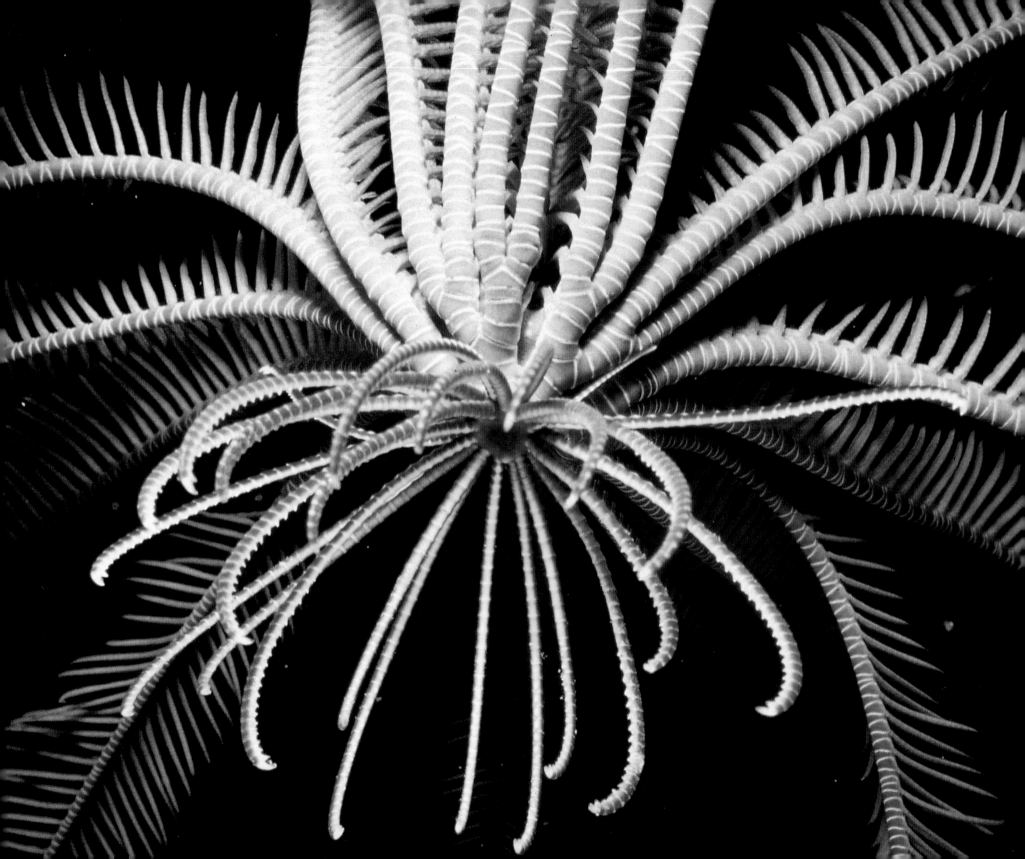

Still, most divers swallow hard when given the best piece of advice about night diving: Abandon big, bright searchlights in favor of small, dim flashlights. Many more balk when told that the only way to see some of the most incredible sights is to switch *all* lights off and keep them off until human eyes become accustomed to their absence. For then the nighttime reef is seen the way it evolved to be seen—in total darkness.

The first hints of the unusual in tropical seas at night can be seen without putting a single toe in the water. Strolling along a beach with enough wave action to stir up sand and gravel, even a casual observer can soon spot glimmers of faint, blue-green light flashing on and off in the surf. At first, the pinhead-size sparks seem like optical illusions; reflections, perhaps, of distant lights or even more distant stars.

But they are real, as a glance over the railing of a pier or a boat can prove; they appear affixed to pilings, rocks, anchor lines, and any other stationary object washed by strong currents. Divers on the reef at night who are willing to shut off their flashlights see an even more dramatic display; not only are their bodies coated with flickering lights, but their fingers, flippers, and rising air bubbles leave behind streams of twinkling stars.

Careful inspection reveals that these luminescent motes don't appear out of nowhere. They drift through the water invisibly until they strike an eddy in the current or an object in their path. Sparkling briefly when jostled by waves, boat propellers, or a diver's body, they fade into obscurity as soon as they drift unencumbered once again.

Are these some sort of marine fireflies? Not quite. In fact, they usually aren't animals at all, but tiny, luminous algae that belong to the drifting plankton community. When disturbed, they glow briefly with bioluminescence, the scientific term for cold, living light. That light is so dim that even a small flashlight renders it invisible. It appears bright only to the dark-adapted eye in total darkness. But under these conditions it can be dazzling. One inlet in Puerto Rico is called the Bahia Phosphorescente in honor of its dense population of these organisms. Paddling through that water in a rowboat or kayak is a magical experience, even to seasoned travelers who've seen the swirling points of light many times.

Another star of the nighttime reef is the rare and beautiful Spanish dancer, one of the largest shell-less sea snails known. Ranging in color from deep blood-red to rose-pink, Spanish dancers can be seen by day only in deep coral caves. By night, however, they emerge, often carrying with them a mated pair of commensal shrimp that ride along on their flowing mantles. Dislodged from the reef surfaces where they normally graze, these animals undulate gracefully through the water, waving their "skirts" like silent facsimiles of their flamboyant flamenco namesakes.

Researchers have known for years how these tiny plants—and other organisms that make their own light—accomplish the trick. They make a protein called luciferin and an enzyme called luciferase. When the two are mixed together—whether in the cells of marine algae or in the posterior ends of fireflies—the enzyme attacks the protein, chemically breaking it apart. In the process, light is given off with virtually no detectable heat.

Fireflies blink to communicate with one another or to attract prey. But no one has yet devised a convincing explanation for why plant plankton glow in the dark. Some think it might be an evolutionary ploy to startle animal plankton that try to feed on them. Others propose that producing light when disturbed might be a more indirect means of protection; if plant plankton glow as animals try to eat them, they might illuminate their enemies, who would then be more obvious to *their* predators. Over time, fewer plant eaters that choose luminescent foods might survive, thus favoring both glow-in-the-dark algae and predators with less flamboyant tastes. Neither of these explanations, however, has been widely accepted.

A host of other marine organisms—including species of bacteria, plants, fungi, brittle stars, squid, shrimp, and transparent planktonic invertebrates called comb jellies—produce their own versions of luciferin and luciferase and combine them to glow in the dark when they choose. Researchers haven't a clue as to the significance of light production in many of these species, but some use their bioluminescent talents in more obvious ways. The most striking among them is the elusive, nocturnal will-o'-the-wisp known to divers as the flashlight fish and to biologists as *Photoblepharon*.

These remarkable fish appear on the reef in force only during moonless nights, where their activity can be as unnerving as it is magical. Swimming along the reef in the dark, a diver becomes aware of an uneasy feeling that he or she is being watched—a suspicion engendered by subliminal perception of sinister eyes hovering just out of sight. Then, the source of that impression becomes visible, hovering at the limits of vision: a swarm containing dozens of disembodied, paired, elliptical patches of blue-green light that could easily fill in for demonic eyes in any Hollywood thriller. Somehow, the combination of their shapes, their paired habit, and the fact that they wink on and off—literally in the blink of an eye—conveys an unshakable impression of malevolence.

This nighttime coral garden is dominated by collections of pastel-colored soft corals, seen here fully expanded to nearly twice their daytime volume.

Following pages: Gorgonian corals, striking even by day, show their full beauty at night when their polyps—often a color that contrasts with their branches—are open and feeding.

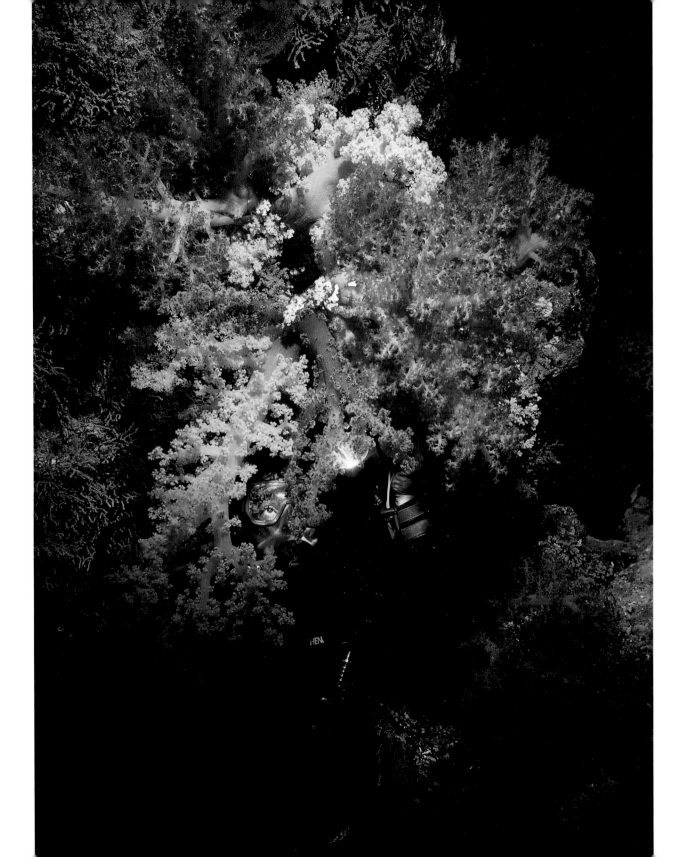

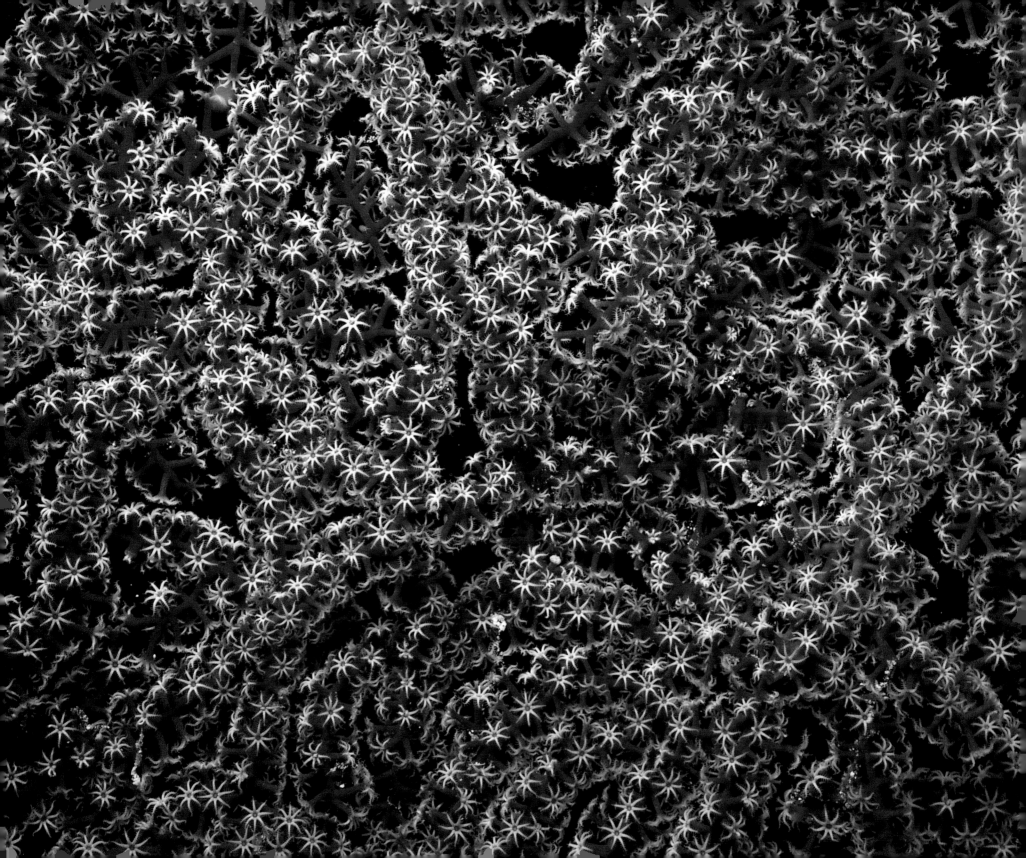

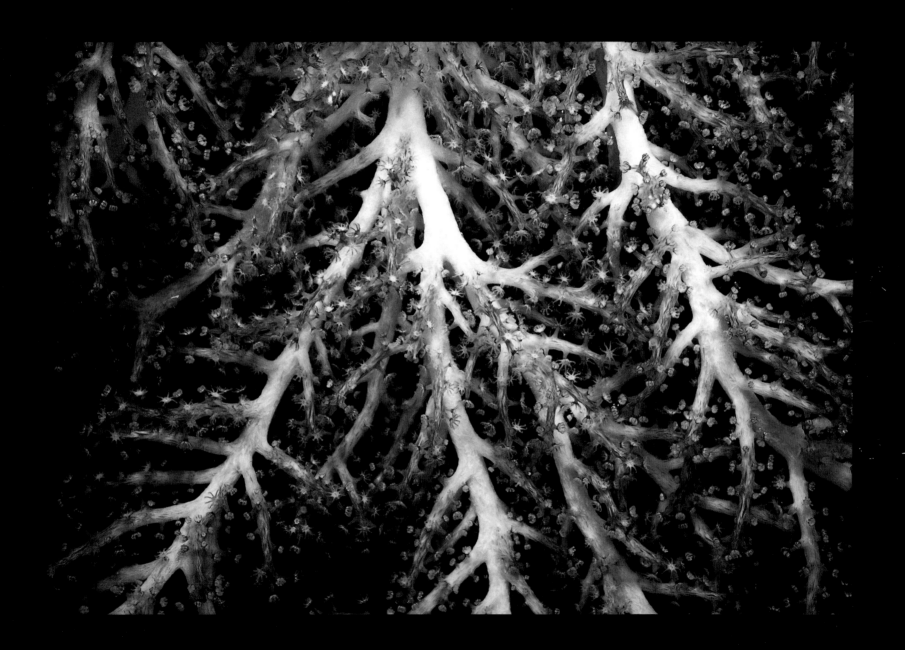

Photoblepharon, though, is harmless—at least to humans and other large animals. And, first impressions to the contrary, those luminous patches aren't eyes at all, but rather light-producing organs whose design and function is as remarkable as any accomplishment of natural selection on land or in the sea.

Photoblepharon, like other animals with backbones, cannot glow in the dark by itself, because it has never evolved the ability to produce its own luciferin and luciferase. Instead, its light-producing organs offer a congenial home for a dense culture of luminescent bacteria that live symbiotically with the fish; the host provides oxygen and food, while the "guests" give off a steady glow. The light organ has two other striking features: a mirrorlike backing that reflects light out like the reflector in a floodlight, and an opaque structure that covers and uncovers the bacterial colony by "blinking" open and closed like an eyelid. In total darkness—which is to say, far from the lights of the dive resorts springing up near many reefs these days—the light given off by a sizable school can often be seen from the surface and from many yards away.

Flashlight fish seem to use their light organs for at least three purposes. During the day, they hide in caves as deep as 100 feet within the reef, where individuals may (or may not) use their built-in lanterns to navigate. At night they emerge, rise to within a few yards of the surface, and hunt for small, free-swimming plankton. As long as they face no competition from moonlight, their light organs are bright enough to attract several kinds of medium-size planktonic prey.

In addition, *Photoblepharon*—like many other fishes with light organs—use their personal flashlights to communicate with each other in a sort of Morse code. Finally, as any diver who has tried to catch them knows all too well, flashlight fish use their lights to confuse predators. Swimming in one direction with their lights on, the animals will suddenly switch them off, turn on a dime, and head off rapidly in another direction. Because the fish absolutely disappear with their blinkers closed, any predator trying to track them is tricked into heading in the wrong direction, time and time again.

Perhaps because both the first and last of these functions are compromised by even weak light (not to mention strong moonlight), *Photoblepharon* rarely venture into shallow water for several days on either side of a full moon and on other nights are most active before the moon rises and after it sets. Thus, if you are planning a dive trip to a reef where these fish live, you can maximize your chances of finding them at a comfortable depth by planning your expedition to coincide with a new moon. (And remember to switch off your own lights.)

Virtually never seen by day, scores of aptly named, paper-thin flatworms emerge from reef crevices to graze along the reef surface after dark. When dislodged from rocks and corals by currents, they flutter through open water like kites whose strings have been cut, heading back for the security of the reef surface.

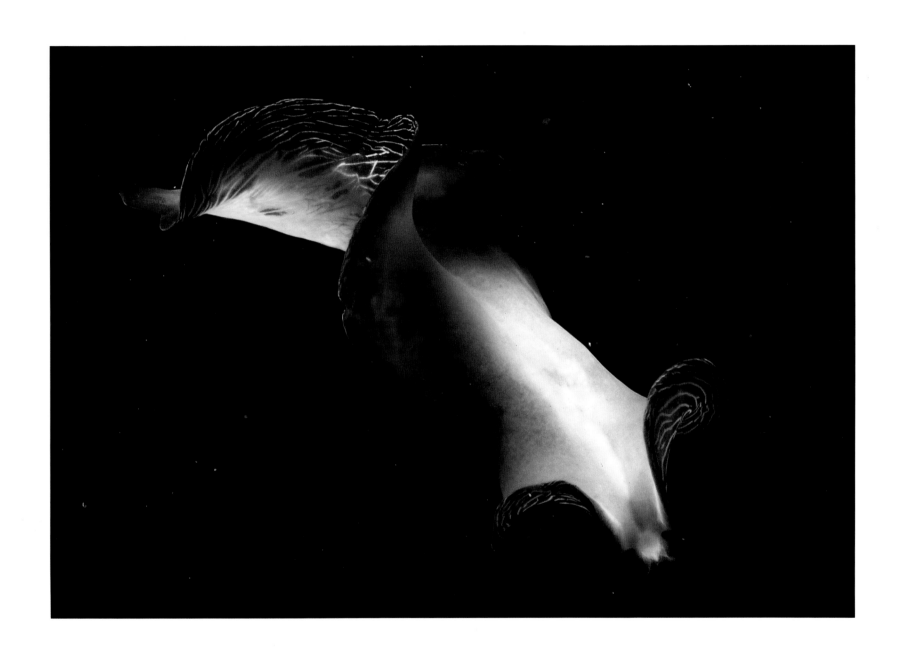

Meanwhile, below the surface on the reef itself, the transition between the last moments of twilight and the advent of total darkness brings out the other members of the reef's night shift, most of whom don't carry their own light with them and must make do with the huge, staring eyes with which chance, necessity, and natural selection have equipped them. Soldierfishes, squirrelfishes, and cardinalfishes emerge, somewhat nervously taking up positions close to the reef that were recently abandoned by the daytime crowd. Remaining there for a while, they seem to acclimate and get their bearings before venturing any further.

The most dramatic scene is staged at the mouths of coral caves in shallow water. There, schools of iridescent fish known as sweepers slowly emerge from the shadows in which they have remained all day. Gradually, more and more individuals emerge, and because they hesitate to move far from home at first, they gather near the cave entrance where they "pace" nervously up and down the face of the reef. Ultimately this skittish aggregation may contain thousands of individuals that alternately mill about in disarray and synchronize their movements with dazzling skill.

Other fishes that prefer darkness to light also choose this time to head toward their nighttime feeding grounds. Young grunts, who had rested in groups around favored coral heads by day, and became restless as dusk approached, converge around a conspicuous landmark. Often that staging area is a promontory that juts out from the reef toward a preferred feeding ground—a sand flat, perhaps, or a lush bed of sea grass. Like sweepers around the mouth of their cave, grunts at their staging area seem ambivalent about going any further.

For a time, the bravest individuals make brief, anxious forays out along a path they all seem to "want" to follow. But even these pioneers rarely get more than a yard from the group before they turn tail and head back to safety. Until the water is totally dark, they are wise to be cautious. Dusk-active predators—jacks, groupers, and their ilk—who have just finished terrorizing the last stragglers from the day shift, are still around and can still see well enough to pose a formidable threat. They are also still hungry and therefore more than ready to focus their attention on the most adventurous members of the night crowd.

Brittle stars (right and following pages) are so named because they can voluntarily break off their arms to distract predators—whatever "voluntarily" means when applied to an animal with nothing even remotely resembling a brain. The severed arms—which regrow rapidly—continue to twist and squirm by themselves, giving the animal itself a chance to head for cover. Despite this clever defensive strategy, brittle stars invariably make themselves scarce by day, squeezing their flattened bodies into tiny crevices. By night, however, many of them emerge, as did those pictured here, to roam across the reef in search of food—and, occasionally, mates.

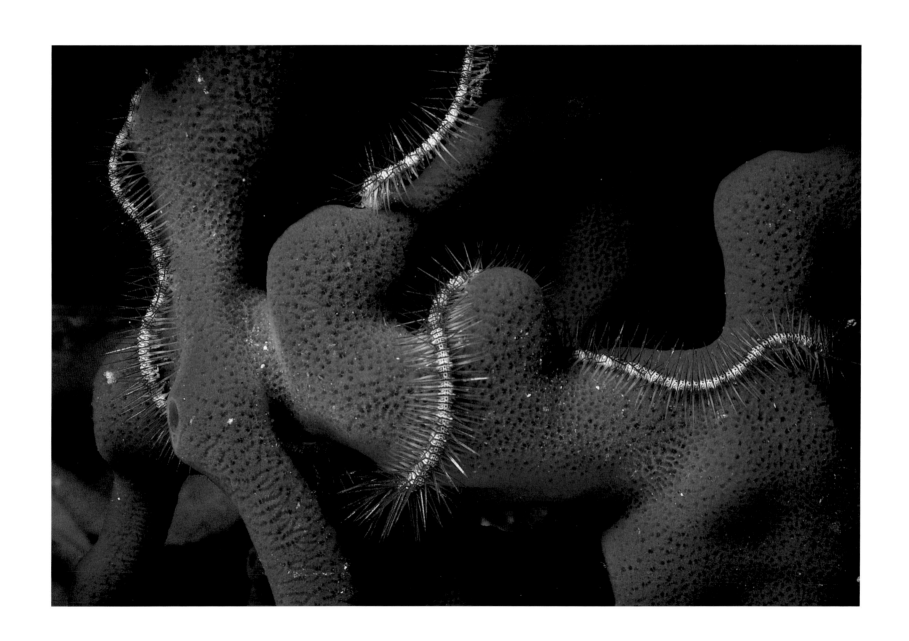

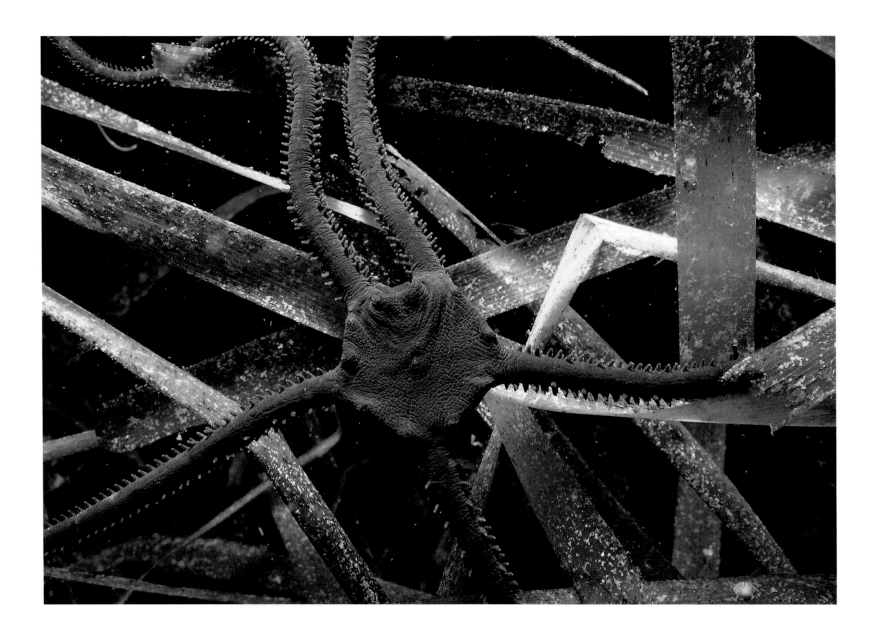

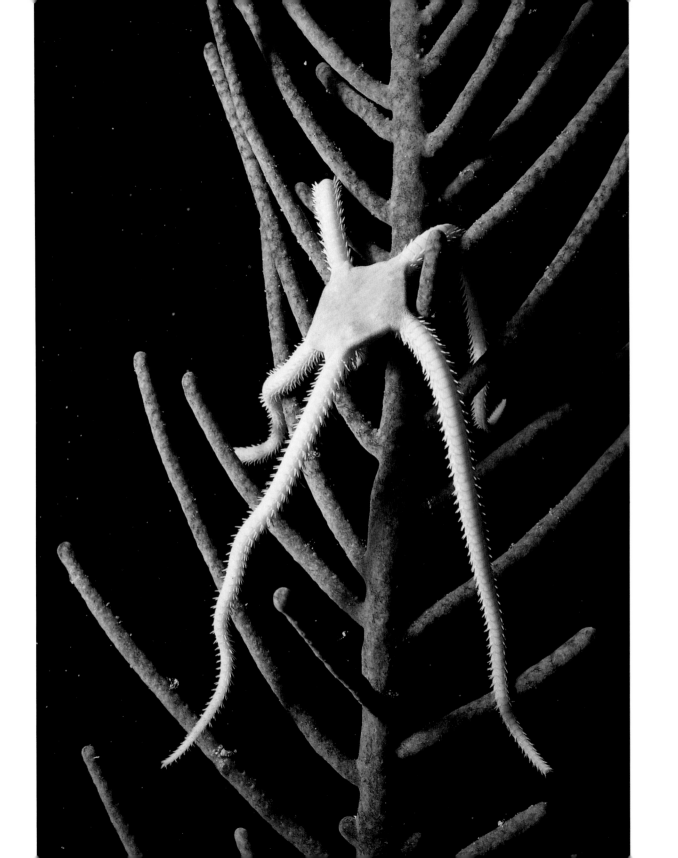

Finally, as the last vestiges of light vanish, the night shift shrugs off its uncertainty and heads off "to work" in force. The huge aggregations of sweepers break up into smaller groups of 100 or so that charge away from the reef and out to the open sea. There, they vanish into the darkness; as far as we know, members of the swarm scatter widely and search for planktonic prey in open water throughout the night. Emboldened juvenile grunts finally follow the lead of the adventurous among them and stream off the reef in a direct line toward greener pastures as far as several hundred yards away. On reaching their goal, the individuals head off on their own, feeding throughout the night on worms, small shrimp, and other invertebrates that live in the sand.

Both of these fishes, like their diurnal counterparts, know their resting and feeding areas well. Sweepers feed all night in pitch darkness and in open water so far from the reef that divers have yet been unable to track them. Yet each individual sweeper somehow finds its way back to the very same cave in which it sheltered the previous day. Grunts, for their part, shelter in the same coral head, assemble at the same staging sites, follow the same migratory route, and feed in the same places year after year.

This consistent behavior is even more remarkable given the fact that the groups turn over constantly; as young grunts mature, they move elsewhere, and as older sweepers die they are lost to their group. Without clear leaders or teachers among them to provide continuity, new recruits must somehow learn the local traditions of any group they join. In fact, experiments have shown that individuals captured from one group and transplanted to another are readily adopted by their foster family and quickly learn to follow a new migration route.

Back on the reef itself, a diver's flashlight beam can expose nooks, crannies, and passageways—which appear during daylight to be dark, even forbidding recesses—as luxurious boudoirs for diurnal fishes. Peering into them is not unlike looking into the rooms of city apartments at night. The main difference is that the "bedrooms" of these coralline apartments are usually more lushly furnished—carpeted with sponges, soft corals, and other invertebrates whose colors and patterns rival the tapestries and carpets of Bedouin tents.

Cone shells—whose beautifully patterned domiciles are prized by collectors—are most active at night. But their habits explain why their shells are often high priced. These are predatory animals that stalk their prey by smell, paralyze them with a venomous "harpoon," and then devour them at their leisure. Some species carry poison enough to be fatal to humans; others, like the species pictured here, have a sting that is merely painful and temporarily debilitating.

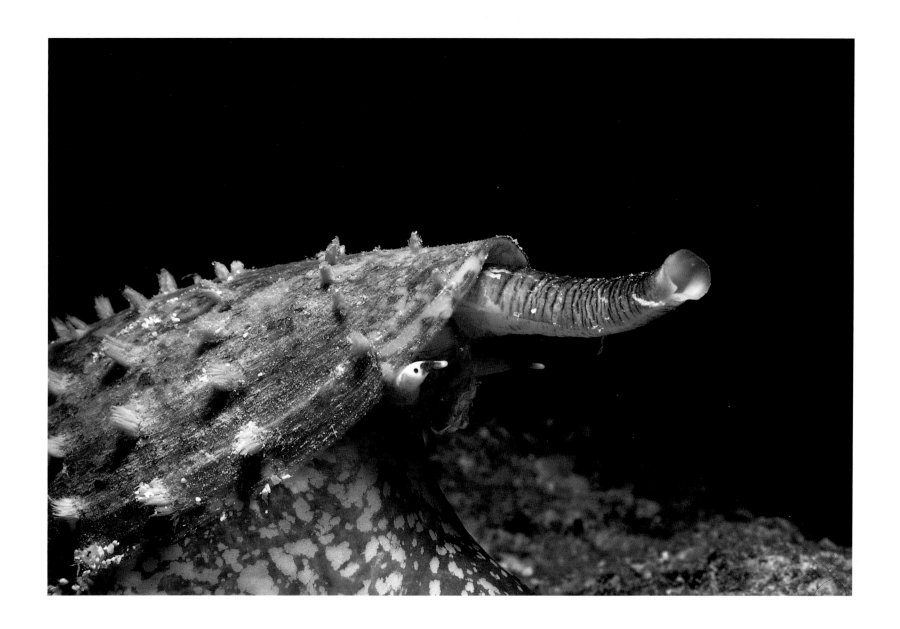

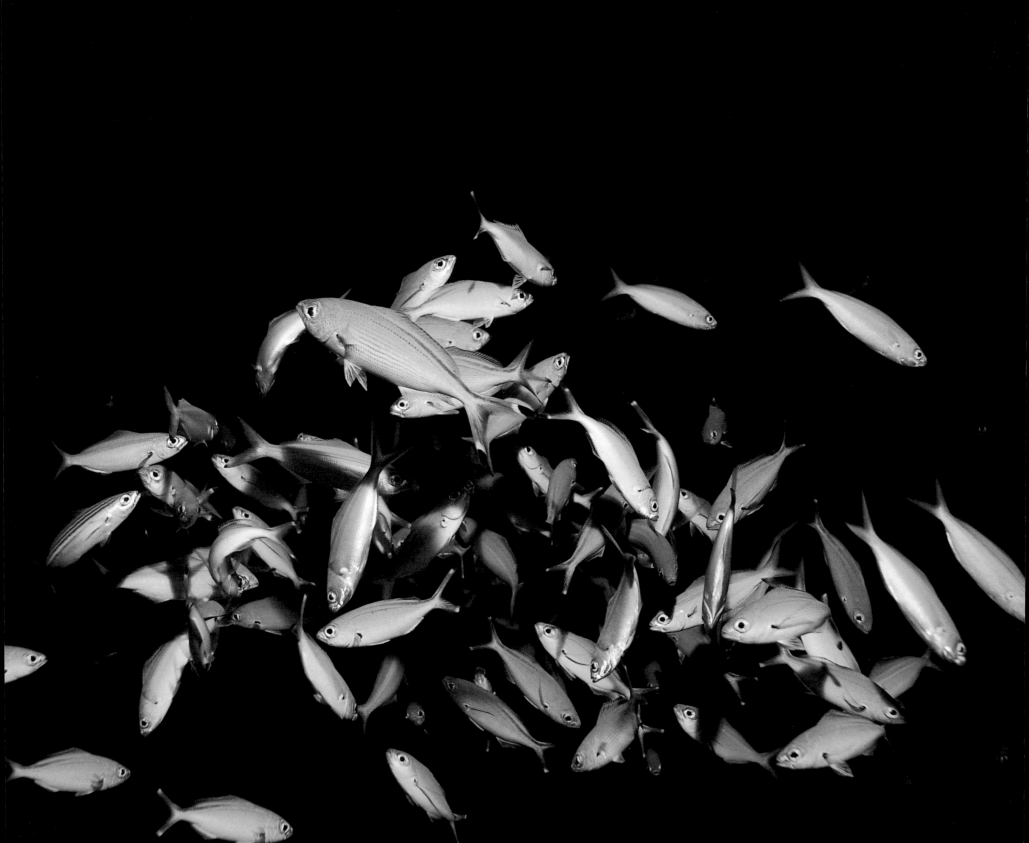

And in nearly every potential sleeping chamber, the observant diver will find at least one pair of staring eyes belonging to a diurnal animal in nightclothes. One of the greatest lures of night diving is the chance to approach such animals much more closely and for much longer periods of time than would ever be possible in the daytime. That's one reason why night diving with a camera can be an underwater photographer's dream come true.

Individual stories of many such sleeping beauties are told in the captions of this book, but we can make some general comments here. With a few notable exceptions such as parrotfishes, diurnal fishes often lose their bold, distinctive markings at night. Some actually seem to don the piscine equivalent of pajamas, obscuring their bright colors with pale blotches or masking them with overlaying solid washes of brown, red, and silver.

The evolutionary reasons for this change aren't clear, since almost any color pattern is nearly invisible in pitch darkness. Perhaps it represents some sort of evolutionary relic—a holdover from an earlier stage in the evolution of reef ecosystems. It is possible that before the habits and defensive adaptations of coral fishes were as highly developed as they are today, the ancestors of modern species "switched on" their brightest hues only when actually needed for communication. At all other times, they may have assumed less conspicuous patterns in ways that decreased their visibility to predators. Many freshwater and temperate marine species do that to this day, striking an effective compromise between conspicuous visual signals for communication and camouflage for protection.

On the other hand, it is also possible that the function of less-complicated nighttime coloration is actually the opposite. By simplifying their patterns, some species may make their broad outlines more distinct, improving their visibility and making it easier for them to identify one another in dim light. Experiments and observations are needed to answer this question.

While triggerfishes, butterflyfishes, and their daytime companions sleep, scores of invertebrates that might otherwise be their prey come out of hiding. These animals include crabs, ranging from barely the size of a human thumbnail to the diameter of a dinner plate, and shell-less soft-bodied creatures such as the nudibranchs, snails whose name means "naked gills." Many of these animals are breathtakingly beautiful, and few, if any of them are visible by day.

Encountering a dense patch of plankton in open water off the reef, this small group of fusiliers has begun a feeding frenzy that continues either until the food is exhausted or they are interrupted by larger predators.

 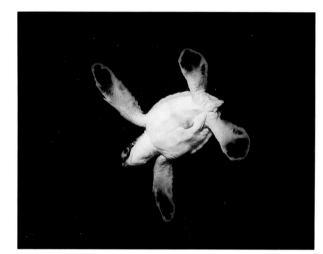

Sea turtles, though they spend their entire adult lives in the sea, lay their eggs in nests dug in sandy beaches. When those eggs hatch, the newborns dig their way to just below the surface, where they wait for night to emerge. When the sand cools sufficiently to signal the cover of darkness, the hatchlings emerge en masse and scramble madly for the sea. Those that escape nocturnal predators on land run another gauntlet in shallow water, where they must sneak past all the waiting mouths of sharks and bony fishes. A few survive mainly because so many of them hatch at once that predators can't possibly catch them all before they reach the relative safety of open water.

The nighttime reef is hardly free from hungry jaws, however, for it houses its fair share of true nocturnal predators as well. Many (though not all) of these exclusively carnivorous animals are remnants of the ancient fish assemblages that dominated ancient coral reefs while *Tyrannosaurus* was king on land. Current theory holds that these fishes, once active by day, moved into darkness slowly over time. To some extent they were pushed, displaced by intensifying competition from the growing crowd of newer, daytime fishes. And to some extent they were pulled, drawn by the evolutionary flight of their even-more-ancient prey, as they took up nocturnal habits. Whatever the reason for their transition, however, it was possible only because these animals were able to evolve either incredibly sensitive eyes, keen senses of smell and taste, an acute sense of touch, or a combination of all three.

Squirrelfishes and soldierfishes are prime examples of this group—piscine equivalents of souped-up Model T Fords cruising bars and all-night hamburger joints after dark. Their huge eyes, which distinguish them at a glance from the daytime crowd, are sensitive enough to produce useful images in near-total darkness but aren't sharp enough to spot things as small as the prey preferred by their daytime counterparts. That's why these nocturnal hunters generally pursue much bigger targets than day-active plankton feeders. They also go after larger shrimp, crabs, and the like that scuttle over the reef at night and must stalk their quarry at close range. With these handicaps, it isn't too surprising that the reef supports fewer such animals at night than during the day.

Then there are moray eels—animals most associated in divers' minds with "jaws" on the reef, experts at hunting almost exclusively by smell and taste. Morays, whose numerous species range from the size of a hand-rolled Cuban cigar to the apparent bulk of a small cow, spend most of their time slithering through caves and tunnels deep within the reef. By night, however, they emerge from hiding to cruise the reef surface. Their sense of smell—like that of sharks—guides them toward prey from a surprising

This moray eel is smaller than those that remind divers of sea monsters, but it shares all the characteristics that give its larger relatives their fearsome aspect. Its teeth are long, sharp, and recurved, so once those jaws close on prey there is little chance of escape. The two "nostrils" visible on its snout are not used for breathing but are instrumental in following odor trails in darkened reef tunnels and at night. Water is pumped through those tubes, which are lined with extremely sensitive sensory cells.

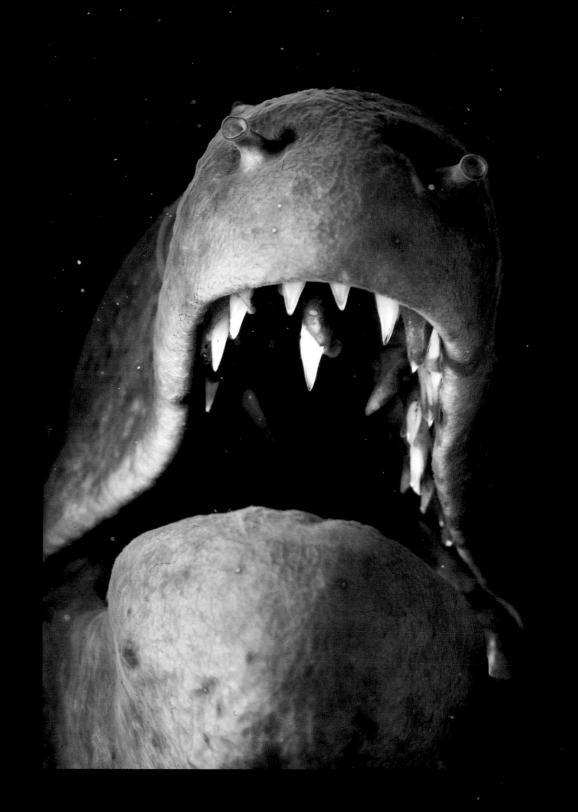

distance and with disconcerting speed and enables them to surprise unwary nocturnal fishes and invertebrates. (Many a spear-fishing diver has scarcely finished subduing a catch before discovering the need to defend it from a hungry moray who has suddenly appeared out of nowhere.) But while smell brings morays toward food, taste commands their jaws to bite; only at a range close enough to excite taste receptors around the mouth do those jaws really go into action.

The threat of attack by these olfactory and tactile predators, in the minds of some researchers, explains certain aspects of the nocturnal behavior of parrotfishes. As mentioned earlier, parrotfishes are among the relatively few fish species that really "sleep." (With only a handful of exceptions, fishes don't have eyelids, so they can't sleep by shutting out visual stimuli altogether as we do.) That pronounced (and enforced) rest period obviously puts parrotfishes

at risk from nighttime attack, so they cover themselves with mucus cocoons that "seal in" odor cues and seal out the tactile organs of would-be predators. That approach helps protect them, not only against morays, but also against predatory sea snails who also use the cover of darkness to stalk their prey.

Ecological researchers noticed years ago that some of these nocturnal species provide, to some extent, what are called "replacement sets" for guilds of sleeping diurnal species. But that notion is strictly an approximation. First of all, not every daytime guild is replaced. Among fishes, for example, there seem to be no nocturnal plant eaters, coral feeders, or cleaner fishes. Several other specialized niches that require highly developed jaws are also absent, for those ecological slots belong to species with sharp, high-light vision.

Despite an expression that begs for contrary anthropomorphic interpretation, this parrotfish acts as if it is drugged a short time after sunset. Preparing itself for sleep among coral formations, it begins to enter a state of deep torpor. Photographing these normally skittish animals is easy once they reach this stage; they can be gently handled and surrounded with lights for several minutes before they regain sufficient consciousness to swim away. That inability to respond highlights a real weakness; predators would do more than play if they could find them.

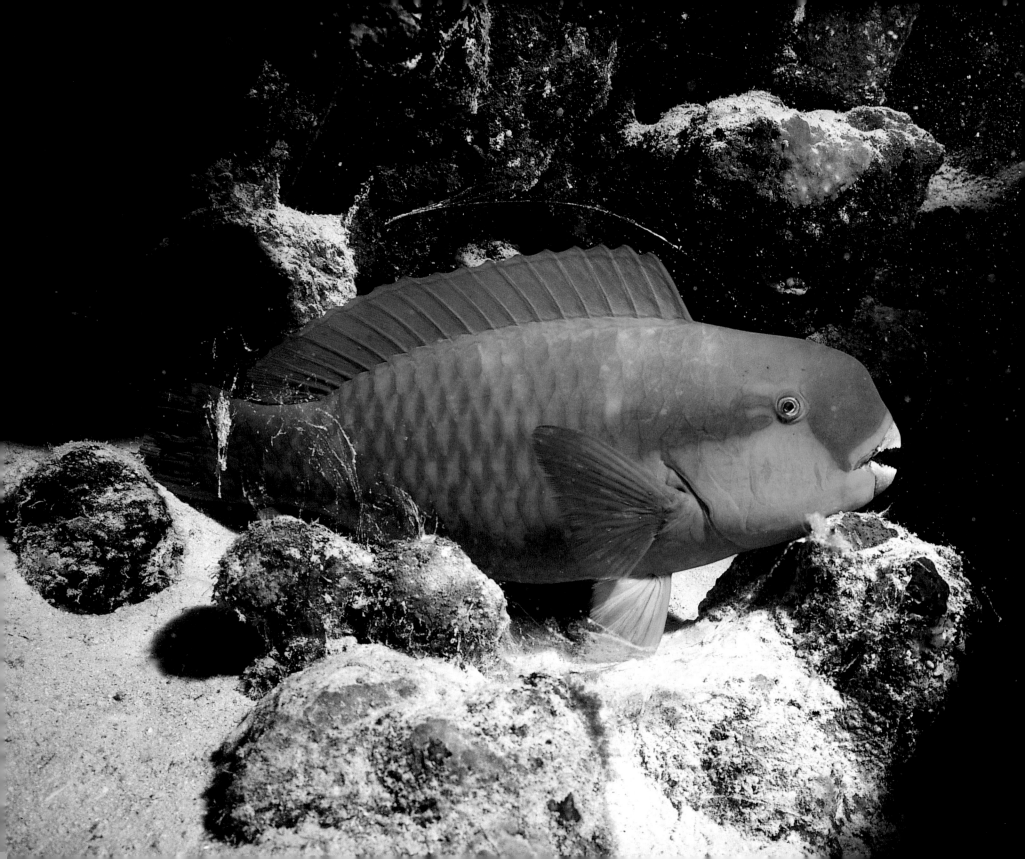

Fully settled in for the night in a coral nook, this parrotfish (above) has enveloped itself in a protective mucus cocoon that prevents its characteristic odor from alerting nocturnal predators to its presence. This sort of protection is especially valuable to fishes that "sleep" as deeply as these. Another individual (right) rests at some distance from the reef and its dangers. This parrotfish isn't dead but simply sleeping on its side in an exposed location.

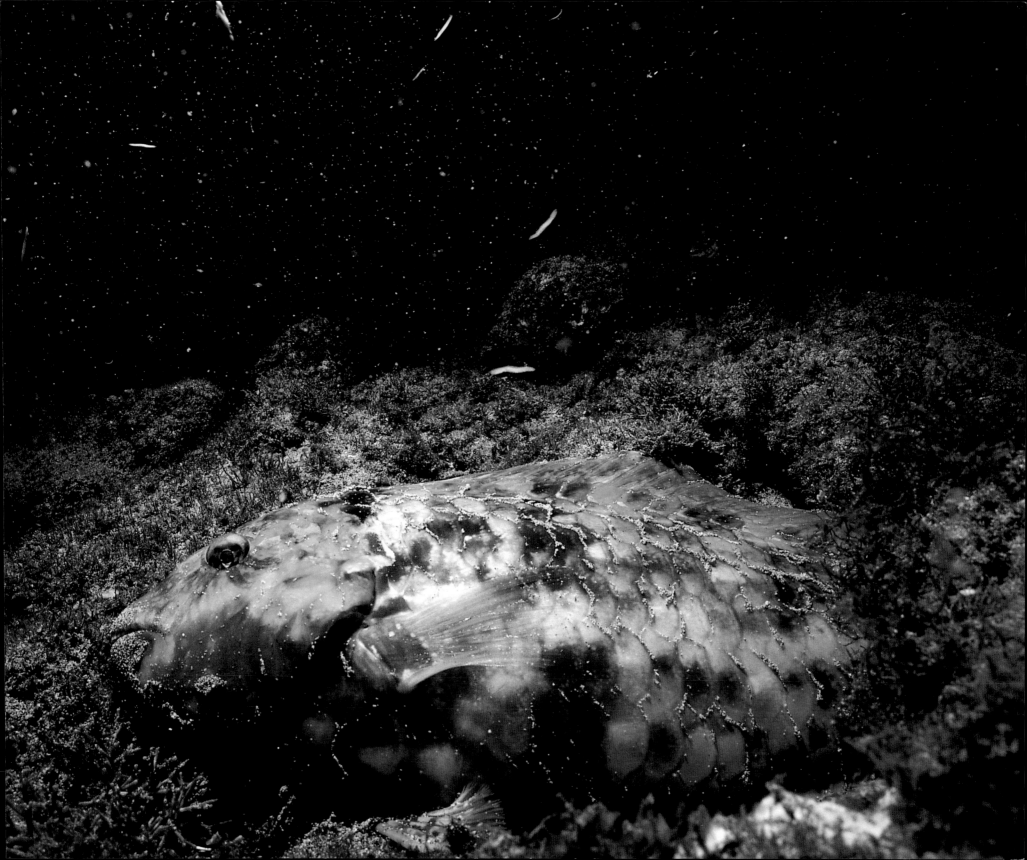

Even the daytime guilds that do have nighttime counterparts aren't always replaced precisely. The scores of silvery, red, or reddish-brown plankton eaters such as squirrelfishes, bigeyes, cardinalfishes, and sweepers that cruise the darkened reef do, to some extent, replace the diurnal guild of planktivores. But they are fewer in number than the daytime guild and don't scour the waters adjacent to the reef as thoroughly. Several other species, though they hide in the reef by day, migrate by night to nearby sea-grass beds and sandy areas to feed, so they don't replace diurnal guilds that feed on the reef itself. Perhaps because of the absence of visual cues, nighttime plankton feeders are less likely to form large schools than are daytime fishes, although a few species somehow do form aggregations, even in total darkness.

In addition, researchers who've looked closely at the diets of these fishes have found that their prey is usually larger than that of their daytime counterparts. A number of them—including certain species of squirrelfishes, groupers, and snappers—though nominally described as planktivores, are also fairly selective predators who rely on good night vision to find relatively large crustaceans and resting fishes.

Finally, the plankton itself is different at night. A substantial portion of the plankton in and around the reef after sunset often emerges from within the reef itself, rather than drifting in on onshore currents. Some of that nocturnal reef plankton is produced by the evening and nighttime spawning activities of corals, brittle stars, and other invertebrates who time the release of their eggs and sperm to avoid the dense concentration of hungry daytime mouths. Other nocturnal plankton rise from sandy areas in shallow water, and still other, larval and juvenile stages of reef invertebrates, hide in the reef by day and come out only after dark.

Night divers on the reef can see some of these nocturnal animals by setting out bright lights as "bait." Turn on a lamp, leave it in one place near the reef face for a few moments, and a thick cloud of dancing zooplankton soon fills the light beam and crowds up close to the lens.

Busy pumping water over its gills at night, this clam is undoubtedly taking full advantage of the absence of daytime fishes. Its shell is open wider than it normally is by day.

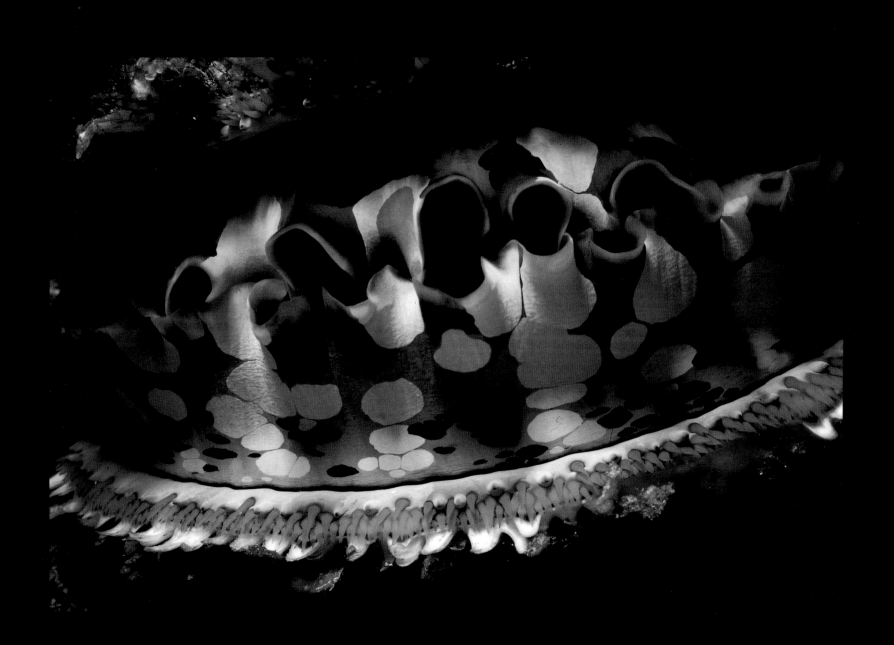

There are many gems in the plankton at night that only a handful of divers have ever seen. Finding them requires abandoning the relative safety and comfort of near-shore reefs for a completely different venture into the open water beyond. Offshore waters are the last frontier for many accomplished divers, and for very understandable reasons. The notion of jumping off a boat in the middle of nowhere in the middle of the night with the ocean floor as much as a mile and a half below the surface is enough to provoke a shiver of unease in even the most committed adventurer. If diving on the reef at night is unnerving, diving in open water can be positively terrifying. And the typical dive boat, though reassuringly large from a deckside vantage point, seems positively minuscule when it is the only safe haven in a vast, wine-dark sea.

Yet there is good reason for the truly curious to venture into this floating realm. This is where many nocturnal planktivores, such as sweepers and fusiliers, feed under cover of darkness. Here, too, live the young of many fishes and invertebrates, staying for weeks or even months, while making the metamorphosis from larvae into juveniles that ultimately settle on the reef.

This is also where many open-water plankton originate, to be swept later by winds and currents into the hungry mouths and tentacles of sedentary reef dwellers.

Finally, it is here, and at night, that all these animals meet the otherworldly fauna of the deep sea—a bizarre and outlandishly beautiful assortment of animals that rise from the depths to within a few yards of the surface each night. These tiny animals, though they often lack the well-developed nervous systems and eyes of higher invertebrates and fishes, nonetheless migrate daily over enormous distances. These migrations, though vertical rather than horizontal, are made for the same reason: to evade predators that cluster in the sunlit water near the surface by day. The problem is that these same sunlit waters are the only place where floating algae—the foundation of the planktonic food web—can absorb enough solar energy to function. Thus, large numbers of animal plankton, though they shun surface waters by day, brave the smaller number of enemies they contain by night to feed on a richer, more nourishing soup than they find deeper down.

The diminutive blue-ringed octopus, generally shy and secretive by day, is more adventuresome (and potentially more aggressive) after dark. Photographed around midnight on Australia's Great Barrier Reef, this specimen showed no inclination to tackle a photographer many times its size. That was fortunate, because these tiny octopi are among the few marine animals whose bite is backed by venom powerful enough to threaten humans.

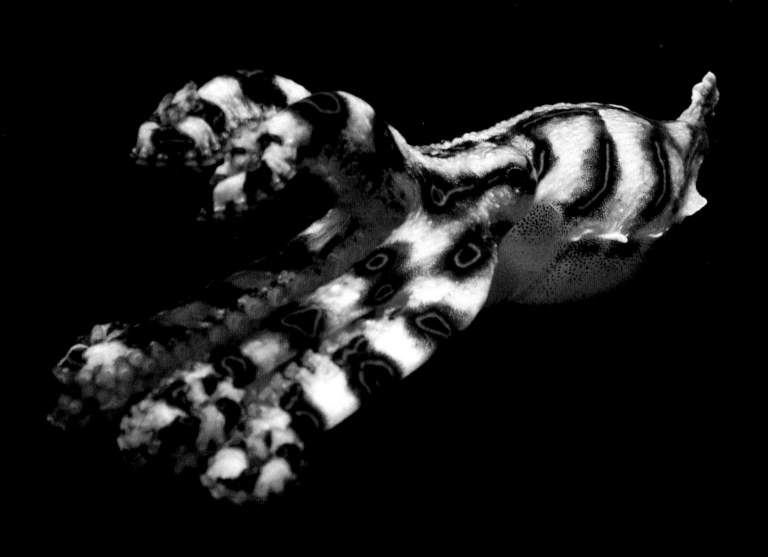

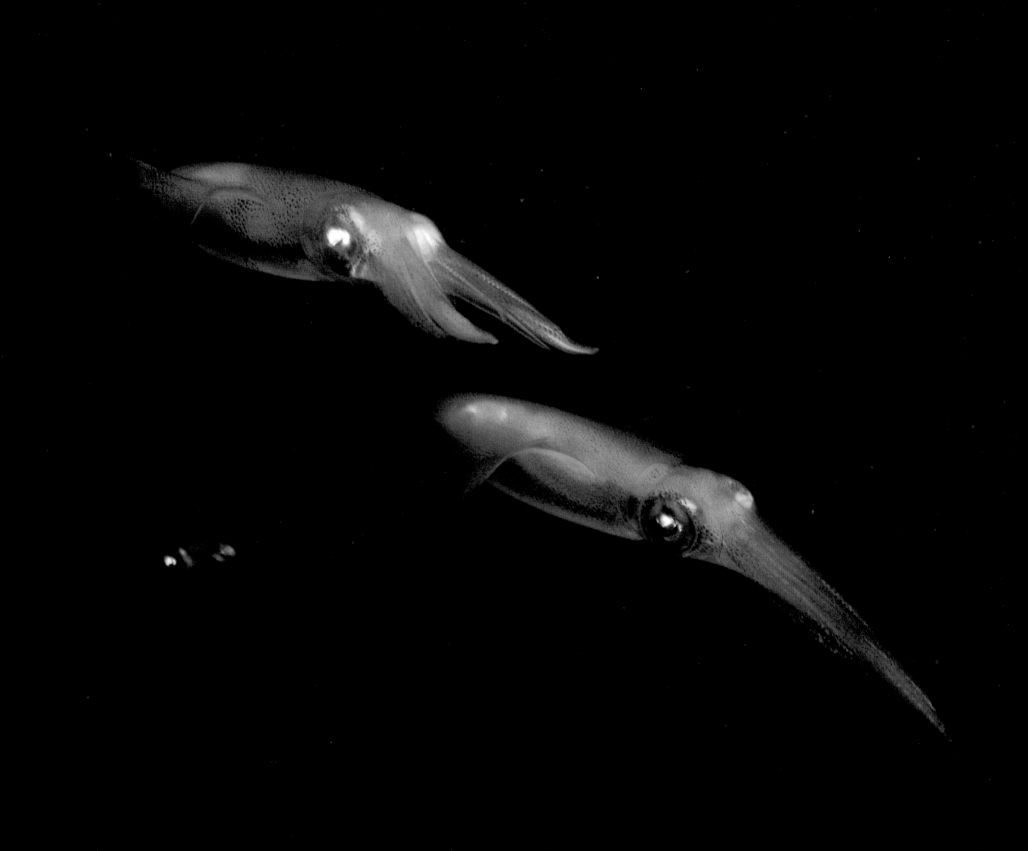

Learning about these animals by reading about them or even dragging them out of the sea with a net and watching them squirm under a microscope—as fascinating as that can be— doesn't come close to the excitement of actually swimming with them, seeing them float by, and watching them eat and be eaten. Part of that difference is the not-altogether-pleasant realization that by immersing ourselves in the world of those often translucent and sometimes bioluminescent drifters, we become like them, floating waifs more at the mercy of the sea and its dangers than most terrestrial organisms are used to being.

From a strictly logistical standpoint, the preparations for open-water night dives are straightforward, though time-consuming and expensive. A thoroughly dependable dive boat (with an equally dependable and knowledgeable captain and mate) is equipped with an onboard generator, a winch, 120 feet or so of stout cable, and a shark cage carrying one or more powerful underwater lamps. The purpose of the lamps is simple. Open-water plankton—types that normally live near the surface, that spend most of their time in the depths, and that migrate up and down on a diurnal cycle—are powerfully attracted to lights at night. As in the case of the reef plankton mentioned earlier, lights attached to the cage serve as bait for nocturnal animals— and, incidentally, allow divers to see them.

On, ideally, a moonless night, the boat is positioned for the dive in one of two ways. The more reassuring strategy is to drop anchor in a shallow spot upcurrent from a major underwater drop-off, and then to pay out enough anchor line to position the stern over the much deeper water. A bolder alternative is to take the boat far from land and allow it to drift freely with the current. In either case, the cage is lowered to a depth of between 25 and 120 feet, and the lights are switched on. Then, as the divers prepare themselves, the bait does its work.

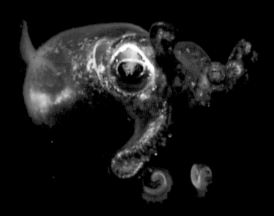

Among the sparkling and charming animals that appear in the blackness of open water at night are several species of open-water octopi (left and right), squid, and cuttlefish (following page). Some of these are juvenile forms of species that live more sedentary lives in more familiar places as adults. Others are miniature versions of their better-known relatives.

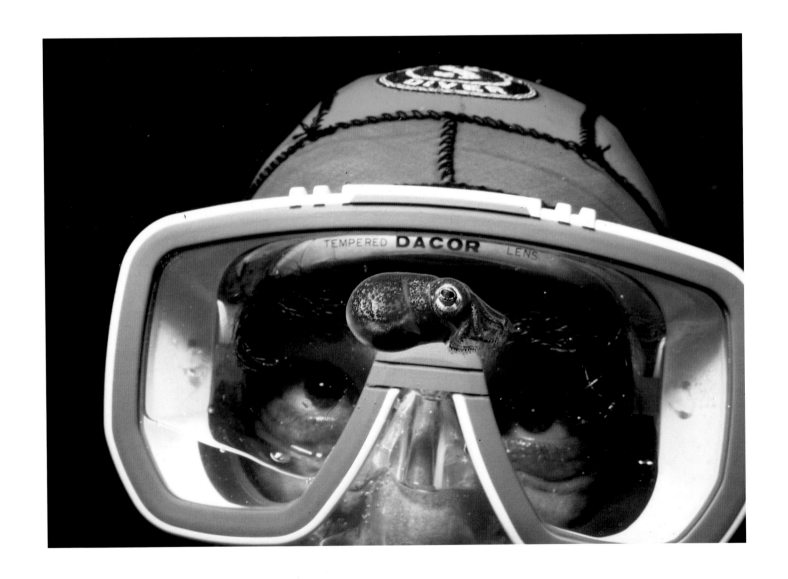

From on board ship, the cage and its powerful lights look almost unreal. The light radiating from the floodlamps forms a soft, ethereal blue hemisphere that punches down to a depth of 100 feet or more and fades horizontally in a circle reaching 60 or so feet around the boat. At the edges of the luminous region, light dissipates gradually into the utter blackness of open water. The cage seems to float at the center of that hemisphere of light like some strange sort of aquatic elevator stalled at the third floor.

It is worth noting that these distances are described as we humans see them and relate to the performance of our eyes, adapted to the intensity and color of light we see on land in the daytime. To the nocturnal eyes of fishes and other creatures, adapted to the sea and to the cool, blue wavelengths that travel farthest in clear water, that light appears many times brighter—and is visible at far greater distances. That reality is seldom lost on divers.

It isn't easy to take the initial leap from the comfort of the deck into the unknown. The ritual that accompanies the jump is as tense and as important as that of rock climbers checking ropes and belaying gear or skydivers inspecting parachutes. The direction and speed of local currents must be gauged, all diving equipment must be rigorously inspected, and buddy signals are rehearsed one last time. Finally, there's a single deep breath, a reassuring glance, and the "thumbs up." Then, in a splash of luminescent plankton, the journey begins.

It is soon apparent that swimming into and around the lighted cage feels a good deal less peaceful and much less soothing than the view from the surface might suggest. Shafts of light from the lamps, visible in the plankton-filled water like beams of light in a smoke-filled room, brighten the immediate vicinity of the cage but vanish down and out into total darkness. There is no hard, visible boundary between light and dark, no visual surface to define near from far, visible from invisible, real from imagined. There is instead only a soft, enveloping, mysterious darkness that continues effectively without limit in every direction except vertically, toward the surface.

The most prominent animals visible at first are what biologists refer to informally as "gelatinous plankton"—animals such as salps and open-water jellyfishes which, from a distance, resemble transparent cylinders or hemispheres of transparent jelly. Some of them are so small that they are barely visible to the naked eye. Others are larger but still almost invisible except from certain angles, because they are completely transparent. A few form long chains, six feet or more in length. These animals don't just look fragile, they are fragile; most are so flimsy that even the current from a hand waved in the water a foot away is sufficient to tear them to bits.

The ecological importance of gelatinous plankton has only recently been appreciated, because previous efforts to study them were futile. Because they are so delicate, any of them caught in traditional plankton nets are crushed and macerated beyond recognition. Not until a few daring marine biologists began diving at night in open water, observing and collecting these animals by hand in jars, were their true numbers realized. Those observations led to further studies showing that salps and their kin are far more numerous than previously expected, sometimes traveling in swarms that cover several square miles. They often use a mucus net to filter-feed on bacteria too small for other macroscopic organisms to eat and in turn provide food for other organisms ranging from small zooplankton to sea turtles.

As the lights continue to work their magic, other members of the plankton hover around the lights briefly before being swept past them by the current. After an hour or so, they often arrange themselves in concentric rings organized more or less in terms of size—and in terms of position in the food chain. Discovering a steady stream of these animals is exhilarating to connoisseurs of the novel and unexpected.

Immediately around the lights circle the tiniest drifters—minute shrimplike animals that seem mesmerized by the illumination. Around these smallest plankton roam larger animals, fishes ranging from about one to four or five inches in length. Some of them, on close inspection, turn out to be immature forms of familiar reef fishes, with eyes and faces proportionally larger than the rest of their bodies—the aquatic equivalent of doe-eyed puppies and small children. Other members of the plankton are diminutive open-water squid or shrimp, similar in general form to their shallow-water relatives, yet distinctly different, often wraithlike, and occasionally iridescent in the light beam.

This fragile and translucent pelagic octopus lives among the true deep-water plankton that spend their entire lives migrating up and down between night and day and drifting with the currents.

Still other visitors to the cage are animals normally seen only from deep-sea submarines—strange fishes, either goggle-eyed or blind, with jaws enlarged out of all proportion to the rest of their bodies. Few, if any, of these animals would be visible during daylight dives to the same area. Some—such as those that migrate up from the depths—simply aren't present in shallow water during the day. Others are too small, too translucent, and too scattered to attract the attention of human eyes. But at night, spotlighted and concentrated by searchlights, the entire planktonic menagerie reveals clearly the connections between reef and open sea. Ocean-borne plankton feed the adult plankton feeders of the reef, while larvae of reef fishes and invertebrates provide food for larger members of the open-water food chain. Like the lives of so many other ecosystems, that of the reef, neighboring mangrove and sea-grass areas, and the open water are intimately intertwined. Nowhere else are these realities so very obvious.

That can be a bit unnerving at times, for the behavior of planktonic animals can remind observers that ocean food chains are more than just abstract concepts. Try to use a flashlight beam to point out an animal of particular interest—a shrimp with a bright red sac of eggs or large reflective eyes, perhaps—and chances are you'll watch it be devoured in an instant. Single out any solitary creature, and its predators are likely to break in from their outer circle to swallow it before your eyes.

There are other reminders of that sobering reality as well. Schools of tuna and jacks occasionally appear at distances of ten or twenty yards from the cage, barely visible at the edges of the illuminated region. There these predators circle, dash at prey, and regroup, apparently at leisure. But then, suddenly, they bolt away and disappear from sight.

Salps are among the most unusual open-water animals and among the least known to marine biologists and the lay public alike. In fact, even oceanographers didn't know until just over a decade ago that these animals are both numerous and important members of the plankton. Why? Because they are even more fragile than they look. Collected in plankton nets, they decompose into an unrecognizable mass of mucus and jelly. Many salps are magnificently iridescent when seen in strong light and brilliantly bioluminescent when seen in the dark. This chain is actually a colony composed of dozens of individuals linked together.

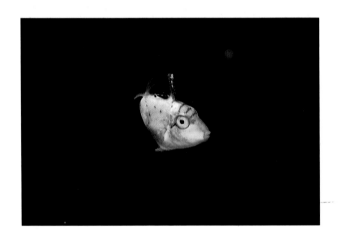

Many fishes spend at least part of their lives as larvae and juveniles, drifting, feeding, and being fed upon as members of the plankton before taking up life in their normal adult habitats. Some of these, like juvenile triggerfishes (far left) are easily recognizable by their resemblance to distinctive adults, while others (above and following pages) can be identified only by specialists in fish larval development.

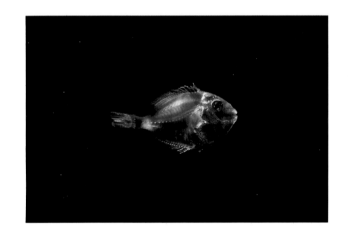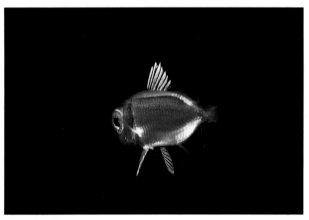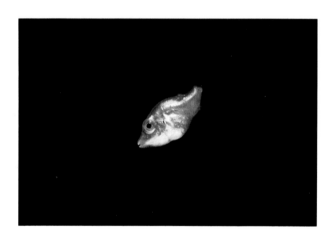

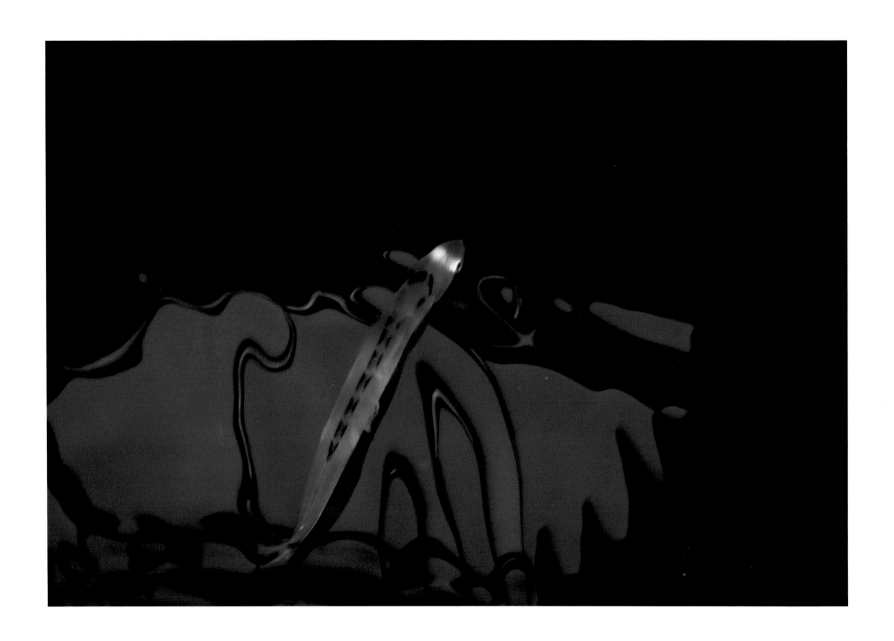

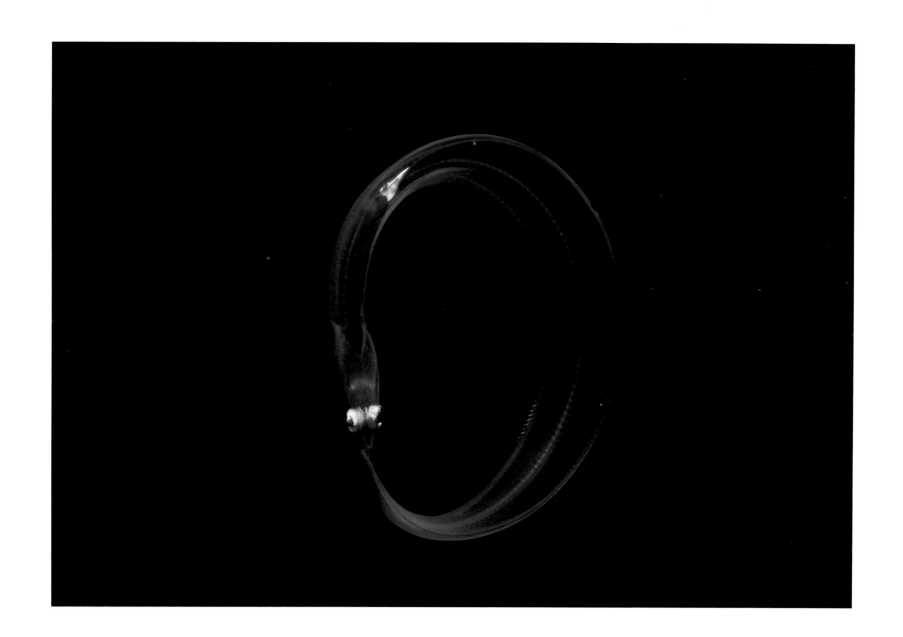

It is difficult for divers in this situation not to wonder why these sizable fishes, some of which seem nearly as large as humans, flee so abruptly. Who—or what—might have frightened them? It can be hard, at such moments, for divers to put out of their minds how visible they are, brilliantly illuminated by floodlights shining above them. It is only human nature to imagine the presence of still larger predators, circling and hunting at still greater distances, themselves unseen beyond the boundaries of human vision, but easily able to see the wet-suited figures hovering in their world.

The final scene in the nighttime drama of tropical seas is played out at dawn, a time that evokes quite different associations for humans than dusk. To most of us, the former brings promises of relief at the end of the workday; the latter signals the beginning of toil. One seems gentle, romantic, and welcome, the other harsh, practical, and necessary. Of course, to people who work the night shift, those associations may be reversed; sundown, for all its glory, means drudgery ahead, while dawn means a large meal and a chance to sleep.

Viewing twilight on the reef, we are outsiders. Our detachment lets us see clearly that, in this part of the natural world at least, dawn and dusk are very much mirror-image phenomena. For during dawn, the events that occur at dusk reverse themselves, often in reverse order.

In the last few moments before dawn, while the sky is still dark, the water is still pitch black. Yet most nighttime predators—last to rise and the first to retire—seem to feel the day coming, for they have already started slipping back into their holes. There are, scattered around the reef, a few straggling soldierfishes, squirrelfishes, and groupers who, after a night on patrol, look like nothing so much as half-dazed night watchmen awaiting the end of their shift. As these groggy worthies retire, the nighttime wanderers return—grunts, sweepers, and others—first milling about near their resting places and then heading for cover as the water brightens.

Slowly, steadily, the day shift begins. One or two at a time, parrotfishes in fraying mucus cocoons stir fitfully. Soft corals, which have been grazing through the night with polyps fully expanded, seem to melt like wax as the first beams of sunlight penetrate the water and strike them. Pulling in their polyps, they pump water

out of their flexible bodies and shrink to a fraction of their nighttime size. Hard corals also pull in their polyps, though somewhat more reluctantly. Sea lilies, too, wilt as light hits them, pulling in their feathery arms and skulking down into hiding places. Acting as though chastened, driven, even cursed by the sun, they evoke the images of witches retiring after Walpurgisnacht on Bald Mountain.

Still, precious few fishes are to be seen anywhere, as the dawn equivalent of the quiet period slowly passes.

Then, individual events gather momentum. A few fusiliers at a time, then dozens, then hundreds, return from off-reef feeding forays and—instead of retiring, like the sweepers—cluster near the reef crest and swarm around coral heads in huge numbers. At the outset, twilight predators launch another round of strikes, impressive for both their vigor and their intensity. Jacks, in particular, work the fusilier schools, constantly surrounding them, swooping in and out among them, attempting to corner them near the surface.

At first the jacks manage to feed repeatedly, snapping up meals in gulp after gulp. But as the water continues to brighten, the prey detect them sooner and evade them more efficiently.

By the time the sun has actually risen, the jacks are reduced to their daytime games, worrying the fusiliers with passes that the school evades with the grace—and apparent ease—of figure skaters carving arcs in clean ice.

It doesn't take long before the rest of the reef responds to the welcome light of day. Within fifteen minutes, its face is transformed. Daytime fishes stream from their hiding places. Still wary, and still a little drowsy (they would probably be blinking and rubbing their eyes if they had either eyelids or hands), they restrict their forays to a layer no more than a foot or two deep across the face of the reef as they take stock of their condition and surroundings. The entire daytime fauna, thus squeezed into a fraction of the space it normally occupies, produces a swarming mantle of life that seems all the more vibrant and alive in contrast to the monochrome emptiness that preceded it.

Then, slowly, with increasing speed and confidence, butterflyfishes and angelfishes, damselfishes and wrasses, begin to make forays to greater distances. Pairs re-form. Schools take up residence. Territorial boundaries are reclaimed. The familiar daytime reef is back in action.

CHAPTER FOUR DIVING AT NIGHT

The better part of valour is discretion.

William Shakespeare, **Henry IV**

No experience on land can prepare you for the sensations of night diving in a tropical sea. You can wander though local woods in the dark, listen to rodents rustling in the underbrush, and strain to spot owls hooting in overhead branches. You can stalk through tropical rainforests with a flashlight, savor the fragrance of night-blooming orchids, and search for elusive nocturnal mammals.

Illusions of light and shadow notwithstanding, the nighttime sights and sounds of forests, fields, and streams are not all that different from their daytime counterparts. Trees look the same. Bushes don't stop acting like plants and begin to dance around or try to strangle one another. And even if you find yourself skipping nervously through the darkness whispering, "Lions and tigers and bears! Oh my!," your feet are on the ground, you are breathing air, and—fantasies aside—you have a reasonably good idea of what is and isn't stirring around you.

Familiarity with the sea doesn't prepare you, either. You can study marine life for decades, experiment with plants and animals in the laboratory, and even dive to observe them in the wild by day. But if you visit the reef only during daylight hours, you become accustomed to tropical sunlight streaming down from overhead.

Judicious use of flashlights reveals many treasures on the darkened reef. This footlong Spanish dancer moves slowly enough to permit close observation.

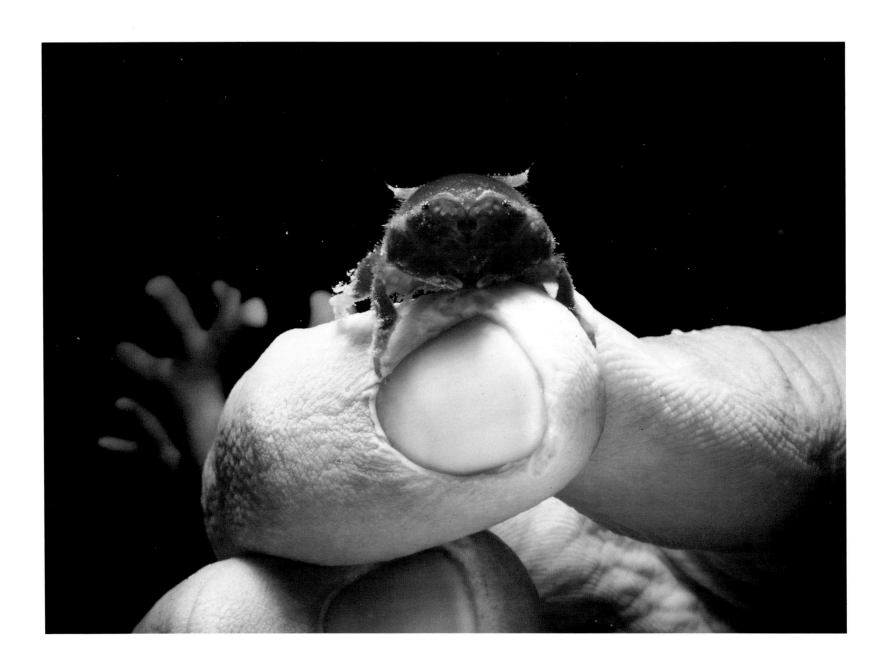

Leaving the safety of their daytime refuge, many delicate and vulnerable crabs become relatively fearless at night, crawling widely across the reef in full view.

Rippling reflections of the sky at the surface remind you constantly just where that surface is, and a surprising amount of light is reflected and refracted by water, sediment, and plankton. Much of that light bounces to your eyes from all directions, illuminating the depths into which the reef wall plunges and emanating from shallow water all around you with an inviting, reassuring, blue glow. Potential handholds on the reef nearby are conspicuous. Excellent visibility offers the reassuring (though illusory) impression that nothing can sneak up on you unseen.

In the ocean by night, on the other hand, things are both very different from everyday reality and very real indeed. As a properly equipped diver, you float freely in a weightless state in an alien medium. Without the sun overhead, the distinction between up and down becomes a concept rather than a reality; only rising air bubbles from your regulator (and increasingly befuddled signals from your inner ear) remind you of where the surface might be. Outside the beam of your underwater flashlight, you can see virtually nothing—and what your flashlight does reveal tells you clearly that you're not in Kansas anymore. Even if you know the reef by day, everything—from fishes to invertebrates to plankton to corals themselves—is totally transformed by darkness. And this transformation is real.

Even experienced divers admit (in private, at least) that the thought of the unfathomable darkness beside them makes them uneasy. For as comfortable as any of us are on the sunlit reef and as adamant as we are in denying the existence of things that go bump in the night, we can't help but wonder who (or what) might be lurking in that vast obscurity, and whether "they" might be attracted to the lights gripped tightly in our gloved hands. Instinctively, we hug the coral wall along which we'd turn cartwheels with near-abandon by day. Familiar landmarks seem much further apart, the surface seems much farther away, and the depths seem infinitely more boundless—and intimidating.

Yet despite any anxiety that darkness may cause, the story of the nighttime reef isn't all—or even mostly, or even largely—about fear. Once, some years ago, a popular science magazine ran text and photos we assembled on the subject under the banner "Night on Terror's Reef." Now that's scientific yellow journalism! Nothing could be further from the truth.

My first night dive is still fresh in my mind, two decades later, although diving wasn't new to me at the time. As a marine biologist in training, I had been sport diving since I was thirteen, and had used scuba in field studies for more than three years, nearly always in the tropics and usually on coral reefs. I had even made several dives in sandy areas of the Red Sea at twilight, so I thought I had a reasonable idea of what to expect. But I had never visited a full-fledged reef at night.

In several ways, both the setting for the dive and our mental and physical preparation for it were ideal. Our Sinai Peninsula expedition, led by Eugenie Clark, internationally known ichthyologist and shark researcher from the University of Maryland, was camped at the oasis of Dahab. That was several years before Dahab became the diving resort it is today; we slept in palm-thatched huts on the beach, shared what passed for a latrine with the local camels, and had to bring in our own water—not to mention compressed air—from elsewhere.

By the time our group of half a dozen decided to venture into the water after dark, we had been spending at least four hours a day diving along the magnificent fringing reef that bordered the oasis. We were mapping coral formations for scientific studies and conducting visual surveys of resident fishes, so we knew the layout of the reef very well. Its table rose to within a yard of the water's surface, its fore-reef slope tilted steeply into deeper water, and its seaward edge was a precipitous drop-off that plunged into several hundred feet of water.

As scientific observers, we had been trained to pay close attention to the physical parameters of the reef environment, so we were also well acquainted with local water currents. Because we had been diving regularly, we were all intimately familiar with our personal dive gear; we knew just how our regulators felt, just how to manage our weight belts and buoyancy-compensating vests, and just where our watches, diving knives, depth gauges, and snorkels were located on our bodies—without needing to look for them. We also knew our diving partners well enough to trust them and to understand each other's strengths and weaknesses as divers.

Most easily spotted when out and about at night, these "decorator" crabs minimize their visibility by tearing off bits and pieces of their surroundings and sticking them onto their bodies.

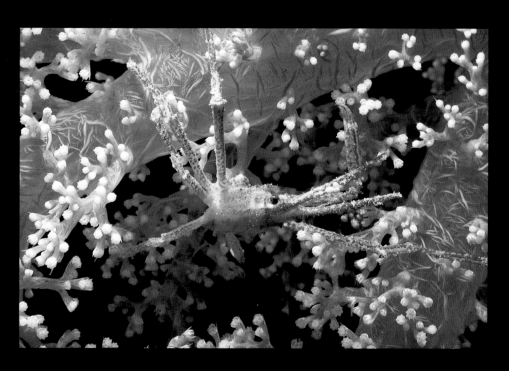

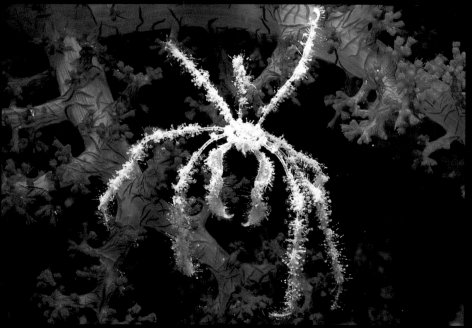

Access to the reef at Dahab was as simple and as safe as we could possibly hope for. The main reef was only about twenty yards from shore and ended just north of a sandy strip of beach that it protected from heavy wave action. We could, therefore, suit up at leisure on that beach, walk in to waist-deep water to don our masks and flippers, and calmly and easily check out each other's equipment and inspect our diving lights. Then, when we felt ready to dive, we could follow a familiar route we had taken scores of times in daylight, swimming around the edge of the reef and out into deeper water above the precipitous drop-off.

Even though Genie had been diving at night many times before, the rest of us were nervous—and appropriately so. Though we were young, confident, well-prepared, and in good physical condition, we were seasoned enough in the ways of the sea not to take anything for granted. We were also acutely aware of the fact that if anything untoward happened, we had no telephone or radio and were at least three hours from the nearest regional hospital in southern Israel, near Eilat. We were farther still from anything resembling a proper decompression chamber. So we proceeded slowly, stuck close together, thought carefully about every move,

and ventured no deeper than about fifteen feet. We had a spectacular adventure that included sighting *Photoblepharon*, foot-long Spanish dancer nudibranchs, an octopus, scores of sleeping fishes, and countless sea lilies and brittle stars.

The success of that night leads me to suggest that divers contemplating night trips of their own should try to duplicate the positive aspects of those conditions as closely as possible. Of course, the elements that contributed to a safe, successful night dive, elements I thought had fallen naturally into place at the time, had been carefully orchestrated by Genie. (Her young son and teenage daughter were members of the group, after all. Though an adventurer herself, she would hardly endanger the rest of us.)

You will note that I've taken a very personal approach to this chapter, using the first person singular for the first time since the introduction. The reason is simple: Night diving is a very personal experience that carries a special excitement, in part because it offers an acid test of your diving ability. If you can honestly say that you are comfortable underwater at night, you are saying indirectly that you are a truly seasoned and accomplished diver.

A school of juvenile jacks is attracted to light radiating from the powerful floodlamps on a shark cage. Schools of mature jacks occasionally appear ten or twenty yards from the cage, barely visible at the edges of the illuminated region.

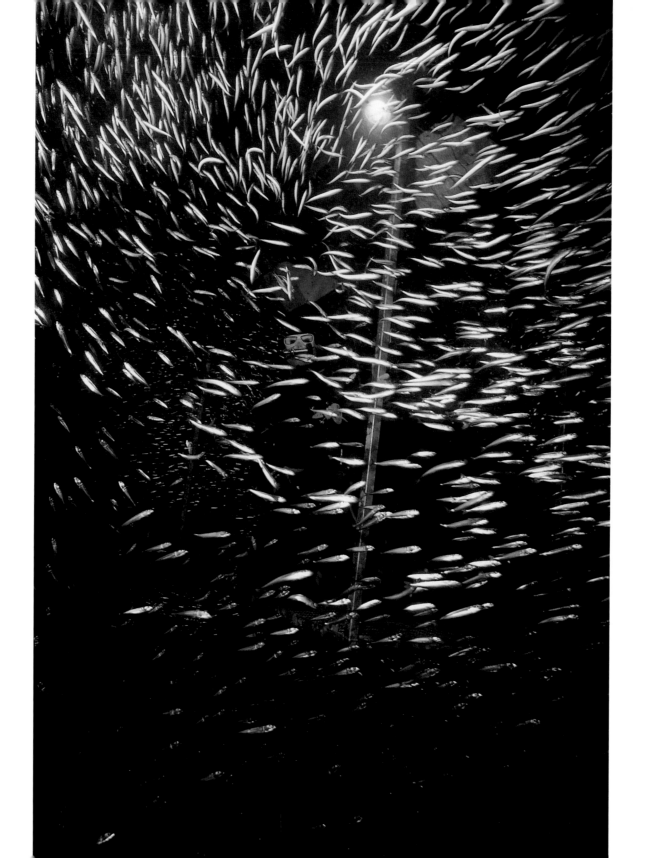

But diving at night, like cave diving or diving in blue holes, blends exhilaration with fear and mixes thrills with risk. If not done properly and with the amount of respect and caution it deserves, night diving can be dangerous. That means a lot to me, because I am among those divers who have lost friends because they got a little too cocky for their own good underwater. Those lost divers weren't stupid, but they thought they were above the rules of diving safety. Each of them took one dive from which they never returned. That may sound overstated, melodramatic, and corny, but it's the truth.

I will never forget the day in graduate school when the director of the marine science program called us together to announce the death of a fellow student in a diving accident. That budding biologist, unable to find a diving partner to accompany him, had decided that his ongoing experiment needed attention anyway. He dove alone in late afternoon, in shallow water, in a spot he'd known for years—a fairly well-visited spot not far from a university marine laboratory. Somehow, he got caught in one of his own buoy lines. The rope wrapped around him in a way that apparently prevented him from using his diving knife to cut himself loose. A search team found him—still tangled in the buoy line—several hours later.

The announcement was all the more tragic because this particular tragedy was totally preventable; if that young man had followed proper diving safety precautions, he would still be with us. And that was only the first of three would-have-been biologists of my acquaintance who have died during fieldwork of one kind or another.

That's why I want to present this information in the first person. I don't want to sound like a know-it-all who has decided to drop a few pearls of wisdom before you. The advice Jeff and I offer here is advice we follow ourselves. To the letter. All the time. Because as much as we both love diving, we also love our families and the lives we lead. To our minds, encouraging people to visit the reef at night without offering proper safety tips would be irresponsible and unethical.

So please, any of you who choose to dive at night, read and follow our advice carefully.

Sandy areas near the reef are the preferred home of electric rays, which spend much of the day half-buried on the bottom. Come nightfall, however, they roam more widely, often swimming freely through the water as seen here.

BEFORE YOU DIVE AT NIGHT

Experience: It goes without saying that you should be comfortable underwater in the daytime before you venture out after dark. In this regard there is no substitute for experience, practice, and refresher dives for people who indulge in dive vacations only once or twice a year. All the major American diving organizations (YMCA, NAUI, PADI, and NASDS) have begun to offer special courses in night diving. Take one. In addition to knowledge that will help keep you safe, the instruction will give you the confidence you need to enjoy your adventures to the fullest.

Know Your Limits: When thinking about night diving, pay careful attention to your limits in all respects—endurance, tolerance of water temperature, and depth.

Be certain to get enough rest before you head out, especially if you are making a night dive as part of an extended diving vacation. Getting up in the middle of the night to go diving does not come naturally to most of us, and spending several hours underwater takes a greater toll on the body's resources than many people realize. If you are exhausted from daytime exertions (or from evening partying) you will feel stressed and uncomfortable before you even start your dive.

Be sure to keep warm before you suit up. Even in the tropics, the night air out on the water can be chilly—especially when you are wet, and especially if there is an onshore breeze. If you get chilled before you enter the water, it will not be easy to warm up during the dive. By the same token, have warm, dry clothes ready for your return.

Be extremely cautious about diving deep at night. The dive tables that govern dive depth, duration, and repetition to avoid the bends are, of course, the same at night as they are in the daytime. The amount of gas under pressure that dissolves in your blood over a given period of time depends only on the immutable laws of physics. But nitrogen narcosis—that strange, disorienting, mildly drunken feeling brought on by the effect of dissolved nitrogen on the nervous system—is a phenomenon of the mind that has both physical and psychological components. And that makes it another matter entirely.

Most of us are more susceptible to nitrogen narcosis at night than we are in the daytime. Why? I can offer several possible explanations here. First, our bodies have a variety of daily

rhythms that both involve and affect mental and physical activity, hormone levels, patterns of food digestion, and so forth. Diving at night puts you underwater at a different point in those cycles, even if you aren't noticeably tired. Fatigue stacks the deck further. In addition, most of us are more anxious about night dives, so we start off in a different psychological state. Finally, the surrounding blackness—in addition to being exciting and challenging—can also be unnerving and disorienting in ways that we might or might not recognize consciously. Together, these factors can cause you to react differently to the same amount of dissolved nitrogen in your bloodstream. Often, they cause the sensations of mild narcosis to begin in shallower water at night.

Now, many divers brag about being comfortable while diving deeper than they should. I have done so myself. I pride myself on knowing in advance how deep I can go before narcosis significantly affects judgment or thought processes. But I also know that narcosis doesn't suddenly begin at a specific depth; its effects begin slowly, unnoticeably, and build as you go deeper. If you were to take a simple test of mental skills while sitting on the beach, and then repeated an equivalent test at a depth of forty feet, you would see a difference in your score. And I know that, personally, though I might not notice that difference in mental state by day, I might well be aware of it at night.

As a recent example, I can point to one of the dives Jeff and I took while working on this book. It was made a couple of hours before dawn, after a previous dive earlier the same night, following hard on the heels of three previous nights of intensive and tiring diving. We headed slowly and steadily down to about ninety feet. Soon after we reached that depth, I felt acutely mentally uncomfortable—far more uncomfortable than I have ever felt during a daylight dive. I therefore headed slowly and steadily back up to around seventy-five feet. After a few moments' equilibration, I could descend back to about eighty-five feet—but no deeper. Now remember that I have been diving for more than twenty-five years and night diving for twenty.

On the positive side, remember, too, that you don't need to go deep at night to have a spectacular dive experience. During that first night dive of mine, I went no deeper than fifteen feet—and had enough fun to get hooked for life!

Choosing Dive Partners: Always dive with a buddy. Because of limited visibility at night, it is important to dive with a single buddy you can stick close to; it is hard to keep a larger group in tight formation. If you must dive with more than a single partner, be certain to divide up into pairs. Always know from the start who your buddy is, and agree in advance to stay within two or three yards of each other. As is the case with daytime dives, the buddy should be someone with whom you can agree on a preferred style of diving: slow or fast, deep or shallow, adventurous or conservative, and so forth. For night diving in particular, your buddy should be an experienced diver whom you know and trust—both personally and in terms of diving skill. This is no time to get to know someone or to induct a novice! And if, for any reason, you lose sight of each other, surface immediately.

Dive Preparation and Planning: For your first experience, you should probably join an organized junket with a dive shop or resort operation. Those folks will have the necessary extra gear for night diving, will know the best locations, and (one hopes) will supply experienced and professional

dive masters to supervise the operation. Although this isn't the best way to see everything there might be to see, it is certainly the safest and most comfortable way to get your feet wet.

Once you have advanced to the stage where you feel ready to go it on your own (with your buddy, of course), here are a few things to remember:

Select a dive site that you know well and that offers easy access. Jumping off a boat is the easiest and probably the safest way to enter the water at night. Clambering out from shore over a reef in surf is both the most difficult and potentially the most dangerous route. It is hard enough to see where you are putting your feet in the dark on a calm night; wave action makes that nearly impossible, and surge will continually threaten to knock you over. A good middle ground would be either a reef that ends conveniently near a sandy patch (such as that reef in Dahab) or a reef with a quiet lagoon and an easily locatable break in the reef crest that allows you to pass through far enough below the surface to avoid the pounding of the waves. Alternatively, hire a boat with an experienced captain who is competent at navigating around reefs in the dark.

Cuttlefish (right and following page), like many other animals that are able to swim more quickly than humans, are more easily approached at night, when they can actually seem quite tame. Though not able to change color as completely or as dramatically as their cousins the octopi, they are fascinating to watch as they hover effortlessly.

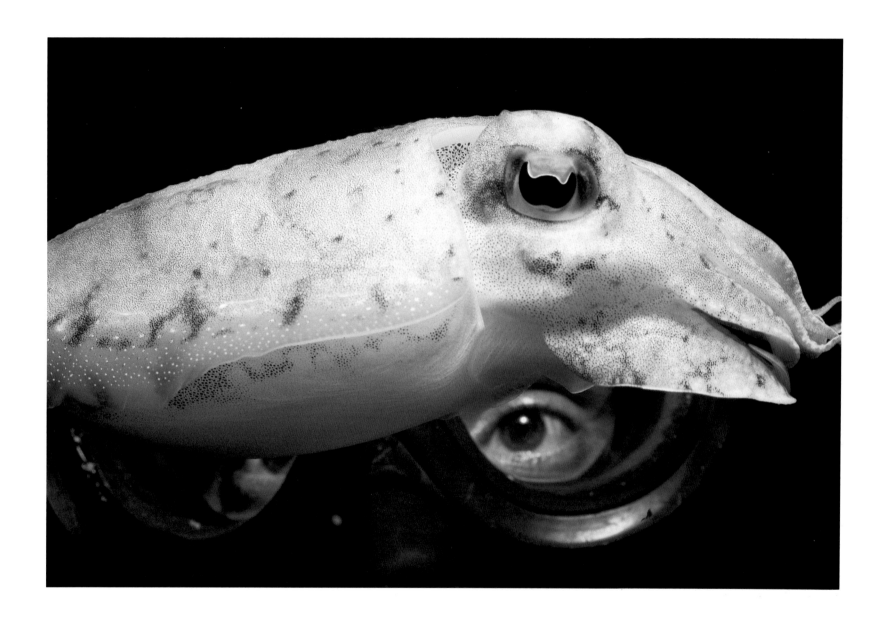

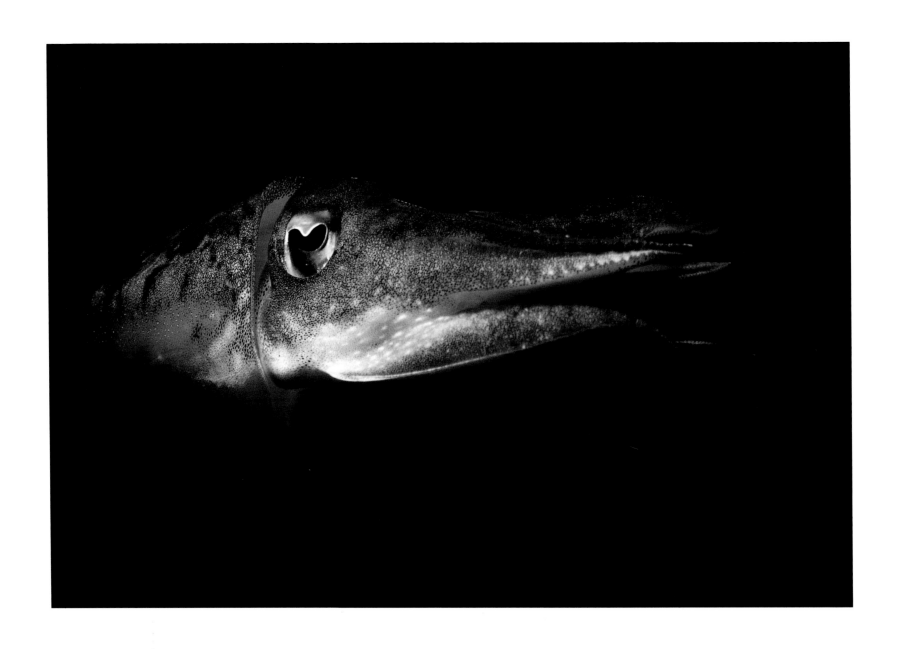

In any case, make at least one, and preferably several dives along your intended nighttime route by day. In so doing, remember that everything will look different after dark; distances will seem greater, visibility will be more limited, and your desire to know where you are will be strengthened. Keeping that in mind, try to find along the way a succession of landmarks within a few yards of one another. Remember that a promontory you can just make out in the distance by day will be completely invisible at night.

As you lay out your dive route and plan for time and depth, remember to leave yourself an extra few minutes' worth of air. The added excitement of diving at night makes most of us breathe a little faster and heavier, and you don't want to be caught short.

To avoid being swept away in the dark, be certain to learn as much as you can about winds, tides, and currents around your dive site. Of course, every dive site differs in these respects. In the Gulf of Aqaba at the northern end of the Red Sea, tidal fluctuations (and therefore tidal currents) are minimal in most locations. In some spots, though, water currents driven by seasonal winds can be quite strong. And powerful winds can spring up out of nowhere in the middle of the night over the course of less than ten minutes, raising surf and creating currents that don't exist by day.

In other places—notably, in narrow straits or channels between reefs that make particularly good dive sites—the situation is exactly the opposite: Winds may not amount to much, but tidal currents may be fierce.

Equipment: In addition to standard equipment, each diver should carry:

· A bright-colored, highly reflective buoyancy-compensating vest.

· Two underwater flashlights with wrist lanyards. These should be small enough to be held comfortably in one hand and designed so that they can be switched on and off easily. One of these you will use most of the time; the other is a backup. The beams they produce should be bright enough to allow you to see but dim enough that they don't send light-sensitive marine life scattering in all directions.

· A chemical glow-in-the-dark light-stick of any reputable brand. These devices, which work much like the fluorescent necklaces often sold at outdoor concerts these days, light up when you break an internal container to mix two sets of chemicals. (Remember luciferin and luciferase?) The result is a bright yellow-green light that lasts for an hour or more and is highly visible at night. Nice to have on hand in case of an emergency.

Nearly anyone who has snorkeled along a tropical beach is familiar with the big greenish or black animals aptly called sea cucumbers that crawl around in full view on white sand bottoms. But another group of these fascinating animals — which are related to feather stars and starfishes — are more reclusive and are seen mainly at night. Some simply are a bit more conspicuous at night, rearing up rather like short, stubby snakes in the sand to perform what has been described as a mating dance (left). Others, more usually found on the reef, are quite slender and can reach lengths of up to a yard (right, draped over sponges). These can be seen wandering about to feed from sunset to sunrise on the reef itself.

Each buddy pair should carry:

- An inflatable, fluorescently colored emergency buoy. These handy, compact tubes fold into packages small enough to store comfortably in a diving vest pocket. Inflated, they form a cylinder a yard or so in length that will be visible for some distance, even in fairly choppy water. We've never had to use ours but felt better for having them with us.

- A good-size, bright, underwater lantern with a wide beam. Ideally, you shouldn't use this one too much or too often, but it's nice to have one along if you need it.

- An underwater compass. Darkness is extremely disorienting underwater. If you plan to cover any distance over open water or to wander among patch reefs more than a few yards apart, learn how to use a compass underwater, and carry one with you.

Getting Dressed: Don your gear slowly, carefully, and methodically. Even if you are not generally meticulous, dress neatly. Every piece of essential equipment should have its specific place on your body. Know where all your equipment is well enough that you can find it by touch alone in total darkness. When and if an emergency arises, familiarity with your equipment can mean the difference between life and death.

Dark Adaptation: Because you want to make do with as little light as possible during the dive itself, you need to prepare your eyes to function in dim light. Remember that it will take your eyes a little more than twenty minutes to make their major adjustment from bright light to dim light. (Your entire visual system continues to adapt in subtle ways for some time after that.) You want your eyes and brain to make their adjustments before you get in the water, not afterward. So if at all possible, plan to get dressed in subdued light to prepare your eyes. Once you are in the water, never shine a light in your companion's face.

Crinoids are among the most striking of the animals that, while actually quite common on many reefs, are seldom (if ever) seen by most divers because of their strictly nocturnal habits. On Red Sea reefs they are absolutely invisible between dawn and dusk, although in deep water off Borneo, some of them are out and about during the day.

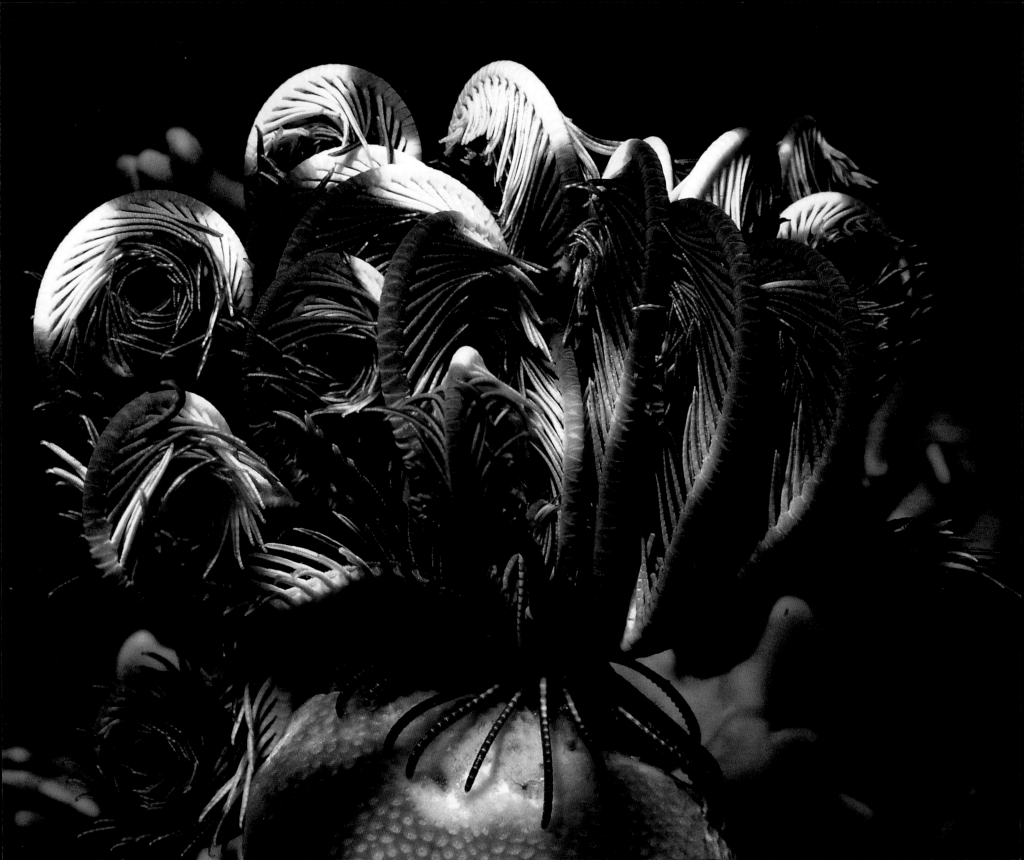

Don't Tread on Them: As you may have noticed during our description of animals active during twilight and darkness, some of them are not the sort that you would want to rub elbows with, literally or figuratively. Some are just a nuisance, some can cause painful problems, and some are downright dangerous.

• Sea urchins: Because they are considered delectable by many diurnal fishes, most sea urchins make themselves scarce in the daytime. Because they prefer to stay hidden beneath coral ledges or wedged in spaces between piles of coral rubble, they are often hard to find, but are also not wandering around where you can accidentally bump into them. At night, however, most of them come out to graze on algae. Sandy areas in reef lagoons that you could safely walk across barefoot by day can look more like minefields studded with long-spined urchins by night. So don't assume that a route you have scouted by day will be clear after dark. Keep your eyes open, especially if you walk into shallow water to finish suiting up. In addition, on a Pacific reef, you may encounter a few species of nocturnal urchins covered with truly venomous spines. These can be much more than a minor inconvenience, so take extra care when edging close to the surface of the reef.

• Scorpionfishes and stonefishes: These venomous animals are not out to get you, day or night. But after dark, several species do tend to hang out in more exposed locations than they choose by day. Take it from someone who nearly cut his life short by sitting on a superbly camouflaged stonefish: Don't step on, sit on, or brush against any questionable surface without investigating it closely first.

• Miscellaneous venomous animals: Stingrays, like several other venomous creatures that live on the bottom, would never attack divers unprovoked, regardless of the time of day. But some of them might well be slower to move out of your way at night. If you step on them accidentally, both you and the trod-upon will regret the encounter. Cone shells of several species are also harmless to humans—unless handled. Several Pacific cone shell species can give a nasty sting with the venom-tipped harpoons they normally use for hunting fishes. A few species carry venom toxic enough to be really dangerous. Though the venom itself might not be fatal, it can cause pain and/or convulsions severe enough to incapacitate even an expert diver. If you don't know these animals very well, leave them all alone. (You shouldn't be collecting living seashells anyway.)

Sharks, the ocean predators most feared by swimmers and divers, are much more of a threat to their normal prey—relatively small fishes—than they are to larger-than-bite-size humans. Twilight predators par excellence, sharks are guided by a keen sense of smell that can home in on wounded animals from great distances downstream. Their eyes, much maligned yet quite functional, help guide their strikes at intermediate ranges. At extreme close range, they rely on a remarkable ability to detect minute electric currents created by the breathing and muscular movements of their prey. And then, of course, there are the teeth. As shown here, the teeth of many sharks are produced continuously, one after another in rows. Normally, outer teeth become worn and fall out during the course of feeding, to be replaced by new ones from inside.

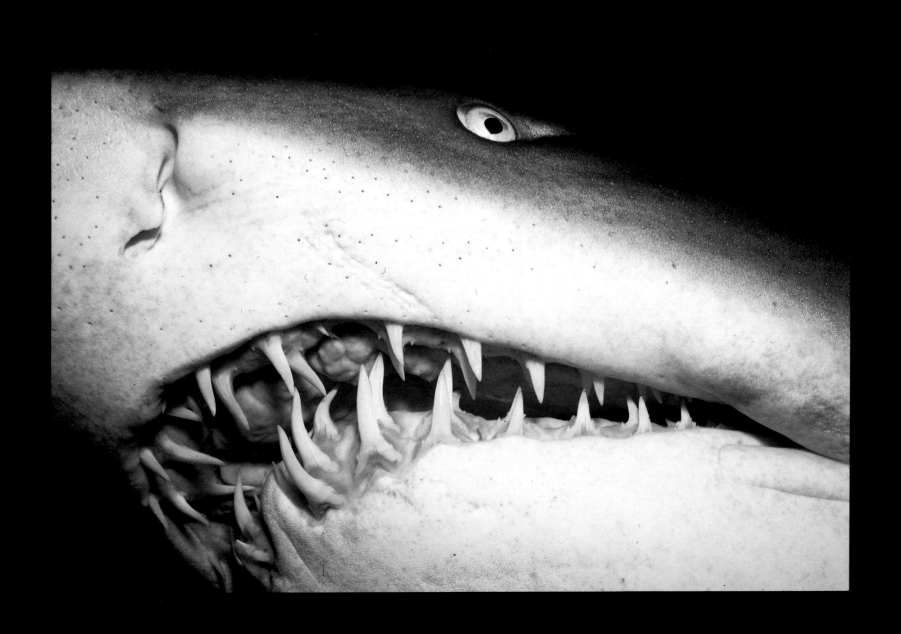

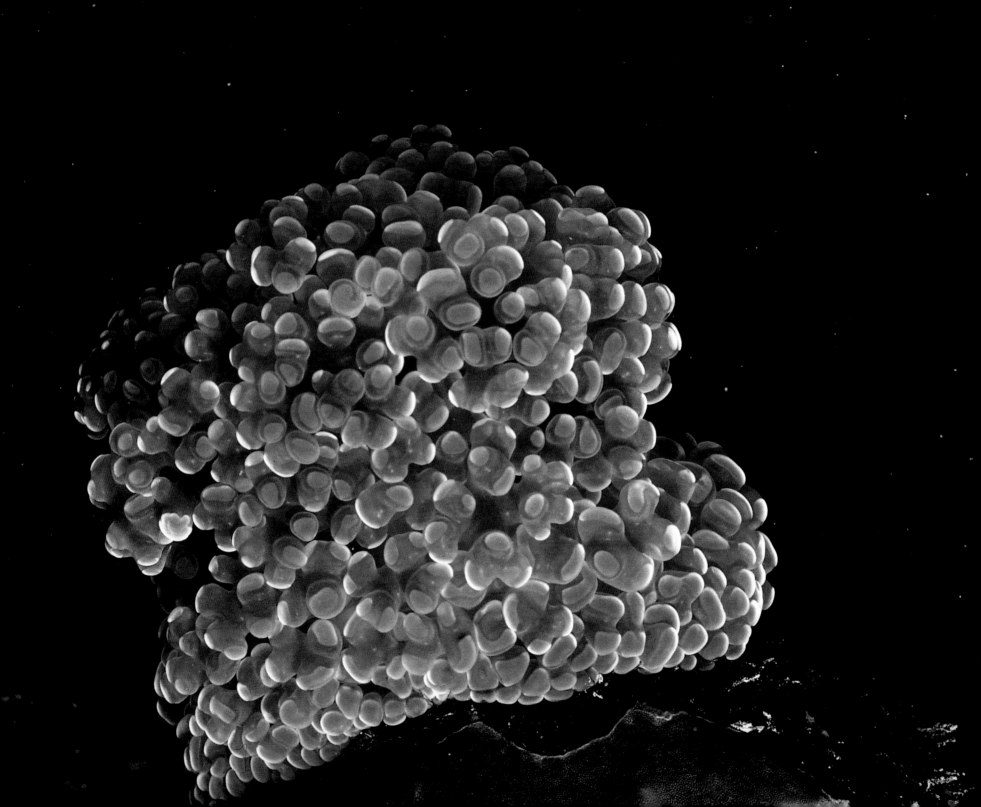

This anemone, among the few Indo-Pacific species with stinging cells powerful enough to seriously hurt humans, spends most of the day withdrawn into a coral crevice. At night it is more exposed, and can give a wound as serious as a score of bee stings—or worse, for individuals with allergic reactions to natural venoms. This is one of the reasons why night divers must always be extra careful about brushing against the reef.

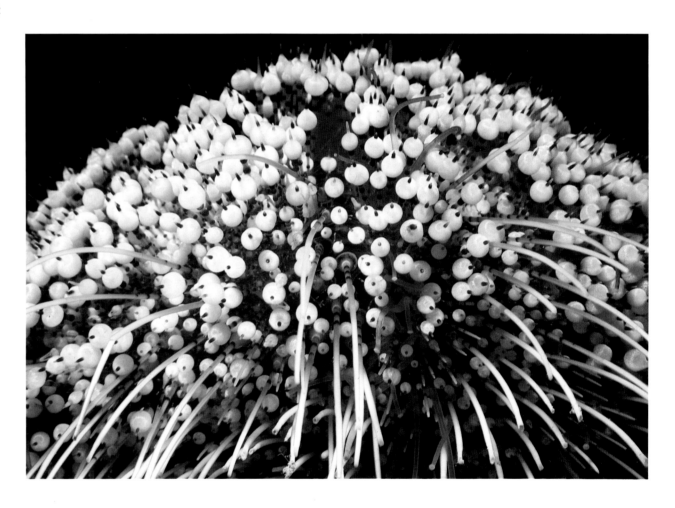

The spines of many sea urchins are sharp, can lead to serious infection, and—once lodged—are difficult to remove. But few of them—such as this one—are actually venomous. Those translucent white globes that look like pearls impaled on spikes are actually sacs filled with venom that can produce serious pain and inflammation.

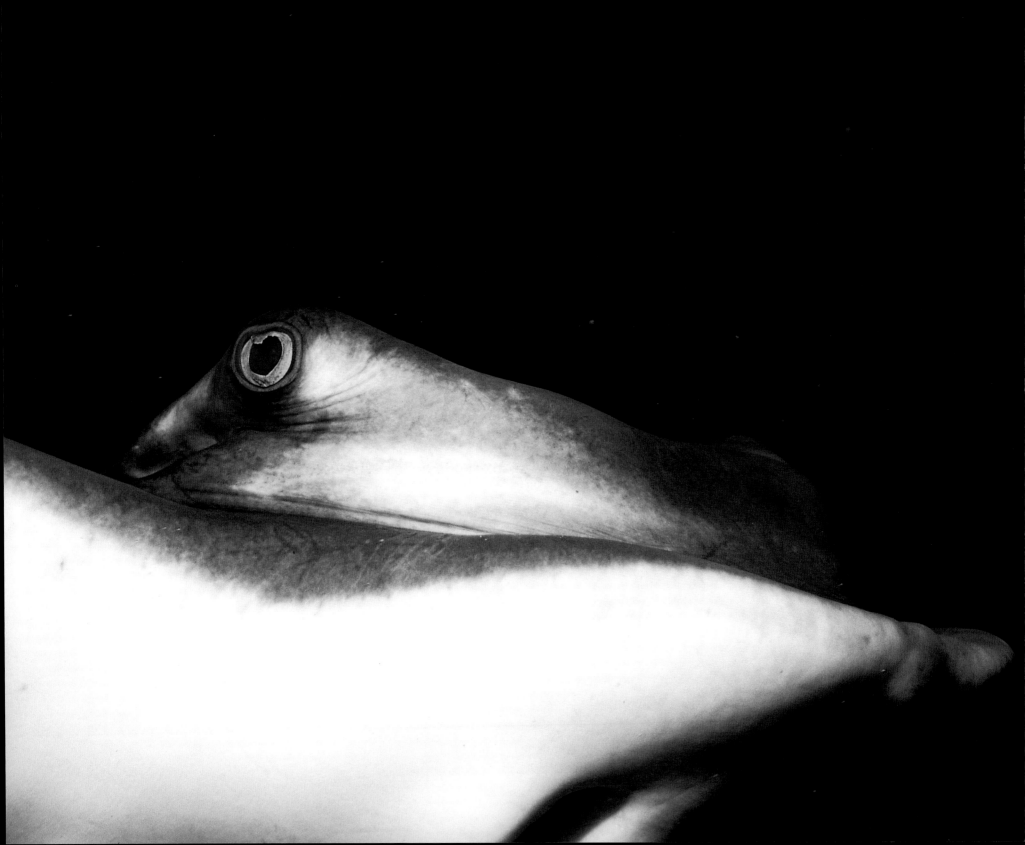

THE FINE POINTS:
GETTING THE MOST
FROM YOUR NIGHT DIVE

As mentioned earlier, taking night dives with organized groups is the safest, most convenient, and most comfortable way to start. But it's not perfect. The disadvantage is that many such groups are run (as they must be) in deadly fear of liability claims and with less knowledge of the nighttime fauna than you have if you've read this book. As a result, many group night dives are accompanied by generator-powered underwater floodlights that illuminate the area around a dive boat brightly enough to make you think you're attending a night baseball game. Chances are, too, that you'll be obliged to tag along with some novice photographer who thinks that the best way to get good pictures in the dark is to use underwater movie lights. Sorry, Charlie.

There is a time and place for underwater floodlights—specifically, in dives where you want to attract plankton. Elsewhere, they do more harm than good. It is true that even in shallow water bright lights will attract lots of plankton and that a reasonable number of nocturnal planktivores may swarm around to take advantage of the unexpected bonanza. But once the novelty of all those flashing bodies in a feeding frenzy wears off, you'll find that many of the animals you would most want to see have disappeared for the duration of your dive.

This doesn't mean that no one on a night dive team should carry powerful searchlights; it just means that they shouldn't use them unnecessarily. Night divers quickly learn to use flashlights as sparingly as possible, for many of the nighttime reef's most delicate and unusual animals are extremely light sensitive and strongly resent being in the spotlight.

Sea lilies, for example, normally spread their feathery arms wide in the darkness. But though these animals usually move in slow motion reminiscent of lunar landing vehicles, they wither with surprising speed in the beam of even the smallest flashlight. Hold a light on them for more than a few seconds, and they shrivel up like night-blooming flowers scorched by summer sun. Illuminate them for a few moments longer, and they curl back up into the fist-size balls in which they spend their days.

Sea lilies' relatives, the swift and elusive brittle stars, normally either scurry across the face of the darkened reef or remain in crevices while extending their fragile arms to sweep the reef surface and adjoining water for food. But "touch" them with a light beam, and the animals react as though they've been stung, retracting their arms in a flash and disappearing altogether within seconds. The speed and intensity of their reaction is all the more remarkable because these animals not only lack recognizable eyes but don't have even the specialized light receptors common to so many other invertebrates.

Corals, too, respond noticeably to strong light at night, although not as quickly as some other animals. Many soft corals, in particular, wilt in their own way under strong illumination, pumping water out of their bodies and appearing somehow desiccated even though underwater.

With these caveats in mind, you will soon learn to employ small flashlights to maximum advantage, using their light sparingly—almost like a magic wand—to strip away the veil of darkness for a few moments at a time. It is here that the "up close and personal" nature of night diving comes to the fore. After you dark-adapt carefully, and once you are comfortable with the notion of being surrounded by blackness, stick to a small, dim flashlight. Using that sort of tool to see things yourself and to point them out to your dive partner, you will uncover the maximum number of the night reef's treasures. Of course, you should use your larger lantern if you get disoriented, want to look for a large landmark, or need to adjust your gear. But use it as sparingly as possible, and I'll guarantee you an extraordinary experience.

Timing Can Be Everything: When you first begin diving at night, you will be able to make eminently satisfying dives just about any time of the year and during any part of the month. There's so much to see that the few things you might miss aren't worth worrying about.

Once you become a nightlife connoisseur, however, you might want to do a little more planning, a little more digging through the literature, and a little more chatting with local divers. As discussed periodically throughout the text, certain groups of animals behave differently in different seasons or at various parts of the lunar month. Some animals such as flashlight fish rarely come up near the surface when a full moon is out. Several species of butterflyfishes spawn at dusk during particular parts of tidal cycles governed by the positions of the moon. In subtropical regions, spring and winter are characterized by different sorts of animal activity, and in the tropics proper, wet and dry seasons often have an effect on reef fauna.

If you can't get to local people in advance to check out particulars, a good fallback strategy is to plan your dives for a few days on either side of a new moon. That will maximize your chance of seeing extremely light-sensitive animals if you plan to dive on reefs; it will also enhance the effect of your floodlights if an open-water plankton dive is in the offing. Remember to allow yourself a couple of days to familiarize yourself with your site and equipment—and good diving!

Whitetip reef shark, Great Barrier Reef, Australia.

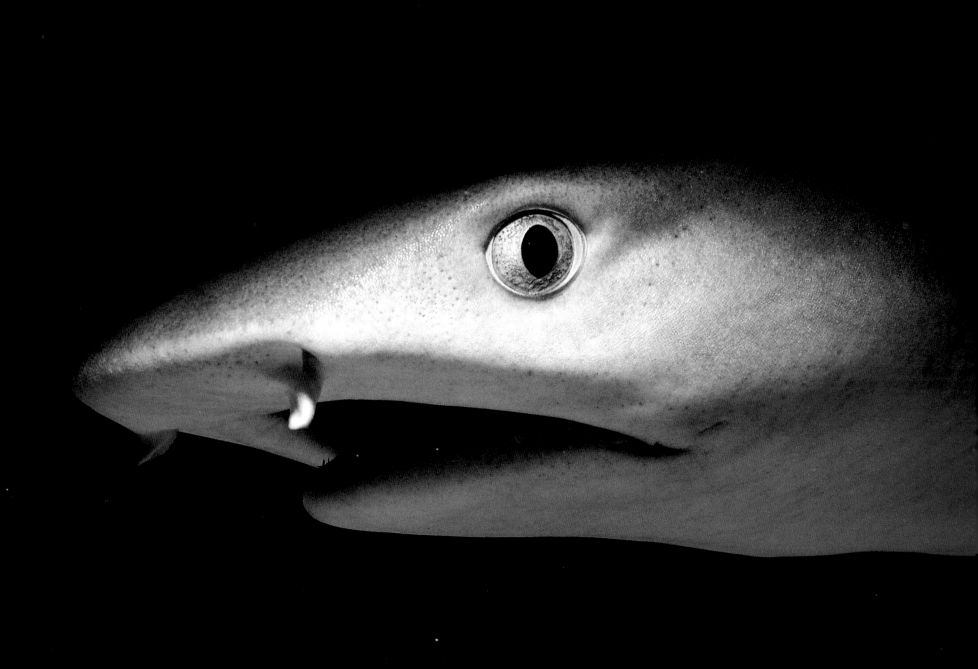

EPILOGUE REEFS UNDER SIEGE

We who love nature, enjoy travel, and are doubly infatuated with nature travel face a spicy yet disconcerting menu these days: delights peppered with disappointments and opportunities interwoven with predicaments. Ecotourism now enables average citizens to visit environments once accessible only to dedicated field biologists. We of moderate means and little vacation time can now paddle down the Amazon with indigenous people, tramp through the jungles of Borneo, or dive the Great Barrier Reef—all with reasonable confidence that we can be back in the office for that important meeting Monday morning. Yet along the way we find ourselves cringing at acres of ravaged tropical rainforest and coral reefs under siege from uncontrolled coastal development—some of which we may be encouraging by our very presence.

Increased access to the natural world is both personally exciting and politically important. Biologists who spend their lives learning how the biosphere works (and have therefore seen the effects of human activity firsthand) have been concerned for more than a century and alarmed for several decades about the health of many ecosystems around the globe. Those of us committed to spreading environmental concern pray that as more people experience the glories of nature—and see the result of ecologically imprudent activity—they will better understand what all the fuss is about.

Pufferfishes, like this juvenile spotted napping at night, are known for their ability to inflate their bodies to discourage predators. When not immobilized in defense, puffers can swim fairly quickly and maneuver deftly around obstacles while searching for invertebrates to crush with their small but powerful jaws.

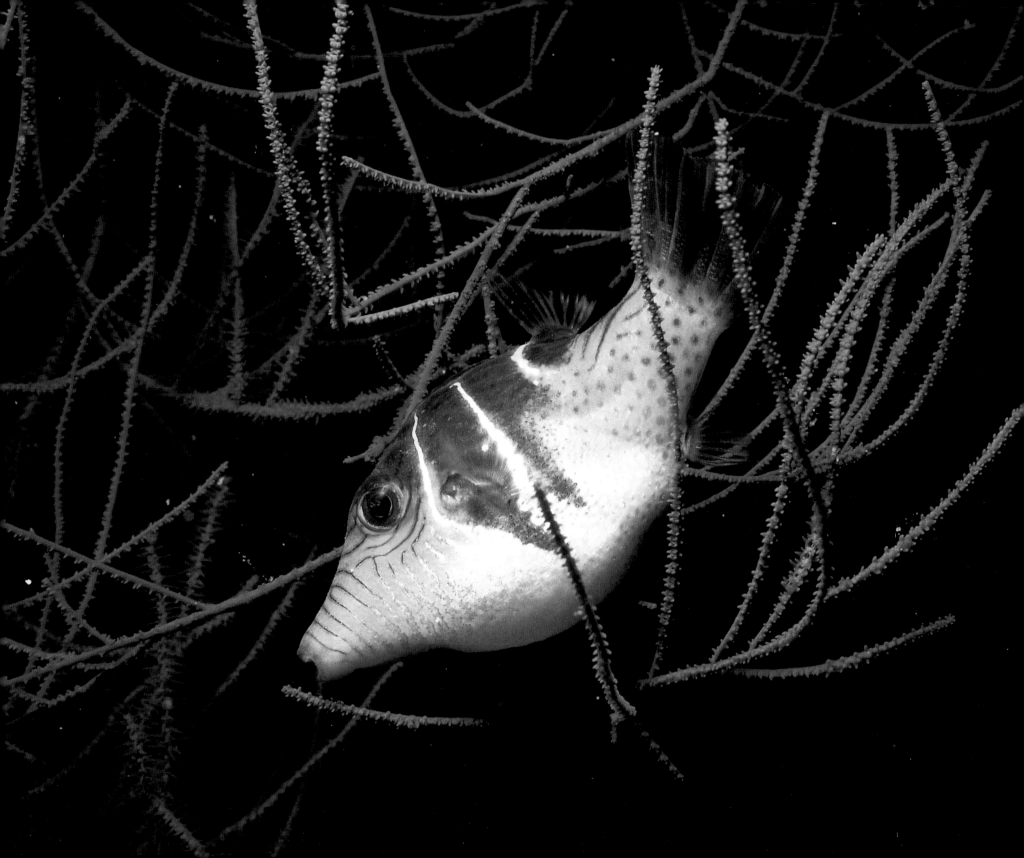

Like their cousins the brittle stars, the common starfish from the Mediterranean have extraordinary powers of regeneration. Here, a starfish that has been torn nearly in two, either by a predator or by an irate shellfisherman, is regrowing its lost limbs.

The state of the world's coral reefs, like reef biology, is enormously complicated. Right now, apocalyptic pronouncements are premature. But if it's true that the sky isn't falling on coral reefs, it's also true that dark and threatening storm clouds loom on the horizon. Reefs in at least twenty countries—from the United States to Mexico, Indonesia, Japan, and Australia—are clearly in trouble. Yet the precise effects of human activity on reefs isn't easy to assess, and its interactions with natural stresses—such as droughts, floods, hurricanes, and heat waves—are even more difficult to sort out.

You've seen throughout this book how complicated reef ecosystems are. Corals and other invertebrates, algae, and fishes interact with and depend on each other in innumerable ways—which means that the absence of one vital organism can have a ripple effect throughout the system. You should also remember that some theories credit reefs' complexity to their history

of being coddled by generally benign, stable, and predictable environmental conditions. Reef communities have evolved in ways that make them remarkably resilient to tropical storms and other kinds of natural stress. But corals and other reef dwellers are far less resistant to unnatural stress than, say, inhabitants of temperate ponds and other aquatic ecosystems in which temperature, water quality, and other conditions can vary wildly from one season to another.

A full discussion of documented and potential environmental pressures on reefs around the world would require a book by itself—and would raise more questions than it answers. At the risk of misleading through oversimplification, we present only a brief survey of the situation here, by placing the sources of reefs' environmental problems into three broad and general categories: pollution, development, and fishing.

Under the general heading of pollution fall such problems as oil spills, heated effluents from power plants, and the discharge of chemical wastes. These problems periodically threaten reefs just about everywhere, near both developed and developing nations. In arid regions and on isolated islands with growing indigenous or tourist populations, salty discharges from desalination plants can be added to that list. And in certain industrialized countries—such as Japan—reefs are still vulnerable to bureaucratic decisions that result in them being covered with concrete and transformed into airports.

Improperly planned development—whether driven by population growth, industrialization, or construction of coastal resorts—has both direct and indirect effects on reefs. Direct effects, usually local in scale and effect, include physical damage from coastal dredging-and-filling operations, harbor construction, collection of coral rock for building material, and sewage discharge. Indirect effects are often larger in scope and can be caused by activity many miles away. Deforestation of inland watersheds can boost the amount of silt washing into local rivers and streams, significantly increasing siltation in coastal waters around river mouths to the point that accumulating sediment begins to smother corals. Destruction of moisture-holding tropical rainforests, in addition to elevating siltation rates, can also increase freshwater runoff during rainy seasons, lowering salinities along the coast for miles around river mouths to levels that stress corals and other organisms.

Fishing for food can upset reef ecosystems in two ways. In the immediate vicinity of several Caribbean islands, for example, tourists' fondness for parrotfish stew and broiled grouper have led to overfishing that has significantly altered populations of several species. In the Philippines, "fishing" is often done with explosives rather than hook and line; whole sections of reef are blown to bits, unconscious fishes are gathered up, and the devastators move on to new territory. Damage of this type can take centuries for slow-growing hard corals to repair.

Sea lilies, also commonly called feather stars or crinoids, are so striking and unusual on their own that many divers fail to notice that they, too, often carry camouflaged partners. Here a feather star is viewed from below as it clings to a branch of orange wire coral at night in the sea off Borneo. Look closely at the red spot near the center of the photograph; this luminous orb is the reflective eye of a tiny commensal shrimp that makes its home among the feathery arms. The nature of the relationship is not known.

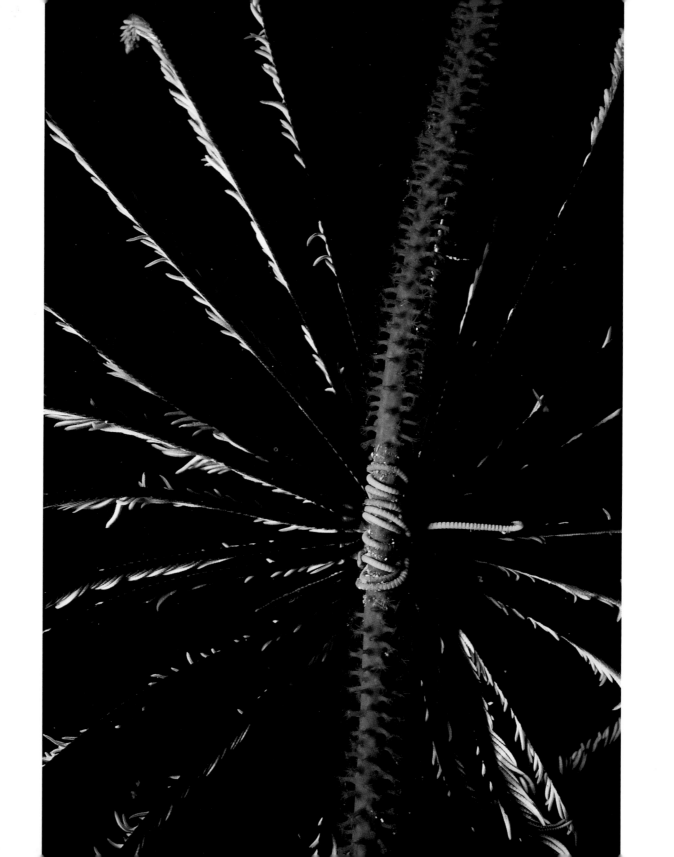

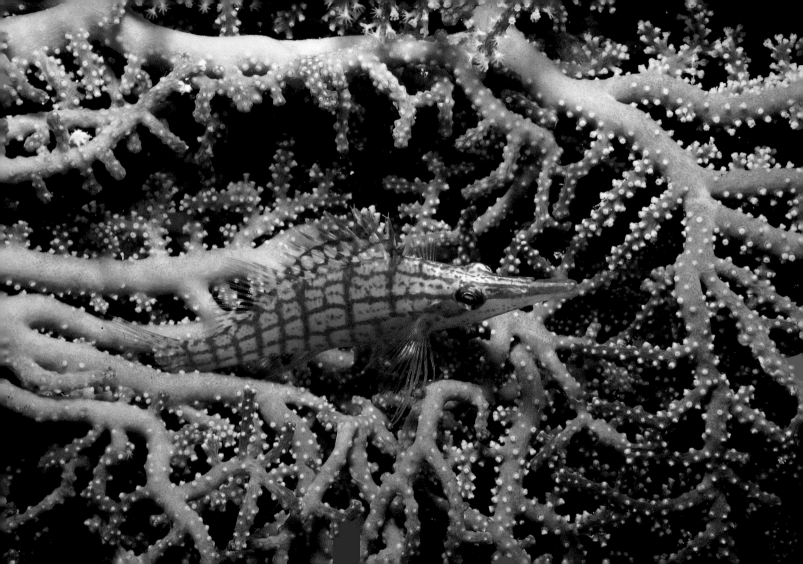

The longnose hawkfish, usually found below 100 feet, spends much of its time perched on gorgonian or black coral. A thoroughly modern carnivore, it tends to sit still between brief feeding forays, during which it uses its long, tube-like mouth to suck up planktonic animals and pluck other small prey from among cracks and crevices that are inaccessible to other predators.

In addition, many reefs—again, particularly but not exclusively in the Philippines—are being overharvested by collectors who supply home aquariums in North America and Europe with live fishes and invertebrates. While there is scientific evidence that many reef organisms can be harvested in sustainable fashion, careless collection can be disastrous. Unfortunately, some unscrupulous collectors gather fishes with the help of "drugs," often a euphemism for poisons dumped on the reef that stun the fishes temporarily. The fishes appear to recover but often suffer damage to their internal organs that ultimately proves fatal. Such collectors are also known to harvest invertebrates (including living coral and coral rock) with crowbars.

Other than the easily identifiable effects of these last few activities, the failure of corals or fishes can rarely be traced to a single specific source of stress. Most of the time, reefs in trouble are harmed by the cumulative effects of several stressors combined—a situation that a noted ecologist once likened to being "nibbled to death by ducks." A temporary increase in water temperature of a few degrees might not hurt a reef at all. If that increase lasts for a full season, it could weaken certain organisms. And if that long-term temperature increase is combined with higher salinity, increased levels of dissolved nutrients, or other stressors, reef organisms— hard corals in particular—could be in serious trouble.

If you follow environmental issues you may have heard, for example, about the troubling phenomenon known as "coral bleaching." Bleaching gets its name from the fact that when it occurs, hard corals lose their subtle, greenish-yellow hues and turn the sparkling—but stark— white referred to by Al Gore. That color loss signals termination of the reef's most fundamental partnership: the relationship between corals and their symbiotic algae. During bleaching, those algae are either tossed out by their coral hosts or pack up and swim off the job on their own. Whatever the reason, with what you now know about coral biology, you can appreciate the repercussions their exodus has for corals. Bereft of their photosynthetic partners, hard corals cannot grow at all and soon become deficient in certain compounds they need to survive. If corals remain algae-free for long, they die.

Bleaching is not in and of itself a new phenomenon; episodes have been reported from scattered locations for quite some time, often in connection with the appearance of unusually warm water. But since the 1980s, bleaching has occurred more often and in more places than was ever reported before. In addition, past bleaching episodes were usually transient events: Bleaching occurred, corals remained white for a few weeks, and then most of them recovered. Whether some symbiotic algae stayed behind and repopulated the coral tissue, or whether new algae took up residence is still unclear. In any case, the setback was temporary. These days, however, recoveries take longer in some cases and fail to occur at all in others.

Why are current bleaching episodes more frequent and more serious? The scientific jury is still out, but what passes for a consensus now suggests that the stresses mentioned earlier have additive effects that increase corals' vulnerability to—and decrease their ability to recover from—bleaching. Some researchers suspect that more frequent bleaching events are the first indication that ocean temperatures are rising—making reefs the oceanic equivalents of a canary in a coal mine. That would fit neatly into "greenhouse effect" scenarios of climatologists alarmed about increasing concentrations of carbon dioxide in the atmosphere. Other experts, however, do not agree that these warming episodes actually do signal a global trend.

It is important to remember that environments as diverse as reefs don't usually collapse suddenly and all at once. Species have different tolerances for environmental perturbations. Consequently, when human activity alters their physical environment, some species suffer, while others may actually benefit. In many places around the world, certain coral species have survived bleaching episodes while others have perished, a process that lowers the reef's biological diversity. On eastern Pacific reefs, for example, three species of corals disappeared altogether during an unusually warm spell during the early 1980s.

Though not known for intelligence and adaptability among the general public, fishes can exhibit surprising behavioral flexibility. Stingrays usually spend their days lethargically and become active when light is dim. These animals, however, tourist attractions at Stingray City in Grand Cayman, have been induced to change that normal rhythm with food offered strictly by day.

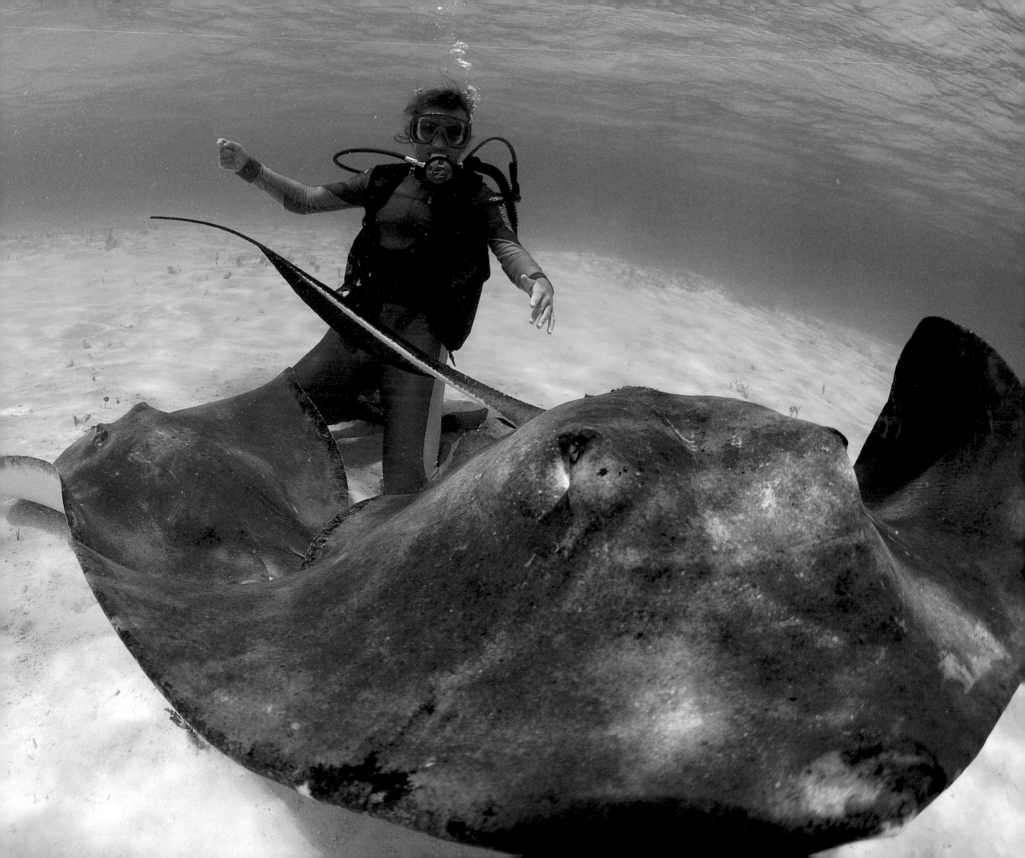

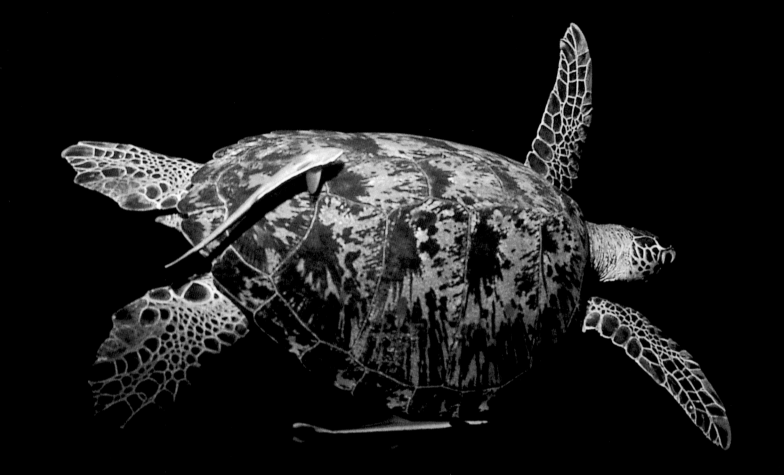

Remoras, usually known because of their fondness for sharks, aren't too fussy about latching on to other large animals, such as this sea turtle photographed off the coast of Borneo. Many people unknowingly denounce remoras as parasites, which they are not. Unlike lampreys (which do rasp away at the skin and feed on the blood of their host), remoras simply hang on for the ride—allowing their host to carry them from one prospective meal to another.

Unfortunately, for a prime example of reefs under siege, we need go no farther afield than southeastern North America, to the only reefs connected to the mainland United States. The reefs in question run south from the vicinity of Miami through the Florida Keys—a chain of islands that dangle from the southern tip of the state like the whisker on a catfish's chin. Many of these reefs are included in state and national parks and marine sanctuaries with underwater components. But despite their protected status, both their total coverage of live corals and number of coral species are declining precipitously, according to recent studies by James Porter and Ouida Meier of the University of Georgia.

Five out of six reefs surveyed by this team lost nearly forty-five percent of their live coral cover between 1984 and 1989. Porter estimates that if the current rate of loss continues, some of the Keys' reefs will be bare of living corals by the year 2000. Already, visitors to North America's prime window onto the underwater tropics now find large expanses of once-living reef either bleached white and dying or covered with long, stringy clumps of green algae.

Ironically, Porter notes that Hurricane Andrew—a class-four storm that devastated terrestrial environments and cities in a broad band across Florida in 1992—caused relatively little damage to local reefs. Reefs, have, after all, evolved in areas where such storms are facts of life; many coral colonies broken by a single storm can ultimately heal—assuming that they are healthy to begin with.

But though Andrew didn't harm Florida's reefs too much, they certainly aren't healthy. During a decade of observations, no young coral colonies appeared at most sites. Porter likens this lack of successful reproduction among corals to a human population composed solely of "houses with no children"; the community's long-term survival would be in serious jeopardy, even if all the adults were healthy. What's more, because no new corals are replacing those that die, bare patches of coral rubble are left open—and are rapidly covered by thick growths of algae.

What could be causing these problems? At first, Porter and Meier couldn't turn up any suspects. Algae spreading across the reef didn't seem to be *killing* the corals—just replacing those that died of other causes. A coral disease seemed to be attacking weakened colonies, rather than killing healthy ones. Instead of a single cause, it seemed to Porter, the corals were succumbing to a series of "unspecified factors" that harmed them more than a class-four hurricane. But what could those factors be? The researchers have developed a hypothesis linking the reefs' problems to much broader environmental changes in the entire southern part of Florida over several decades.

To make a long story short, the problem may lie with the large-scale, long-term diversion of water from central Florida's Lake Okeechobee. In the past, much of that landlocked lake's overflow flowed in a giant, shallow, sheet in a southwesterly arc through the Everglades, sustaining vast marshes and mangrove forests and ultimately ending up in Florida Bay, where it diluted the seawater and created a productive estuary. But several decades ago, the Army Corps of Engineers—who saw the Everglades as little more than wasteland—constructed an elaborate network of levees, dikes, and canals to divert that water eastward in the name of development, agriculture, and flood control.

Today, much of that water empties—unused—into Biscayne Bay. Consequently, so little water now reaches Florida Bay that the bay's salinity has risen dramatically, much of the sea grass that once covered its bottom has died and decomposed, the amount of oxygen in the water has fallen precipitously, and its load of suspended sediment and organic matter is higher than ever before. Today, that altered water may be spilling out of the bay through the Keys—stressing some reefs and killing others as it flows over them.

Porter emphasizes that, as of January 1993, this scenario is still a hypothesis that must be tested by further experiments and observations. If his scenario turns out to be correct, the problem could be reversed by stopping the diversion of Okeechobee's precious water. But the price tag on that operation (which, incidentally, would also go a long way toward saving the parched and dying Everglades) is estimated at more than $1 billion. As further data are collected and the picture becomes clearer, it will be interesting to see what Americans concerned about the fate of our living reefs will be able to do to save them.

Crocodile fish partially buried in sand, southern Australia.

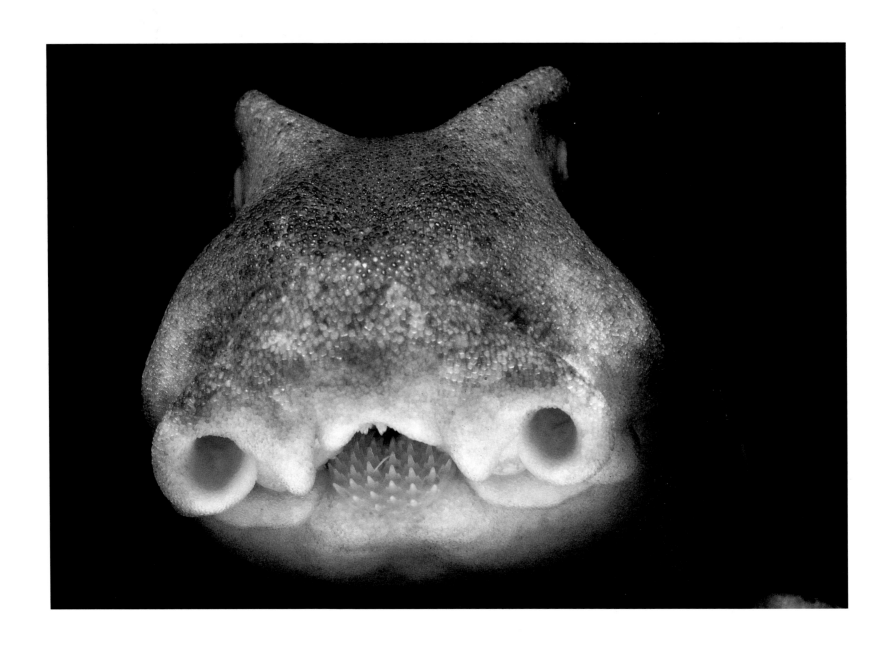

The bizarre Port Jackson shark bears a mouth filled with teeth that serve to crush, rather than cut or tear, the worms and shellfish on which it feeds. Harmless to humans, these bottom dwellers are nonetheless efficient predators whose highly developed senses of smell and taste help them locate quarry buried in sand and mud.

In the meantime, we should all be concerned about the more subtle pressures that are "nibbling" at the species diversity of reefs around the world. Why? Because as E. O. Wilson argues persuasively in *The Diversity of Life*, "Biological diversity is the key to the maintenance of the world as we know it." Unusual events—from hurricanes to prairie fires to tidal waves—periodically tear holes in the intricately woven fabric of ecosystems. Over time, those holes are repaired by a steady succession of species that begins with pioneers, continues with later colonists, and concludes with so-called "climax" species that ultimately hold sway. The point is that this recovery is possible because all those species are present. Each of them participates in the healing process in its own way and its own time.

If too many of those individual living threads are missing, the healing process can be slowed, shunted in a different direction, or derailed altogether. What comes back after a disturbance, whether a bleaching event or a hurricane, may resemble the slimy algal mats that now cover many shallow-water areas of the Florida Keys, rather than the fairy-tale kingdoms we've been celebrating throughout this book.

What's a committed nature lover to do? Individuals can't do much on their own about controlling carbon dioxide emissions, reducing the release of chlorofluorocarbons, and the like. But they (or rather you) can study ecological policy records of politicians on both local and national levels—and determine to vote accordingly. Organizations such as the Sierra Club, the World Wildlife Fund, the Nature Conservancy, and the Cousteau Society can amplify the voices and financial resources of concerned individuals and focus them on specific legal and economic remedies—such as the situation in southern Florida. Once dismissed as fringe groups, such organizations are gaining in power and influence, and are becoming admirably savvy about the Byzantine maneuvers necessary to effect change at the national level. Find one (or several) that share your priorities and support them as generously as you can. Remember, the powerful social and economic forces whose interests often pit them against ecologically sensible thinking are both firmly entrenched and blessed with very deep pockets.

On a more personal level, you can make certain in several ways that you are not yourself contributing to specific local problems. When you travel to exotic locations to enjoy local plants and animals, take an active interest in events around you. Determine how local establishments obtain drinking water and dispose of waste. Support them if they seem to be doing things the right way, and try to steer them in other directions if they are acting irresponsibly.

At first blush this strategy seems simplistic, even futile. "Can I really affect the way a resort hotel handles its sewage?" you might ask. It is true that your actions will have little value if you are the only person who voices concern and threatens to withdraw business if appropriate steps aren't taken. But if lots of potential customers start making noise, businesses listen. Gardeners, for example, will notice that mail-order nurseries are beginning to switch to recycled papers and soy inks for their catalogs, and are offering rebates to customers who

return plastic packaging materials and shipping cartons. That change hasn't come from nowhere; gardeners are a pretty "green" lot, and they've made their concerns known. Progress may be slow, but anything is better than lack of change or movement in the wrong direction. There is no reason to suspect that resort operators— particularly those involved with ecotourism— would be any more recalcitrant than agricultural concerns.

You can also take direct action, both on the reef itself and at home, to make sure that you are part of the solution, rather than part of the problem. See that dive boats you charter use permanent moorings, not anchors, to secure themselves over reefs. An anchor dragged over a reef once in a blue moon won't make much difference, but many popular dive sites now host a dive boat every fifty yards for several miles on a daily basis. That's a lot of anchors, and a lot of damaged coral heads that can take centuries to recover.

On a smaller scale, watch yourself when diving. Try not to break off corals accidentally, either by using fragile formations as handholds or by standing on living coral. Again, an occasional careless diver isn't a problem, but hundreds of little insults to the reef every day add up surprisingly quickly to a lot of damage in heavily dived areas.

Refrain from collecting (or buying from local shops and vendors) hard corals, coral jewelry, seashells, or reef fishes (live, dried, or plasticized) as souvenirs. They invariably look better on the reef than they will on your mantelpiece. If you must have souvenirs, scour the beaches for dead shells and corals washed up by storms; you can often find, amid the rubble, specimens in good condition, and taking them does no harm to the reef. And, of course, you can always take pictures. Finally, share your delight with and concern for coral reefs as broadly as you can.

In closing, remember the concerns of Alfred Russel Wallace, who nearly beat Darwin to the punch by independently deriving a theory of evolution. Over a century ago, Wallace recognized presciently that trends he had noticed could be dangerous in the long run. As he wrote to London's Royal Geographical Society:

The naturalist looks upon every species of animal and plant now living as the individual letters which go to make up one of the volumes of our earth's history; and as a few lost letters may make a sentence unintelligible, so the extinction of the numerous forms of life . . . will necessarily render obscure this invaluable record of the past. It is therefore an important object to preserve them. If this is not done, future ages will certainly look back upon us as a people so immersed in the pursuit of wealth as to be blind to higher considerations. They will charge us with having culpably allowed the destruction of some of those records of creation which we had it in our power to preserve, and while professing to regard all living things as the direct handiwork and best evidence of a Creator, yet, with a strange inconsistency, seeing many of them perish irrecoverably from the earth, uncared for and unknown.

PHOTOGRAPHING UNDERWATER AT NIGHT

Jeffrey L. Rotman

I had been diving for two years when I first took a camera underwater at night. The photographic possibilities shocked and amazed me: I was seeing a new world. Suddenly, everything was confined to a narrow beam of light. The window of sight that the beam of a torch exposes allowed me to focus and concentrate very selectively on a chosen subject. The colors were true—and even electric. Now, almost two decades later, nighttime, dusk, and dawn are my favorite times to investigate and photograph the reef world.

At night, your torch creates an imaginary shield that hides your presence. If your subject sees you at all, it's not you that it sees, but rather the beam of your torch. You become a thief in the night, stealing glimpses of animals and behaviors. When your movements are slow and directed cautiously, your presence is not felt. It is this wonderful ability to become invisible that allows you to observe and photograph in a way that is just not possible during daylight hours.

Larval tropical lobster photographed in open water on a moonless night, Red Sea.

Many of the animals that become active at night are small and unfamiliar, allowing them to be easily missed. For this reason, it becomes important to slow the pace of your dive to a dead crawl. Try spending one hour on a few square yards of coral. You will be amazed at the variety of life you begin to discover. Examine every speck of coral with a fine-tooth comb, and surprise will follow surprise. When you first find a subject you want to capture on film, avoid the urge to shoot. Instead, just watch. Exercise your patience and just look for a spell; see what the animal does. Many of the animals you will come across are in search of a meal, and if you wait—and are careful not to disrupt their behavior with your own—you are likely to see them feed.

A good method to use when searching for animals at night is to work with a dim light—try running down the batteries of your torch before entering the water. This way, many animals are less likely to react to your presence and thus alter their natural behavior. It can also be helpful to light the subject you are trying to view with only the weak edge of a wide beam.

Before you try photographing at night I recommend you take a look at the reef by day. Become familiar with the seascape. Try to locate areas that are most likely to offer active behavior. I prefer the interface of sand and coral; don't overlook a coral outcrop in the middle of a sandy plain. This island in the sand acts like a magnet, attracting the surrounding marine life that emerges under the cover of darkness.

The night constantly offers up new experiences and situations. Meet those events with careful thought before attempting a photograph. Be aware that a fish can wake up in a grumpy mood from having a flashgun fire off in its face.

Surgeonfishes, named for the razor-sharp scalpel blades at the base of their tailfins, often seek cracks and crevices for sleep. Once, while working in a cave, I spotted a delightful anemone that appears only at night. In my excitement to photograph this animal I failed to notice the surgeonfish that was sleeping peacefully nearby. The firing of my flash frightened the fish and, as it attempted to escape, it slashed a deep gash in my thigh.

One night my assistant, Bob, spotted a giant Napoleon wrasse fast asleep in a coral crevice. This fish was humongous! It must have weighed close to 250 pounds. We both quickly realized that its magnificence would be lost in a photograph without a diver to show the scale. Bob suggested that he climb into this narrow crevice to pose alongside the sleeping wrasse. I immediately saw an accident in the making, but Bob convinced me he could handle it—and, of course, that it would make a great photograph.

Crinoid feeding while perched on fire coral in the Red Sea at night.

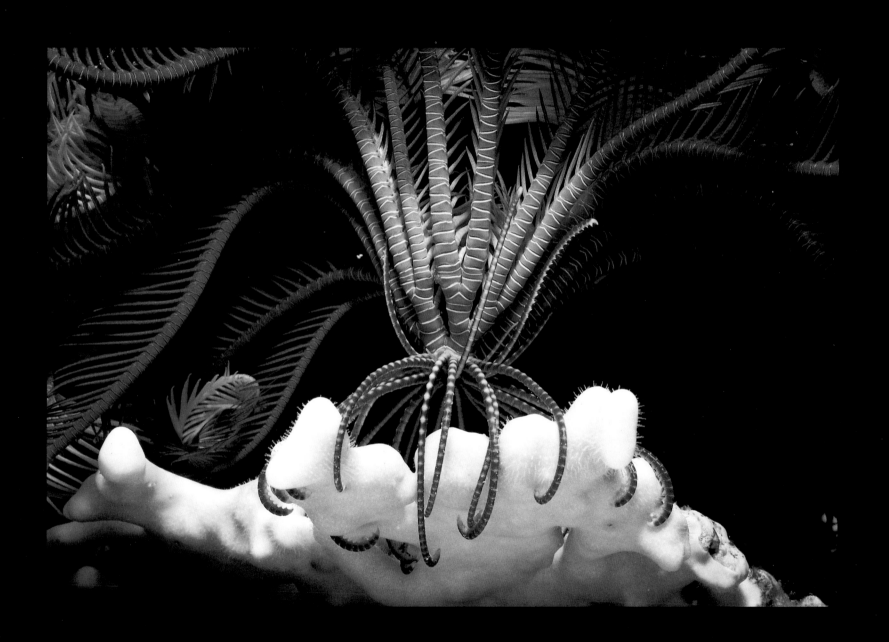

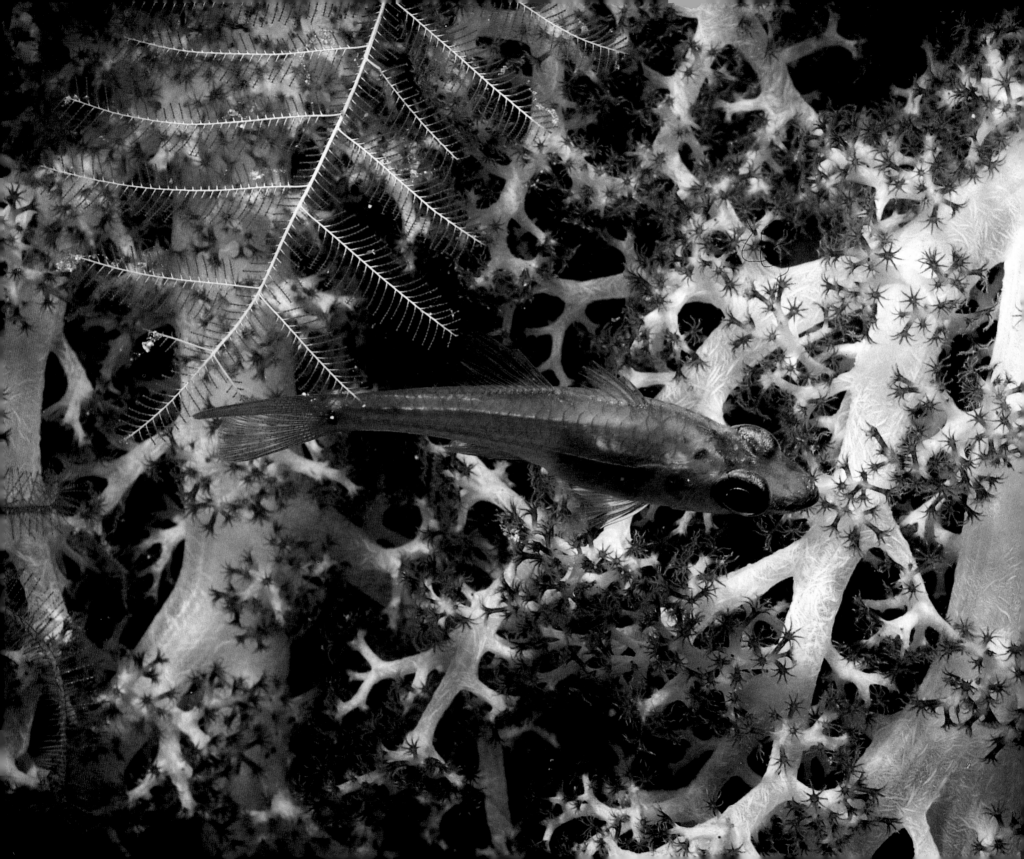

Against my better judgment, I agreed. Before I had a chance to take the photograph, the giant fish woke up in a fit of terror and started wildly flexing its 250 pounds of muscle. Bob's mask and regulator were knocked off, and a major accident was only barely avoided.

Photographing at night need not be deep to offer excitement. The majority of my work has been done at depths above sixty feet. However, there are times and locations that do offer special subjects in deeper water. When attempting a deep night dive, approach it with careful planning. Set a depth limit for yourself, and stick to it. Make sure your dive buddy will feel comfortable at that depth as well. Remember that nitrogen narcosis definitely affects diving below 100 feet at night, and that in general you can expect to feel narked thirty feet sooner at night than during the day.

When you are trying to concentrate on your photography there is the tendency to forget where you are. The level of concentration required to photograph at night results in the diver being diverted from monitoring his or her depth, air supply, and time limitation. Be aware of that happening, and avoid trouble. The most amazing photograph somehow loses its appeal if you are not around to hear the applause!

Two of my favorite times to go in with a camera are the changeovers from day to night and from night to day. During these transition periods, the action can be nonstop for almost an hour, constantly offering up great photographic opportunities. Get in the water well before the action begins, and allow your eyes to adjust to the changing light levels. Monitor your available light with an accurate meter frequently—you can lose or gain an f-stop of light within moments.

Don't worry too much about what type of equipment or film to use. Other than adding a torch, stick with exactly what you're comfortable with on land (in waterproof housings, of course). What you use isn't important for a great photograph—how you use it is.

Once you feel that you have done it all, give open-water night diving a try. Some of the most dramatic diving to be done with a camera can be experienced when you jump off a boat in open ocean at night knowing there is no bottom to stop your descent. In the open water, you will have the opportunity to photograph animals that you will never see on the reef. Most of these subjects are very small and will require total concentration to photograph well, but the experience is not to be missed. And remember, if you drop your camera, don't chase after it!

Good shooting, and safe diving!

Juvenile fish in soft coral at night, Borneo.

Acknowledgments

Both of us would like to extend our sincerest thanks to Margaret Kaplan, whose confidence in our abilities and support for our efforts made this book possible; to Sharon AvRutick, whose editorial acumen shaped its prose; and to Elissa Ichiyasu, whose design sensibility endowed it with its good looks.

I am rarely in the water alone, especially at night. The following dive buddies were at my side when I took these photographs: Ken Beck, Marcello "Capo" Bertinetti, Carlo DeFabianis, Asher Gal, Amos Goren, Yair Harrel, Bob Johnson, Joe Levine, Oren Lipshitz, Ernst Meier, Galit Rotman, Ibrahim of Sinai, and Umbarak of Sinai.

As an underwater photojournalist I owe a great deal to the editors who have supported my work over the years: Elena Adam, Debora Altman, Nikki Barre, Wolfgang Beinken, Pascal Bessaoud, Nele Braas, Christiane Breustedt, Dick Bryant, Renzo Castiglioni, Natasha Chassagne, Maxine Chavanne, Michael Collins, George Darby, Caroline Despard, Phoebe Diftler, Erwin Ehret, Eva Ernst, Larry Evans, Salvatore Giannella, Gianliugi Gonano, Nick Hall, Anne Hauben, Uta Henschel, Venita Kaleps, Franco Lefevre, Barbara London, John Luiso, Claudine Maugendre, Dirk Maxeiner, Tony McGrath, John Nuhn, Lello Piazza, Michael Rand, Sylvie Rebbot, Elke Ritterfeldt, Mel Scott, Lucia Simion, Susan Smith, Alberto Solenghi, Richard Walter, and Kay Zakariasen.

Special thanks to my agent, Maria Lane, whose keen eye keeps me afloat, and to Fred Dion of Underwater Photo-Tech for keeping my cameras clicking.

Jeffrey L. Rotman

To my mentors and friends in the underwater world: Chester Roys and Norton Nickerson, who showed me my first coral reef; Genie Clark, who offered the best-possible introduction to the Red Sea; Ruth Turner, whose dedication to marine life inspired me and whose encouragement steered me to a certain school in Cambridge; Karel Liem, whose wisdom and indefatigable sense of humor created an extraordinary climate for learning; Ted MacNichol, who, while teaching me to study vision taught me what vision really means; and Jeff Rotman, the older brother my biological family didn't provide. The help and support of all these people made what is worthwhile in this book possible. The mistakes it contains are mine alone.

Joseph S. Levine

I n d e x

Numbers in *italics* refer to photographs.